Naomi —

May your own dream
come true !

[signature]

This was a lovely makeshift city. Even the trees and plants did not belong here. They came, like the people, from far places, some familiar, some exotic, all wanderers of one sort or another seeking peace or fortune or the last frontier, or a thousand dreams of escape. —Frank Fenton, *A Place in the Sun*

ANGEL CITY PRESS

DREAMERS
IN
DREAM CITY
HARRY BRANT CHANDLER

LIBRARY OF CONGRESS CATALOGING-IN-PUBLICATION DATA
Chandler, Harry Brant.
 Dreamers in Dream City / By Harry Brant Chandler.
 p. cm.
 Includes bibliographical references.
 ISBN-13: 978-1-883318-84-0 (hardcover : alk. paper)
Celebrities—California—Los Angeles—Portraits. 2. Portrait photography. I. Title.

TR681.F3 C48 2009
779'.2--dc22
 2009003036

Printed in China

ANGEL CITY PRESS
2118 Wilshire Blvd. #880
Santa Monica, California 90403
310.395.9982
www.angelcitypress.com

INTRODUCTION

All men dream: but not equally. Those who dream by night in the dusty recesses of their minds wake in the day to find that it was vanity: but the dreamers of the day are dangerous men, for they may act their dream with open eyes, to make it possible.
—T.E. Lawrence, *Seven Pillars of Wisdom*

From unknown hopefuls to international celebrities, surfers to scientists, quacks to entrepreneurs, Southern California has produced an unrivaled potpourri of dreamers unique in their unbridled optimism and world-class accomplishments. Why?

Los Angeles and the Southern California region have been, for much of the twentieth century, the Promised Land for pilgrims in search of an American dream: freedom for all, fortune for many—and fame for a few. Less than two hundred years ago a dusty pueblo transformed itself into the metropolis known as a world center of creativity and opportunity, a Dream City rivaling London, Paris and New York City.

> *Dreams have a way of struggling toward materialization. Los Angeles did not just happen or arise out of existing circumstances, a harbor, a river, a railroad terminus. Los Angeles envisioned itself, then materialized that vision through sheer force of will. Los Angeles sprung from a Platonic conception of itself, the Great Gatsby of American cities*

This paragraph from *Material Dreams: Southern California Through the 1920s*, by California's eminent historian Kevin Starr, helped inform my own belief about my hometown: that Los Angeles entered the twentieth century with such a small population and so few traditions, and was therefore able to roar into the early decades offering unparalleled opportunity for invention and expansion, unfettered by established practices or an ethos of self-perpetuation. Immigrants found that they could leave behind their conventions, styles and mannerisms of their hometowns and embrace a new climate of opportunity, tolerance and freedom.

In the first half of the last century, land in Southern California was still plentiful, easy to work and cheap. The ideal weather allowed year-round outdoor activities and bountiful crops. These were the siren's call for legions of eastern and midwestern Americans. By the mid-twentieth century, the foreign-born also heeded the lure of the Southland, with Europeans, Latinos and Asians making Los Angeles the top destination for immigration, the world's foremost melting pot of accents and attitudes, careers and creativity, tastes and talents.

The Southern California climate also motivated the shift here of the nascent aviation, astronomy and movie industries from their eastern origins. L.A.'s aircraft manufacturers, the California Institute of Technology, the Mount Wilson Observatory

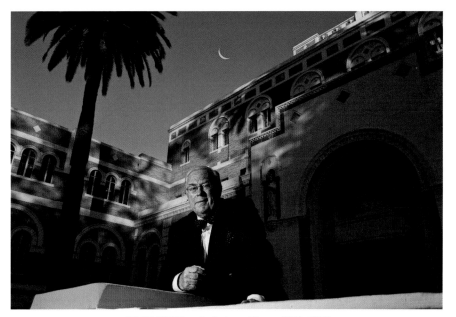

KEVIN STARR at the Doheny Library, USC, 2007

and the Jet Propulsion Laboratory have since attracted many of the world's top engineers, scientists and astronomers.

The success of the film business here attracted the radio, recording and television industries to the region. The world has watched and listened to this city's heartbeat in television shows, movies and songs. Meanwhile generations of singers, starlets, special-effects technicians, stuntmen and sound mixers have been enticed to the world's biggest dream factory by lucrative jobs and the prospect of establishing their own foothold in it.

The confluence of all of these forces has made Los Angeles the epicenter of innovation—and of the individuals who follow uncharted courses to create it.

Absorbing this enormous influx of dreamers has had its downside, however. Perhaps the French architect Le Corbusier summed it up best: "A dream × 1,000,000 = chaos." The millions of dreamers who made it to Southern California transformed the gentle landscape into an urban collision of haphazard planning, cities clogged with tract homes, a concrete riverbed, multistory parking lots, ugly strip malls and overwhelmed roadways.

Achieving dreams in this cacophony called Southern California has become increasingly demanding, as Kevin Starr reflected upon for this book:

> *Miguel de Unamuno [the Spanish philosopher] called it the "tragic sense of life"—when bounty and beauty no longer come as unearned increment. California is increasingly difficult, competitive, and aware of enormous challenges that are forcing its citizens and institutions to struggle mightily. The typical American dreamer can no longer merely say, as he once did: "The solution is that I have come to California." The ante has been upped. The state has become "a reality in search of a myth [that was] never fully repudiated."*

In the course of putting this book together, I have had the pleasure of interacting with dozens of dreamers who have met these challenges and succeeded in validating rather than repudiating our myth as the land of opportunity.

My fascination with these rare men and women in fact started decades ago. I was only six when I met the first dreamer who made a real impression on me. There I was, at my first symphony concert at the Hollywood Bowl with my parents and grandparents, and we bumped into Walt Disney—I recognized him immediately as the man on TV. He was a friend of my grandparents, Norman and Dorothy Chandler, so we stopped to say hello. Without warning, Walt perched me on his lap and began telling me about his just-opened Disneyland theme park. I was spellbound as the master storyteller regaled me with descriptions of the rides and sights of his magical kingdom. I remember being instantly entranced by his tales—what kid wouldn't be?

I didn't realize then that I was living a privileged life, but growing up in a family with its own high-achieving Angelenos quickly made it clear that my heritage was different than most. In part that is why I have written this book—to give back to a city I love and that has been very good to my family. Consider our good fortune:

My maternal great-grandfather, Otto Brant, moved here from Ohio in 1885 to find better land to farm, founded the Title Insurance and Trust Company and was a partner in many prominent land developments, including building the first towns in the San Fernando Valley with my paternal ancestors.

My paternal great-great-grandfather Harrison Gray Otis, also from Ohio, arrived in Los Angeles in 1876 after fighting in the Civil War, and became the first publisher and owner of the *Los Angeles Times*. My paternal great-grandfather and namesake, Harry Chandler, came from New Hampshire in 1884 to improve his health, became the general manager of the *Times,* married Otis' daughter, Marian, and went on to become one of the most powerful citizens of his day. Since Harry died nearly a decade before I was born, I never got to know him, however his Horatio Alger-type story has loomed large in my adult life. It was, in fact, a desire to learn more about him that initially propelled me to begin to read and collect local history books and historical photographs, part of the genesis for this book. (His portrait and story are included on page 122.)

Harry's oldest son, Norman, succeeded him at the paper, expanded the company to include dozens of other media properties, and fathered a son, Otis Chandler, who became the storied publisher of the *Times* from 1960 to 1980. Otis married Missy Brant (Otto's great-granddaughter) and had five children; I was the second oldest.

Norman's wife (my grandmother) was a prominent Long Beach girl, Dorothy Buffum, who went on to found the Music Center, Los Angeles' performing arts center. Fortunately, I did get to know her very well. My grandmother's larger-than-life personality and accomplishments have always been a significant influence on me—and a further incentive to tackle the subject matter of this book. (Her portrait and biography are on page 24.)

She was never the sit-on-her-knee grandmother; she was as formal as a queen. When I was young, "Mama Buff," as her grandchildren called her, was particularly intimidating. I usually saw her only at the traditional Christmas dinner she hosted at her grand house in Windsor Square, the historic neighborhood five miles west of downtown Los Angeles. It was the most formal of

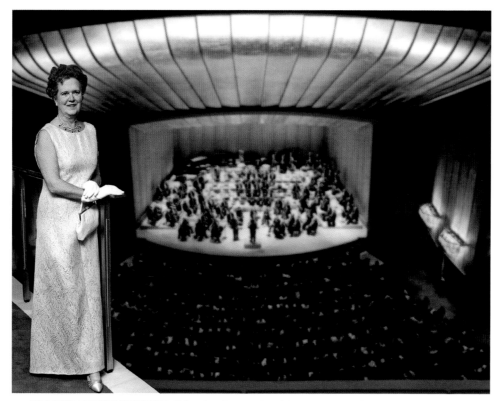

DOROTHY BUFFUM CHANDLER, Philanthropist; opening night of the Music Center, Los Angeles, 1964

evenings in the most formal of homes. The dining room was Versailles-like, with carved paneling, a row of chandeliers, and a table that could seat twenty-five. Wearing coats and ties and party dresses, we grandchildren were instructed to begin the meal by dipping our fingers into crystal finger bowls on silver plates, and then each of us was required to make a toast during the multi-course meal that followed. Throughout the meal and the gift unwrapping that followed in the loggia, she was a reserved, perfectly coiffed hostess rather than an adoring grandmother. No Norman Rockwell moments there.

But despite Mama Buff's regal behavior, our relationship grew deeper as I got older. After graduating from college in 1975, I was living near her, so she frequently beckoned me to escort her to her eponymous Pavilion to attend a concert. Her husband, Norman, had died, and Mama Buff, still active in Music Center affairs, was a regular at the symphonies there. During these evenings together we really got to know each other. The routine was always the same: I would arrive in coat and tie at her mansion, lead her into her Rolls Royce in the motor court and off we would go. She was a traditionalist and always insisted that I, the man, drive—but would then tell me exactly which route to take.

One night, my wife, Denise, and I were escorting her. During a pre-concert dinner with the symphony's conductor Zubin Mehta, the conversation turned to the subject of contemporary women, and Mama Buff made, what I thought, was a particularly naïve and disparaging remark about working women. I decided that she had revealed herself as being just too out of touch with the

struggles of everyday women. So I dared to contradict her, pointing out that perhaps in her position she wasn't exactly in a position to comment on the realities women from other walks of life faced. As soon as I spoke, a chill came over the room, and she sat speechless. Luckily, Mehta left for the orchestra entrance, and we went to Buff's front-row, balcony seats. She didn't say a word to my wife or me during the symphony or on the drive back to her home. I worried that any minute I was going to get chewed out. Finally, as we walked her to her front door, she took me aside. She was crying. She turned to face me and said, "That's why I love you. You're the only one who tells me the truth." Mama Buff hugged me and disappeared into her palace. The queen was human after all.

Even with her idiosyncrasies, I greatly admired Buff's character and achievements, and felt extremely lucky to have spent so much time with her as an adult.

She joins fifty-one other fascinating men and women, plus two groups, profiled in this book. They have all succeeded in accomplishing their dreams on a scale most of us can only envy. Their achievements offer not just a commentary on the mythical city where they flourished, but on what it takes to make it in L.A.

A dreamer is one who can only find his way by moonlight, and his punishment is that he sees the dawn before the rest of the world.
 —Oscar Wilde, "The Critic as Artist," 1891.

HOW THE DREAMERS WERE SELECTED

Once the direction of this book was determined, I set out to identify the rare individuals in Southern California who have had the confidence and imagination to pursue their dreams—and who achieved inspiring, original and lasting results. Many are famous. Most are highly accomplished. All are inspirational. Being a renowned scientist, physician, business leader, athlete, musician, restaurateur or moviemaker in a normal career path was insufficient to merit selection. Dreamers, to my mind, are not content to merely strive to be the best. They must, in fact, creatively reinvent the path to greatness. Sometimes more than once.

I spent more than a year in research, making lists, revising and doing more research. I scoured history books and libraries, consulted experts who included Cecilia Rasmussen, then a columnist of the *Los Angeles Times*, historian Kevin Starr and a long list of friends and family. In the end I chose roughly half of the dreamers from the past and half from modern times. I gave preference to professions that are quintessentially Southern Californian, including aviation, automobiles, film, music and outdoor pursuits. And I decided to include a few unknowns whose immigrant stories help to validate the myth of this City of Dreams.

ABOUT THE PORTRAITS

When I was ten years old, I went to the bank with my mother to withdraw nearly all thirteen dollars of my life savings to make the first big purchase in my life—a Kodak Brownie camera. Although I never took a picture with it that was worth remembering, the

experience of capturing the fleeting moments around me opened an avenue of expression that has been a passion ever since. Sometimes dormant, sometimes in full bloom—as it was in high school and college—my love of photography has only in the last few years truly flourished.

In my photographs I have not been content to just capture what I have seen, but instead, have been perfecting my technique of "post-visualization"—making extensive artistic changes, first in the darkroom and now with a computer—to enhance the pictorial qualities of the image. For the portraits in this book—my originals and those I created from historical photos—I have approached them as an artist, not a journalist. Despite my multigenerational *Los Angeles Times* background, I wanted to deliberately depart from the "pure photography" tradition of recording a moment in time, which journalism demands. Instead, I have created these portraits like a painter would, making alterations from the original setting: changing the composition, removing nonessential visual details, adding or enhancing colors, replacing the skies or the background. I added and subtracted backgrounds, blurred, saturated, lightened and darkened piece-by-piece until I achieved a sufficiently evocative portrait.

For the portraits of many of the contemporary individuals: Frank Gehry, Antonio Villaraigosa, Angelyne, Reeves Callaway, Dan Gurney, Dick Rutan, Gajin Fujita, Ray Bradbury, George Barris and Arnold Schwarzenegger, their time constraints prevented me from photographing them in preferred locations, so instead I shot them in convenient spaces and later Photoshopped them into backgrounds that I felt better suited their personalities and accomplishments.

The inclusion of people from the past, like Howard Hughes, Cecil B. DeMille and the less-well-known, but equally exceptional, Charles Lummis and Helen Hunt Jackson, seemed essential for the book's completeness. But this created a dilemma. As a photographer-artist, I was uncomfortable including someone else's photos of these individuals next to my original portraits of the current day Dreamers. Equally confounding to me was the fact that they were black-and-white images, whereas Los Angeles is a place of saturated colors. I resolved these challenges by remaking the vintage monochrome photos that I licensed into my own colored portraits, hand-tinting historical photographs with modern colors and adding high-chromatic elements to the background—all in the pursuit of creating results that could blend harmoniously with my modern original portraits.

My final goal was to place these individuals in an environment that helps to reveal their accomplishments and personality, rather than simply showing close-ups of their faces. So for these portraits, it was more critical to place them in the context of their dreams than to show the twinkle in their eyes.

I hope that this time the images are worth remembering.

Harry Brant Chandler
Los Angeles
2009

THE BUILDERS

THE BUILDERS

Abbot Kinney—Real-Estate Developer ▪ Frank Gehry—Architect
Dr. Robert Schuller—Minister ▪ Dorothy Buffum Chandler—Philanthropist ▪ Simon Rodia—Sculptor
Mia Lehrer—Landscape Architect ▪ William Mulholland—Water Engineer

Southern California grew too fast. From the turn of the twentieth century onward, its vast open spaces ignited the ambitions of real-estate developers, who divided its Spanish land-grant ranchos into townships and housing developments with little thought to good civic planning and open spaces. By the 1970s, the region's endless stretches of dispiriting stucco buildings had become a national symbol of urban sprawl gone awry.

By contrast, the seven individuals profiled here brought something distinctive and inspiring to the landscape. Each built something unique and lasting, often in defiance of prevailing trends, and each responded to a very particular call. For engineer William Mulholland, whose colossal aqueduct brought the water that allowed a great city to grow, it was the voice of the future. For Dorothy Chandler, whose tireless fundraising built a home for the Los Angeles Philharmonic, it was the music of symphonies. And for outsider artist Simon Rodia, who constructed the strange and enduring Watts Towers with his bare hands, it was the beat of a different drummer.

Also inspired by particular visions and voices were cigarette heir Abbot Kinney and his fanciful turn-of-the-century resort called Venice; the modern evangelist Dr. Robert Schuller, who houses his mega-church in a Philip Johnson-designed "Cathedral of Dreams;" world-famous "star-chitect" Frank Gehry, who first rocked a Westside Los Angeles neighborhood in the 1970s with the house he still inhabits; and the remarkable contemporary landscape architect Mia Lehrer, currently shaping many new urban parks.

Each of these dreamers has made a mark in Southern California, where the openness of the landscape and the freedom of the culture allow it. And in each case, experiencing their legacies is something unforgettable.

My first visit to the Dorothy Chandler Pavilion was a family affair at the gala opening of the Music Center in 1964. I was an eleven-year-old boy, squirming in my front-row seat on the outdoor plaza as I sat through seemingly endless speeches in praise of my grandmother by the parade of dignitaries at the podium. For her and for the city, it was a momentous occasion, but not for me. Only when we went inside was I wowed, as I took in crystal chandeliers the size of cars, the plush red velvet theater seats and luxurious hardwood paneling, and the VIP Founders Room, where my grandmother's oversized portrait hung and where the bathroom fixtures were

golden. When it was time for the concert, my family joined "Mama Buff" in a prominent location at the front of the left balcony, in the seats she would always hold. I was fascinated at first by the array of performers and instruments before me, but about halfway through the concert, my boredom returned. With no lyrics or beat to follow, my untrained mind was losing patience with the symphony, and I tried to escape by listening to a rock-and-roll station on the earpiece of a transistor radio hidden in my jacket. To my frustration, the thick paneled walls of the Pavilion prevented me from getting reception. Luckily, my parents and grandmother were too engrossed in the music to spot my disrespectful behavior.

I was similarly unprepared for my first experience with the work of architect Frank Gehry. I was just out of college when my wife and I heard about the controversy surrounding his newly constructed house in Santa Monica and were compelled to see what the fuss was about. We saw a rough, unfinished-looking structure, all jarring angles and crude, industrial materials, that came off like an affront to its charming bungalow neighbors. But closer up, it was clearly interesting, and there was much to like about its angular design and unconventional use of materials such as asphalt, plywood and chain link. I concluded that it was irreverent, bold, even exhilarating—something that would be architectural heresy in most parts of the world, but in Southern California it was part of the tradition of experimentation. By contrast, when I saw Gehry's Walt Disney Concert Hall in 2003, my reaction was one of awe. I found breathtaking its graceful and unexpected lines, its use of rich, refined materials (warm woods inside and high-tech reflective stainless steel outside) and its sublime acoustics. By this point, Gehry's instinct for the extraordinary and unpredictable had reached its full expression, and my capacity to appreciate his work had also evolved.

My first taste of Abbot Kinney's "Venice-by-the-Sea" was when I occupied a small apartment in this beach community while attending graduate school at UCLA in the mid-1970s. My apartment was located just a block off the boardwalk, on the corner of two streets whose names seemed to characterize the town's funkiness: Ozone and Speedway. It was a fun, unpretentious and lively neighborhood back then . . . one that could at times show its darker side. Every night winos littered the streets with their empty bottles, vandals regularly attacked my parked car and a murder in the parking lot outside my window was viewed as a normal occurrence. However, while living there

I came across photos of the magnificent seaside resort that Abbot Kinney created in the early 1900s with its grand pavilions, dance halls, and enlarged canals with gondoliers. I was saddened to realize how this fanciful community had been neglected over the decades.

There were in truth two reasons for my twenty-one-year-old son and me to head south last year to the former El Toro Marine base. Our stated purpose was to see the plans for, and the initial demolition phase of, Orange County's Great Park. A long-time friend, landscape architect Mia Lehrer and her team were selected to create the huge new park from this now-shuttered military base. As she guided a driving tour, the scale of this colossal site quickly became apparent. When the Great Park is completed, it will become the largest urban park in the country. Mia showed us how a runway would be transformed into a waterway, a group of rotting warehouses into a formal garden and a row of barracks into an alley of trees. This talented designer has already proved herself with some other delightful landscape projects in the Southland, but this transformation of the old Marine facility could well be her crowning achievement.

After our tour concluded, it was time to give in to our ulterior motive for visiting the El Toro base. We dropped Mia at her onsite office and returned to the empty two-mile runways—this time with a less aesthetic purpose. Having talked me into buying a 500-horsepower, 200-mph BMW M5, my son was revved up to experience the car's potential on these wide-open tarmacs. One set of tires and an hour of speed and adrenaline later, we left the future Great Park much happier and headed north.

Garden Grove is north of El Toro on Interstate 5. I had journeyed there a few months earlier to interview and photograph Dr. Robert Schuller. On a lovely campus, I discovered that this dynamic minister has commissioned works from three of the twentieth century's most notable architects: Philip Johnson, Richard Neutra and Richard Meier. My favorite building was Johnson's 2,800-seat Crystal Cathedral. I was fortunate to find myself alone in the upper reaches of this all-glass church as I set up my camera gear. Daylight streamed through the sea of windows, and the great vistas and dances of lights were thrilling to behold. Finally, Dr. Schuller made his entrance. In his eighties, he needed some help ascending to the top steps of the cathedral, but his mind never missed a beat. He is an erudite man who can talk about architecture, psychology or religion with equally deep understanding.

Exploring Simon Rodia's dream—his Watts Towers—was another kind of experience. From photos I had seen, I was expecting something with the grandeur of the Eiffel Tower. This was anything but that—before me was a trio of oddball steeples on a small triangular lot that had once been an immigrant stonemason's backyard. This was folk art, after all, not a grand civic project. But as I gave myself over to a closer visit with this strange creation, I became mesmerized by its intricate details and the ceramic pottery textures and colors—to say nothing of the quixotic spirit of this single-minded craftsman.

My encounter with the masterwork of William Mulholland was unexpected in a different way. Almost every year since my youth I've driven north from Los Angeles along highway 395 toward Bishop to go skiing at Mammoth Mountain, but only recently have a I realized that there, weaving through the foothills and fields of this valley, is one of the engineering triumphs of the early twentieth century. Motoring through the Owens Valley, alongside the majesty of the Eastern Sierras, there are dozens of opportunities to catch a glimpse of this masterwork—now it's an open culvert to drive over, now a line against a hill, now a huge covered siphon that tumbles down one incline and up another. As mighty and enduring as it is, it seems vulnerable and unprotected, particularly considering that without this 230-mile network of canals and pipelines, Los Angeles, Ventura and Orange counties could sustain less than ten percent of their present populations. Now, when I drive up 395 I look eagerly for glimpses of this man-made feature of the landscape and try to conjure an image of the pugnacious Irish-born engineer commanding the thousands of laborers who built a waterworks that changed history.

Each of these builders created a legacy that enhances the experience of living in Southern California. It is equally enriching to discover the personalities behind their accomplishments, as I invite you to do in the portraits and profiles that follow.

The whole country was one rich panorama of flowers, trees, sunshine and beauty. I soon saw why people loved Southern California and my appreciation grew day by day. Then I decided that this was good enough country for me and I let my return ticket expire.

Abbot Kinney

Abbot Kinney was a wealthy and cultured Renaissance man whose greatest legacy was turning a tract of sand and swamp near Ballona Creek into the fanciful, lagoon-lined seaside resort of Venice Beach.

While summering in Santa Monica, Kinney envisioned a lavish development that could bring to Southern California the ambience and architecture of his beloved Venice, Italy. His dream began to take shape in 1904, when Kinney convinced Henry Huntington, owner of the Los Angeles Pacific Railroad, to build a direct rail line from downtown L.A. to the seaside property. Mortgaging all his other properties, Kinney financed a small army of construction workers, many imported from Europe. "Kinney's Folly," as locals called the undertaking, rather quickly came to include a power plant, a casino, a hotel, a restaurant shaped like a sailing vessel, an auditorium and a bathhouse, all constructed with Venetian-style architectural details. At its center was a lavish building with enclosed colonnades, modeled after the Italian city's splendid Piazza San Marco. The resort's crowning touch was a system of canals dug slightly inland and connected to a channel to the sea. Gondolas and gondoliers were imported from Italy to traverse this attractive waterway, and an amusement pier with a roller coaster went up. Encircling the entire development, running a two-and-a-half-mile route, was a miniature steam railroad.

When it made its debut on the Fourth of July in 1905, Kinney's "Venice-by-the-Sea" was an overnight success, causing quite a sensation in dusty, turn-of-the-century Los Angeles. Nearly forty thousand visitors attended in their Sunday best, arriving by trolley, horse and buggy, and a few early automobiles. Some went for the casinos, band concerts and gondola tours; others donned full-length wool bathing suits to enjoy the bathhouse pool and the ocean. And others brought their checkbooks—355 lots were sold in two hours.

Over the next fifteen years, Venice became a resort of national reputation. Kinney continued to build additional attractions, including a roller-skating rink, dance hall, ostrich farm, zoological garden, Japanese tea house and Ferris wheel. Guests could also enjoy a tunnel of love, an airplane ride on 114-foot towers, a thrill ride that spun riders around in tubs before dropping them into a darkened tunnel, circus clowns, dance bands, baseball games and even a Grand Prix car race through its streets in 1915.

When Kinney passed away in 1920, the resort's heyday came to an end. A series of fires decimated the structures, while many of the canals had to be paved over after their channel to the sea filled with silt, rendering them a health hazard.

Today with its cleaned-up canals, high property values and colorful promenade, Venice occupies a niche of its own as a vibrant and edgy seaside community, a magnet for performers and people-watchers. Still, when I see old photos of its original glory, I can't help but wish I could don a straw hat and be transported back in time to enjoy the heyday of the dream park conjured by the "Doge of Venice," Abbot Kinney.

- Born in 1850 on a farm near New Brunswick, New Jersey, to middle-class parents.

- At age sixteen, went to Washington, D.C., to work for his uncle, a senator from Connecticut; studied for three years in Europe, becoming fluent in six languages; upon his return, joined the staff of President Ulysses S. Grant.

- Made his first fortune in a New York City cigarette-manufacturing business he ran with his brother.

- On a chance visit to Los Angeles in 1880, decided he liked it so much that he forfeited his return train ticket and stayed.

- Settled near Sierra Madre on five hundred acres that he named Kinneyloa, adding to his name the Hawaiian word for hill.

- Helped protect the San Gabriel Mountain forests and the future Angeles National Forest; wrote numerous books and pamphlets on political, social and scientific topics; and worked as an activist on behalf of the Indian tribes of Southern California.

**ABBOT KINNEY,
Real-Estate Developer;
Venice Beach, ca. 1900**

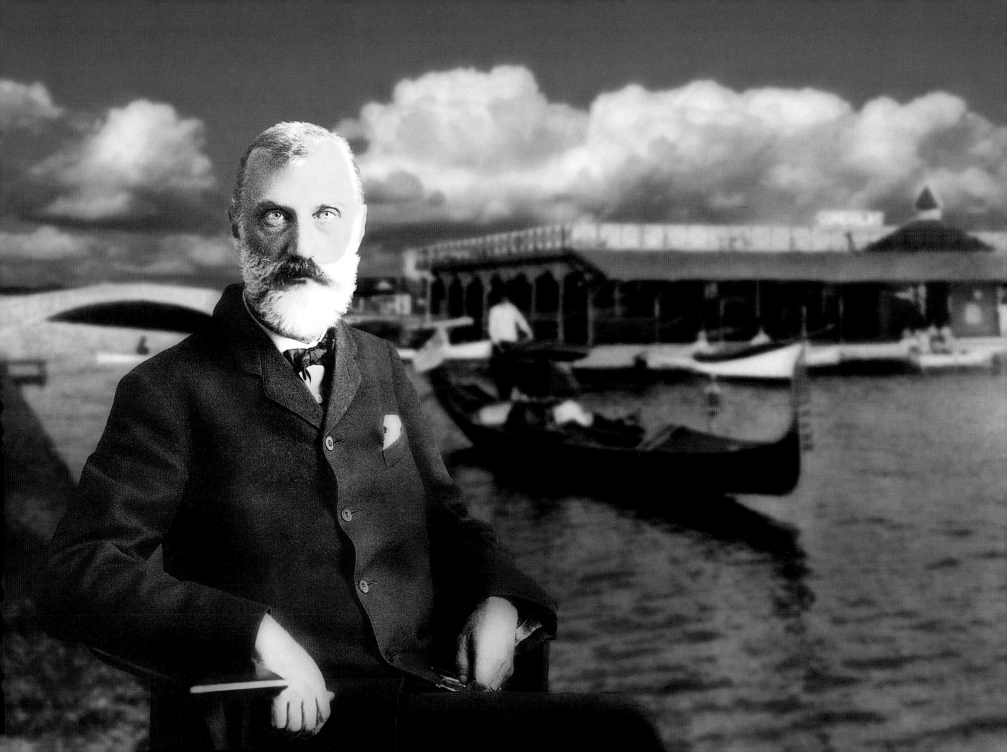

I found a freedom in Los Angeles that allowed me to design under the radar of the eastern critics. If I had stayed in Toronto or Boston or New York, I never would have been allowed to express myself as I have.

Frank Gehry has been a true pioneer in the field of architecture, merging modern sculpture and materials in an adventurous aesthetic. Provocative and original, he has emerged as one of the signature architects of our day.

"Architecture is art" has been his mantra, and making buildings that are more like sculpture has been his dream. He claims to be more at ease with artists like Ed Moses and Ron Davis than fellow architects. His own designs begin like an artist's with a doodle during which his pen never leaves the paper, creating a fluid scribble, full of movement. He then transforms those drawings into simple models that resemble a sculptor's maquettes. Finally, his staff turns these into construction drawings and finally into buildings.

Gehry gained notoriety as an architect in 1977 when he remodeled his small, ordinary Dutch Colonial house in Santa Monica, putting his interest in affordable materials to the test. His deconstructionist design involved a collision of angles, in which exterior forms tilted away from the original structure, and he clad the outside in plywood, chain-link fencing and corrugated metal. He even used asphalt for the kitchen floor. Gehry's bold approach created an instant stir of excitement and controversy. Freed from proximity to east coast architectural critics and the constraints of oppressive design traditions, he began to flourish in the anything-goes aesthetic of Southern California, pushing the envelope of form and materials in his buildings. In the ensuing years, his Los Angeles commissions included Santa Monica Place shopping mall, Los Angeles Temporary Contemporary art museum, Loyola Law School and the California Aerospace Museum.

In 1989, Walt Disney's widow, Lillian, donated fifty million dollars for a new symphony hall for the Los Angeles Philharmonic, and Gehry was chosen to design the structure. Inspired by shapes he remembered from his grandmother's bathtub fish, he developed a vision for the downtown structure as a series of overlapping curves, originally clad in stone. When construction funding stalled in the mid-1990s (partly due to his ambitious and complicated design), he used the same approach for an art museum in Bilbao, Spain, and when that titanium-clad landmark opened in 1997, the applause was heard around the world. Art and architecture critics described the startling result as both "an architectural epiphany" and "a lunar lander in search of its moon." By the time the Walt Disney Concert Hall finally debuted in 2003, Frank's lasting reputation in architectural history already had been assured.

More than 150 people work for him in his warehouse office space in the Playa Vista region of Los Angeles. Despite being in his eighties, he's at the apex of his fame, juggling global commissions on a daily basis. Teams of architects, engineers, model builders and draftspersons do much of the follow-through, but the burden of the artistic creation still falls on Gehry as lead designer. When I met him at the end of a long workday, after months of scheduling postponements, he seemed to sag with exhaustion as he sat down to talk. Though the year-end holidays were nearly upon us, he said he'd been too busy to enjoy any downtime. Even so, he's unlikely to slow down, as his drive to continue shaping the urban landscape is simply too great.

"Architecture is a small piece of this human equation," Gehry said in his acceptance speech for the 1989 Pritzker Prize, architecture's highest honor. "But those of us who practice it believe in its potential to make a difference, to enlighten and to enrich the human experience and provide a beautiful context for life's drama."

- Born Ephraim Owen Goldberg, in 1929, to a family of Jewish-Polish heritage in a poor Toronto neighborhood.

- Remembers his grandmother's weekly ritual of putting a live carp in a bathtub full of water as a prelude to making gefilte fish, and says his memory of the fishes' movements and form later influenced the undulating shapes of his buildings.

- Moved to Los Angeles in 1947 as a teenager so his father could recuperate from a heart attack and find work.

- Gained attention in the early 1970s with what he called "the Volkswagen of furniture"—his Easy Edges collection of corrugated cardboard chairs and tables.

- Hobbies have included boxing, ice and street hockey, and full-contact karate.

FRANK GEHRY,
Architect;
at the Walt Disney Concert Hall,
2007

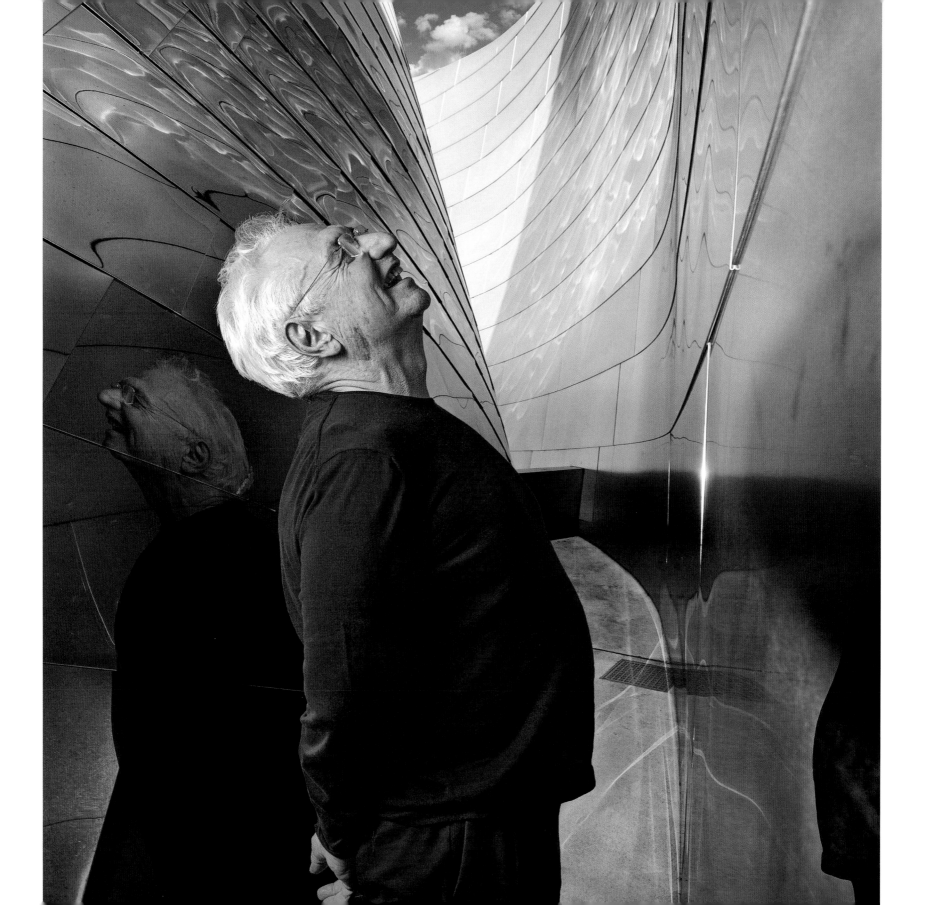

If we can figure it out, it's probably not God's idea. But if it's such a big idea that we can't figure it out, then we better pay attention because God will have to be in it if it is going to happen.

Dr. Robert Schuller has built not only a worldwide ministry and religion's top-rated religious program, *The Hour of Power,* but also a campus of architectural masterpieces, including the ultramodern, all-glass Crystal Cathedral.

As soon as he arrived, Dr. Schuller became a uniquely Southern California phenomenon. Lacking funds for a conventional church, he began by preaching outdoors on Sunday mornings at the Orange Drive-In Theater to congregants who listened in their cars. His message—deemed too liberal by some factions—focused on self-esteem and positive thinking. His first sermon, delivered from the roof of the snack bar, was titled "Power for Successful Living" and quoted the words of Jesus: "If you have faith as a grain of mustard seed, you can say to your mountain, move. And nothing shall be impossible to you."

Of his own move to this region from Iowa, he revealed to me, "I wanted to find a church in a place with a big enough market to preach in my whole life. I wanted its scale to allow me to offer services like counseling centers, choirs and overseas missions with doctors." When services became overcrowded, Dr. Schuller bought forty acres in Garden Grove and chose distinguished modernist architect Richard Neutra to design the world's first walk-in/drive-in church, persevering despite opposition from some key church members, who resigned in protest of the unconventional venue. When the new church was finished, the congregation embraced it and kept growing.

In 1968, Dr. Schuller founded New Hope, the first Christian suicide-prevention and counseling telephone hot line, a twenty-four-hour service that has drawn more than a million users. In 1970, Dr. Schuller saw a way to expand his reach exponentially by doing what various Southern Californian events had been doing: adding television cameras. *The Hour of Power* was born. The show was an instant hit, eventually reaching two to three million viewers each week.

By the mid-1970s, with the Neutra church overflowing, Dr. Schuller dreamt of building a truly grand cathedral while maintaining his blue-sky views. "We spent six years in the drive-in church, and I got used to seeing birds, trees, and the sky when I was preaching. So when I contracted Philip Johnson to design this church, I told him to make it all glass so I could continue the outdoor feeling," Dr. Schuller told me. "I wanted it to be tranquil so the structure delivers a sense of peace. Peace is the ultimate emotional value for communication."

Johnson, whose own all-glass residence in Connecticut launched his career as a world-renowned architect, designed a soaring, earthquake-resistant structure made from ten thousand panes of glass. As building costs soared from seven million to seventeen million dollars, Dr. Schuller recited a mantra he'd often offered to his congregants: "Tough times never last, but tough people do," and hung tough to keep the cathedral moving forward during four years of construction. When it opened in 1980, it garnered great acclaim, including eventual recognition from the American Institute of Architects, which named Dr. Schuller an honorary fellow for "outstanding achievements of national significance." With seating for three thousand, it helped Dr. Schuller establish one of the first mega-churches. He later added to his campus a stunning visitor center designed by New York-based architect Richard Meier.

For visitors today, these structures attest not only to Dr. Schuller's abiding interest in architecture, but to an outsized vision that found a unique time and place in which to flourish. Dr. Schuller is quick to point to the strength of his faith. "Make your dreams big enough for God to fit in," he has often preached. Dr. Robert Schuller certainly did.

■ Born in 1926, in Iowa, to a poor family of farmers of Dutch ancestry.

■ After studying psychology and religion in school, was ordained as a minister in the Reformed Church in America.

■ Came west in 1955 with five hundred dollars and settled south of Los Angeles in Garden Grove.

■ Designed his ministry "not to teach or convert people, but rather to encourage them, to give them a lift. I decided to adopt the spirit, style, strategy and substance of a therapist in the pulpit," he explained in a cover story in *OC Metro Business.*

■ Has written some thirty Christian and self-help books, including several bestsellers.

DR. ROBERT SCHULLER,
Minister;
in the Crystal Cathedral,
Garden Grove, 2007

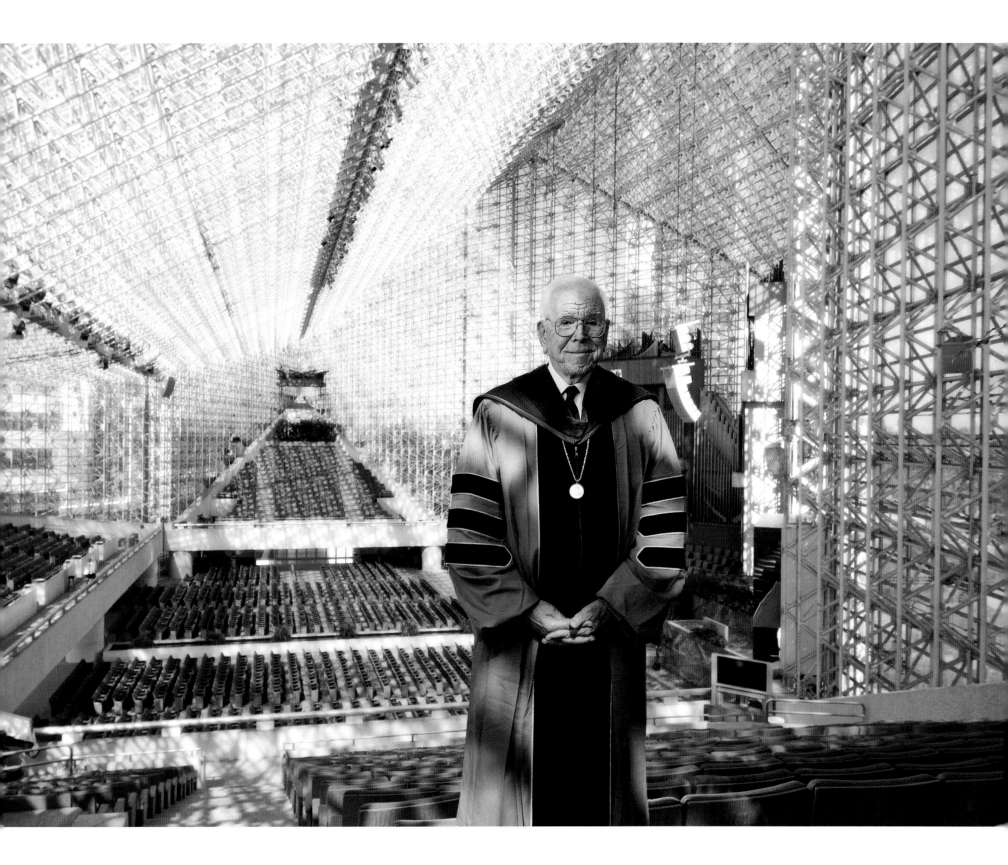

I don't say Los Angeles is the most beautiful place on earth, or even the most desirable. I love San Francisco, for instance . . . in Los Angeles, things will always need doing, things will always need to be made better. Los Angeles is a place for the kind of people who are willing to try something new. It's a place for people who want to build a new world.

Dorothy Buffum Chandler wielded power, persuasion and wealth to become the city's leading cultural advocate of her time. She was also my grandmother.

When her husband, Norman, became publisher of the *Los Angeles Times* upon his father's death in 1944, Dorothy was given both the opportunity and the obligation to increase her civic activities. Her first big success came after a financial crisis forced the closing of the Hollywood Bowl in the middle of its 1950 season. Buff swung into action, chairing a committee that organized a series of Save-the-Bowl benefit concerts. She also recruited new blood to the board and staff to avoid the mistakes that had driven the institution into debt. The coffers refilled, restoring a tradition of summer outdoor orchestral concerts that has flourished ever since.

By the mid-1950s, with her children grown, Buff felt free to throw herself into an even more demanding civic role. Believing that Los Angeles could never become a great city without great culture, she dreamt up a grandiose plan for a new downtown performing arts center. Despite her lack of experience in the area, she wrote a proposal and began pitching it to the city's political leaders. After more than a year of meetings, the board of supervisors conceded to set aside city land on Bunker Hill for the proposed arts complex, provided she could raise the money to build and operate it. Dorothy was ecstatic, and set off on the greatest mission of her life.

Over the next nine years, she and her colleagues canvassed the city, gathering individual dollar donations in her widely popular "buck bags" campaign, and soliciting much larger bequests from the wealthy citizenry. In the segregated climate of the time, Dorothy soon realized that going to her blue-blood friends for donations was not enough. She had to bring together downtown's conservative establishment and the Westside's liberal Jewish entertainment industry. As she persevered, her reputation as a fundraiser became legendary. Actor Charlton Heston told a reporter of an incident when "a very wealthy man gave her a check for twenty thousand dollars, and she tore it up, said it was ridiculous, that she needed more than that."

"Mama Buff," as I called her, once recounted to me the story of her fundraising visit to the notoriously stingy John Paul Getty in Paris. Though his oil company was headquartered in Los Angeles, he seemed disinterested in Buff's Music Center plans. She went through her spiel and then admitted that she was late for a dress fitting, which piqued his interest, and he inquired about the details. He ended the meeting with no funding commitment, saying that he would never stand between a woman and her couturier. A few weeks later she received a letter from Getty asking about the dress, accompanied by a check for twenty-five thousand dollars.

She raised about nineteen million dollars—borrowing the rest—to build the three halls of the Music Center complex. The most prominent building, the Pavilion, was named for her. Buff's leadership did not stop at the physical structures. She hired two young and untested artistic directors to fill the halls with world-class performances: an unknown conductor from Israel, Zubin Mehta, and a thirty-four-year-old theatrical producer and director from UCLA, Gordon Davidson, to run the Mark Taper Forum. Both men have become internationally renowned.

It wasn't until I reached adulthood in the 1970s that my grandmother and I developed a close relationship. Seeing her regularly at her beach house in Dana Point, or when I escorted her to the Music Center, I came to appreciate this larger-than-life woman as a complex and inspiring figure. She could be tough as nails, imperious and judgmental, but also cultured, romantic, and, occasionally, even warm and vulnerable. At her deathbed, I mourned the loss of a great role model of integrity and perseverance.

- Born Dorothy Buffum, in 1901, in Illinois. Moved to Long Beach with her family at age three. Her father and uncle ran a dry-goods store that they later expanded into Buffum's, a department store chain.

- Played piano and violin as a girl, embarking on a love of classical music that would remain a passion throughout her life.

- Nicknamed "Buff" at Stanford University where she met her future husband, Norman Chandler.

- Confronted her greatest test as a mother when her ten-year-old son Otis was knocked unconscious in a fall from a horse and pronounced dead at a local hospital. Too headstrong to accept the verdict, drove him to a bigger hospital where the doctor was able to revive him.

- Fighting bouts of depression and self-doubt in her late twenties, checked herself into a full-time therapy program in Pasadena and emerged after a few months with a heightened self-confidence and willingness to take on even greater challenges.

- Established *Los Angeles Times'* "Woman of the Year" awards program honoring the achievements of Southern California women, which ran from 1950 to 1976.

DOROTHY BUFFUM CHANDLER,
Philanthropist;
Los Angeles, 1956

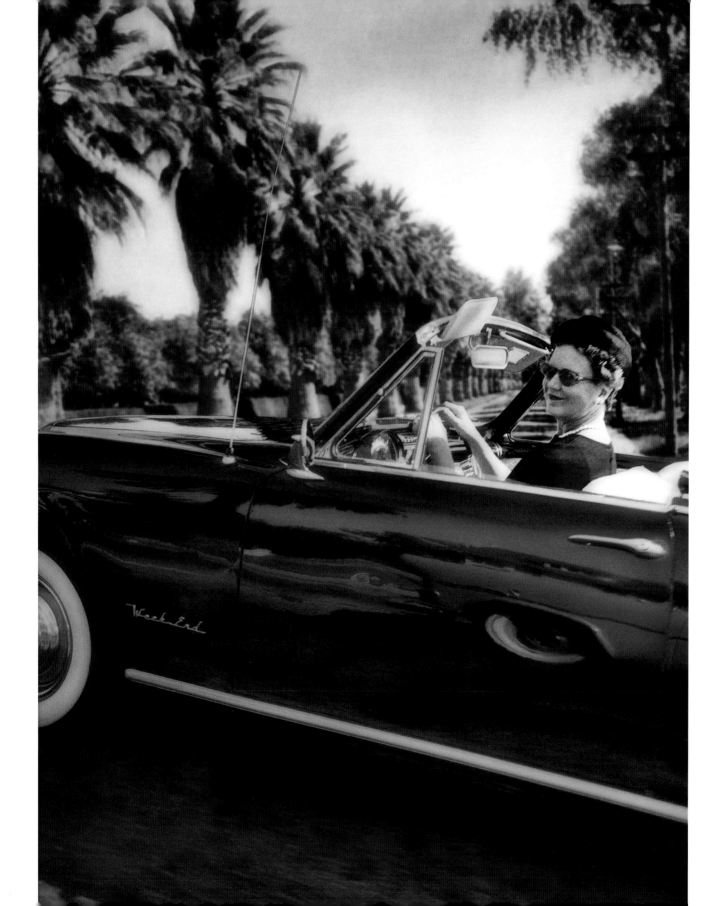

Why I build it? I can't tell you. Why a man make the pants?
Why a man make the shoes?

Simon Rodia was one of a long line of Southern California eccentrics with an obsession. Though dirt poor, untrained, barely literate, and what some people might deem "a little loony," he managed to construct the Watts Towers, one of the greatest and most enduring folk art sculptures in the country.

After struggling with a lifetime of manual-labor jobs, alcohol abuse and failed marriages, at the age of forty-two, he decided to build something he'd be proud of. On the tiny triangular lot of his South Central L.A. home, Rodia began to single-handedly shape what would grow to be a series of seventeen sculptures in the shape of towers, fountains, plazas, walkways and a gazebo. His methods included no plans or drawings, just an instinct for what looked good. Unable to afford welding equipment, he held his steel beams together with chicken wire and, lacking funds for scaffolding, he climbed each level to build the next. Into the mortar of the structures, two of which reached a height of nearly a hundred feet, he embedded broken glass, pottery shards and shells he collected at the beach.

The construction effort for his masterpiece, which he called *Nuestro Pueblo* (Our Town), took years, reducing Rodia's life to solitude and hard labor. He became so increasingly disengaged from the outside world that his mental stability suffered. His nephew, Nick Calicura, later said, "To this day, I can't understand if the man was a genius or crazy."

Finally, at the age of seventy-five, Rodia had had enough. In 1954, he deeded his property to a neighbor (who would later sell the land for a thousand dollars), packed up his belongings and declared that he was going away to die. He headed north, never to return.

Concerned that the project was not structurally safe, city officials prepared to demolish the artwork in 1959, but the move prompted an outcry from artists, architects and community members, who came together to form the Committee for Simon Rodia's Towers in Watts. The committee set out to prove the Towers were structurally sound by devising a lateral stress test that applied ten thousand pounds of stress, replicating the effect of seventy-five-mile-per-hour winds. The Towers passed the test and were spared the wrecking ball.

As this drama was unfolding, the *Los Angeles Times* got a call from Rodia's relatives informing them that Sam was alive and residing in the Bay Area. A *Times* reporter interviewed him but was unsuccessful in getting him to revisit his creation. However, the Committee was able to coax him to attend two events in Northern California honoring his work. "I had in mind to do something big and I did it," he told the crowd, summing up his life's work to a standing ovation.

Rodia died four years later in 1965. The next month, the Watts riots broke out, devastating entire blocks of the neighborhood. His Towers however, were spared.

Architect and futurist Buckminster Fuller summarized Rodia's accomplishments: "Sam will rank not just in our century, but with the sculptors of all history."

■ Born near Naples, Italy, in 1879, named Sabado Rodia; came to the United States at age fifteen with his brother to find work; became known as "Simon" or "Sam."

■ Worked the coal fields, railroad yards, logging camps and construction sites of his adopted country before settling in Watts in the early 1920s.

SIMON RODIA,
Sculptor;
Watts Towers, 1953

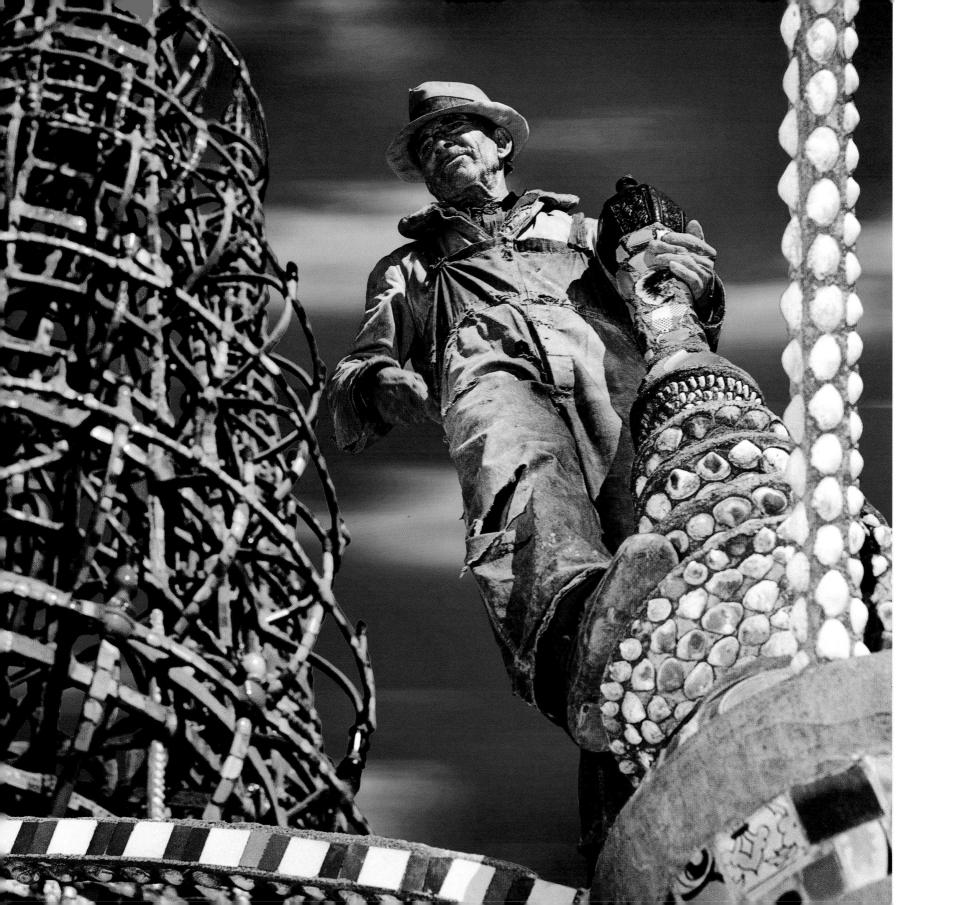

I grew up in Salvador thinking I was going to build things. Frederick Olmsted was always my hero. For me, he was larger than life, larger than God. Yet the scale of his projects seemed overwhelming to me. I never thought I would have a chance to do anything on the size of his big parks . . . yet now I am working on the thirty-two miles of the Los Angeles River and the fourteen-hundred-acre park at the El Toro airfield. What an opportunity.

Mia Lehrer is one of the most inventive landscape designers working today, a rare combination of artistic and pragmatic. Designing with a harmony that balances masses and voids, lights and shadows, she is putting her stamp on the region's largest open spaces, including the Los Angeles River revitalization project and the Great Park in Orange County.

One of the first big career coups for the Latina emigrant was partnering with Ricardo Legorreta, the Mexican architect famous for his brightly colored spaces. Over ten years they collaborated on four residences in Southern California, producing stunning results. To Legorreta's orange and yellow walls, Mia added features like a sculptural grouping of palm trees in pink sand and an azure lap pool bordered in white, floating in a sea of green plants.

Her work on the residences of the Southern California elite, including Dustin Hoffman, Lee Ritenour, Jamie Lee Curtis and Joel Silver, has continued ever since. Mia and her twenty-person firm also expanded into commercial landscape projects, including RAND Corporation's headquarters, the Luckman Plaza, Hollywood's landmark Capitol Records Building, the MGM Towers, Amgen's campus, and the new Water + Life Museum in Hemet. In addition to Legorreta, she has worked with other top architects like Richard Meier, Johnson Fain Partners, and her husband, Michael.

But her real dream was to follow in the footsteps of her idol Frederick Law Olmsted, who designed New York City's Central Park, among other U.S. landmarks. A trickle of park commissions turned into a steady stream for Lehrer, most recently on a scale that might have made even Olmsted jealous. After designing a twelve-hundred-acre park at the Kenneth Hahn State Recreation Area in Baldwin Hills, she became lead landscape designer on the master plan for a fifty-mile renovation of the Los Angeles River.

Her magnum opus may well be the 1,347-acre Orange County Great Park at the former Marine Corps Air Station at El Toro. With designer Ken Smith, Lehrer and her team are finalizing designs to transform miles of tarmac and abandoned military housing into a recreational area twice the size of New York's Central Park, comprising dozens of spectacular gardens, ponds and community centers.

During a driving tour of the colossal site, Lehrer described how a runway would be transformed into a waterway and a group of rotting warehouses into a formal garden. A tough businesswoman who possesses an encyclopedic knowledge of plants, she proved during our visit that she can also be a charming storyteller and a light-hearted Everywoman.

Though she's now offered commissions around the world, Mia says she's quite content to focus on Southern California. "L.A. is a young city that grew so fast it produced decades of environmental abandon, so it still has plenty of room for improvement," she observes, adding, "L.A. is going through a real renaissance now. This is a place where it is so much freer, and where people are really allowed to dream, so our megalopolis has become a laboratory for cities around the world."

- Born Miriam Guttfreund in the mid-1950s and raised in a middle-class El Salvadoran home by parents of German-Jewish descent.

- First displayed her entrepreneurial spirit at a young age when she set up a curbside stand, but instead of lemonade, sold ten-cent cups of Johnnie Walker Black Label scotch taken from the cache of her father, who distributed the liquor in El Salvador; success lasted several days until neighbors noticed their help was inebriated and notified her parents.

- Became interested in architecture when she accompanied her father to construction sites.

- Earned her master's degree in landscape architecture at Harvard, where she met her future husband, Michael Lehrer, a fellow student and architect-to-be; in 1979, followed him to his hometown, Los Angeles.

MIA LEHRER,
Landscape Architect;
on the El Toro Marine Base
runway, site of the future
Orange County Great Park, 2007

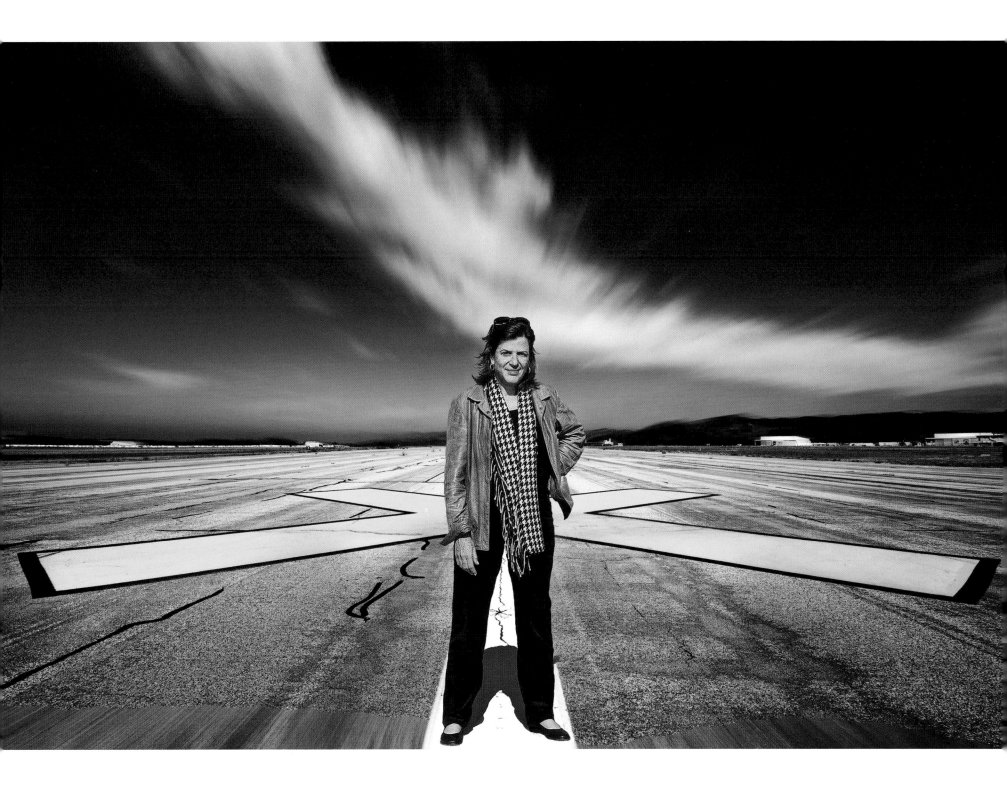

There it is. Take it!

William Mulholland had an immeasurable impact on early Southern California—he built the world's longest aqueduct, a waterway that brought Owens River water to a growing city.

As Los Angeles entered the twentieth century, its population and agriculture production were booming, but Mulholland realized that without imported water the city would run dry in two decades. The nearest ample water supply was more than two hundred miles away in the Owens River, an almost unfathomable distance at a time when a thirty-mile aqueduct was considered an engineering triumph. Undaunted, Mulholland and his former boss, Fred Eaton, a one-time Los Angeles mayor, conceived a plan to acquire and transport the Owens River water. It would require civic support, engineering mastery, unwavering determination and clever deceit—the latter being an area in which Eaton proved more than adept. In 1904, Eaton began surreptitiously buying up land before the residents of the Owens River Valley could organize resistance or jack up prices to a level the city could not afford.

When the *Los Angeles Times* broke the news of the aqueduct to a surprised and euphoric Southern California populace in 1905, residents of the Owens River Valley mounted legal challenges that ultimately had to be quelled by President Theodore Roosevelt, who declared the water "... a hundred or a thousand fold more important to the state and more valuable to the people as a whole if used by the city than if used by the people of the Owens Valley." A few months later, Los Angeles voters overwhelmingly approved a twenty-three-million-dollar bond, giving Mulholland the funds to build his legacy.

During the next eight years, "The Chief," as he was known, tirelessly assembled and directed an army of thousands whose effort stretched across 230 miles of desert and mountain. His engineering skills were continually tested as the route encountered hundreds of obstacles. The corps had to blast and drill 142 tunnels totaling more than forty-three miles, build ninety-eight miles of covered conduits and lay a dozen miles of huge steel siphon pipes up and over hills. Like a general on the battlefield, Mulholland was constantly traveling the length of the project in his beat-up car, giving instructions and supervising crews as they dug canals, carved sluiceways, cleared roads and laid railroad track and power lines.

The completion of the aqueduct in 1913 was marked by a huge celebration near Sylmar. Mulholland stepped up to a speaker's platform in front of thirty thousand euphoric people who had assembled and announced: "This rude platform is an altar, and on it we are here consecrating this water supply and dedicating the aqueduct to you and your children and your children's children—for all time." The gate valves were opened and the mountain water cascaded down the final chute before leveling out in the San Fernando Valley on its way to L.A. reservoirs and a grateful city. The Los Angeles Aqueduct was one of the engineering triumphs of the age.

Los Angeles' thirst did not slacken with the completion of the aqueduct, nor did Mulholland's construction efforts. He led the building of dams and reservoirs closer to home, new filtering stations and miles and miles of water mains to supply the growing city. As a determined visionary, he continued to lead the all-important crusade for water in Southern California.

- Born in Ireland in 1850; left home at fifteen to see the world as a merchant sailor; in the U.S., worked as lumberjack in a Michigan lumber camp, a clerk in a dry-goods store in Pittsburgh, a tradesman in San Francisco and a miner and Apache-fighter in Arizona.

- Arrived in Los Angeles in 1878 and declared that he had found his new home.

- Self-educated as an engineer, began as a ditch-digger and worked his way up to become the first head of the city's early Department of Water and Power and its chief for forty years.

- His expertise was also applied to building the twisting twenty-two-mile highway along the crest of the Santa Monica Mountains, which was named in his honor.

- Resigned in disgrace at age seventy-three after the St. Francis Dam collapsed near Valencia, leaving more than 450 dead and filling him with grief and remorse.

WILLIAM MULHOLLAND,
Water Engineer;
Owens Valley, 1924

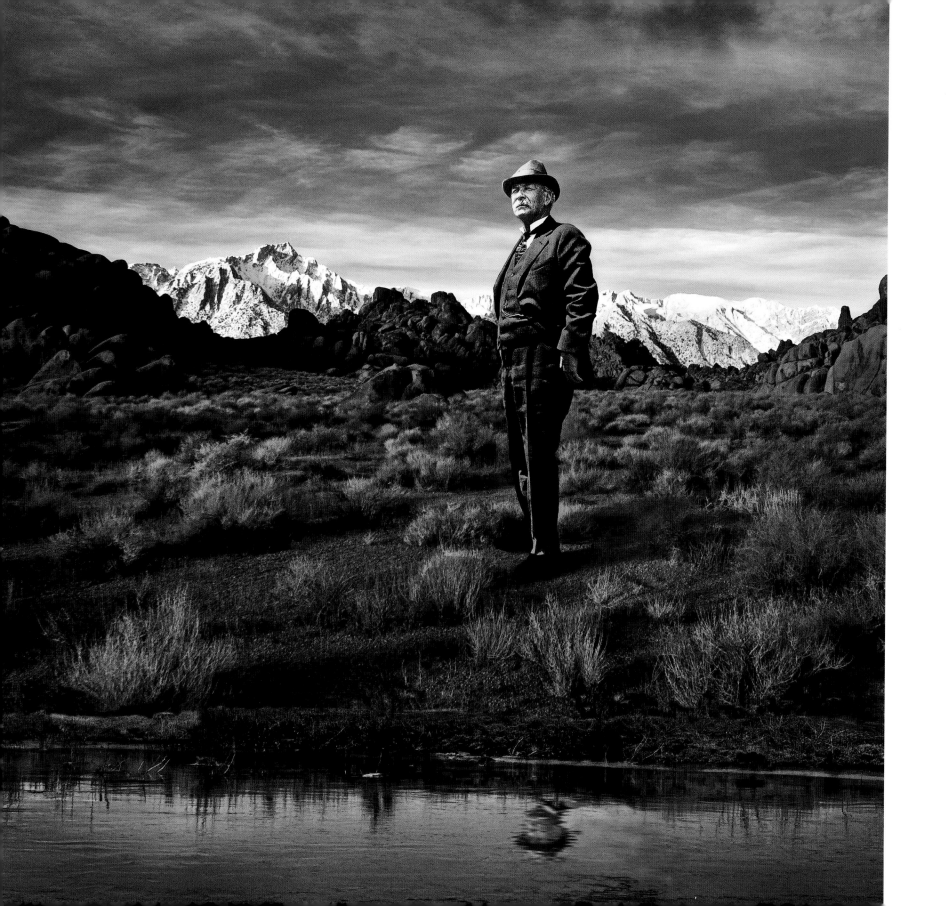

THE INVENTORS

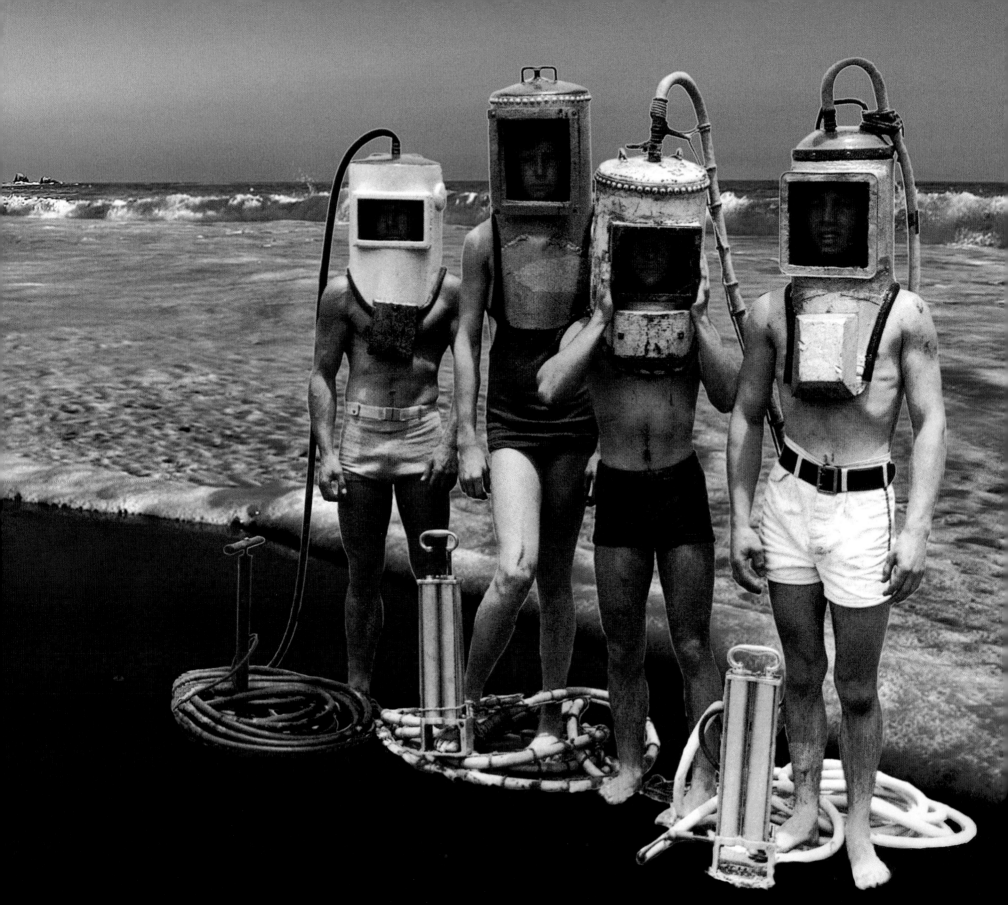

THE INVENTORS

DICK RUTAN—Test Pilot and Airplane Designer ■ GEORGE BARRIS—Car Customizer
HOBIE ALTER—Surfboard/Catamaran Inventor ■ DAN GURNEY—Race Car Driver and Manufacturer
DONALD DOUGLAS—Airplane Manufacturer ■ REEVES CALLAWAY—Automobile Engineer and Manufacturer

From the start, Southern California has bred a spirit of innovation with a frontier geography and free spirit that encouraged its men and women to pursue their visions to the utmost. The cultural and business climates of Los Angeles have helped propel the development of many of the twentieth century's most significant innovations, from movies to the automobile, from aviation to rocketry, from astronomy to the Internet.

The area's newness and open spaces, coupled with a benevolent climate and the optimism of a booming postwar economy, helped fashion an urge to create and a confidence that risk would be rewarded. "More than any other city, the greatness of Los Angeles must be attributed to the ingenuity of its people," said Mayor Tom Bradley.

The men profiled here dreamt of pushing the limits of the possible, engineering cars and airplanes, surfboards and sailboats that could outperform anything that came before. All are inventors and tinkerers, some are also world-class pilots who set speed and endurance records on the track, in the sky or on the waves. Each was motivated to invent by an insatiable curiosity to see if he could achieve something better—and each owes something to the unique environment of Southern California, where the climate of freedom, the open marketplace and communities of like-minded peers were stimuli for success.

These men come across as confident, can-do extroverts with distinct, forceful personalities. Dick Rutan, set a world record as the first man to pilot an airplane around the world without refueling or stopping. Before our photo shoot at the Mojave airfield, we lunched at the Voyager Diner, named for the aircraft he built for his historic flight. Now nearly seventy years old and full of ego and candor, Rutan easily launched into critiques of aviation institutions like the Wright Brothers: they "severely damaged" U.S. aviation by "building an unstable plane, then suing every other U.S. plane designer with better models who tried to follow them;" NASA: they "lack courage and vision, debilitated by fear of failure;" and commercial pilots: "Once you have landed a 747, why in God's name would you want to do it again and again?" A smart and daring man, Rutan is full of opinions.

My first encounter with Hobie Alter, inventor of the fiberglass-foam surfboard and Hobie Cat sailing craft, happened when I was a kid. I was old enough to paddle out on my own, so my father, who had been surfing since he was a teenager, took me to Hobie's Dana Point surf shop to buy my first surfboard. In those years, Hobie was a board shaper with a modest store that was becoming a mecca for top riders such as Corky Carroll and Phil Edwards, who both often worked behind the counter. For a young boy, getting to meet these titans of the sport was unforgettable: imagine buying golf clubs from the likes of Tiger Woods and Phil Mickelson. Hobie had a big grin and used words like "stoked," but no one ever called him a beach bum. He was far too motivated. One of the most memorable days of my teenage years was when my brother Norm and I dropped by Hobie's Capistrano beach house to pick up our family's first Hobie Cat sailboat. Hobie had sold my Dad a used fourteen-foot boat from his personal collection. The plan was for Norm to sail the catamaran up the coast to our Dana Point beach house, while I drove the car home. What we didn't expect was that Hobie and Phil Edwards would take my brother and me out on their catamarans for a little informal race. A stiff wind was blowing when I climbed onto the bow of Edwards' sixteen-foot Cat to try to manage the jib sail, while my brother did the same on Hobie's Cat. Off the beach we went, smashing through the oncoming breakers 'til we hit open water and pitched it up on one hull. Hobie and Norm simultaneously trapezed out on the upper hull while they screamed across the wind chop. The race turned into a surfing adventure as both boats turned around to catch a set of waves, furiously coming about and then bursting through the swells on the way back out. It was wet and wild, fast and furious—and a total thrill to be sailing with these two world-class sailors and surf legends.

I first met another local dreamer, racing legend Dan Gurney, in the 1980s. My younger brother Michael was a professional race car driver who placed twelfth in his first Indianapolis 500 in 1981 and was offered a spot on Dan's race team the following season. I remember being in the pit area before the 1982 Indianapolis race when this tall, confident figure came over to Michael's pit crew. He stuck out his hand and introduced himself as Dan Gurney. His calm demeanor helped quiet some of Michael's nerves, and my brother would later remember Dan as a great team owner—intense, focused and supportive. Unfortunately for both of them, while Michael was testing one of Gurney's Eagles before the Indy 500 two years later, the car lost a tire while going into a corner at about 200 MPH. The car slammed brutally into the wall, and the loose tire ricocheted into his helmet so hard that Michael was knocked into a coma. Michael's

life hung in the balance. A week later, my brother regained consciousness, but his head injuries ended his racing career. Dan was in constant touch throughout Michael's months of recovery, and has remained a friend ever since.

I was at a dinner with Dan in 2001 at the Pebble Beach Concours d'Elegance, America's top classic car show, when I met another motoring pioneer, Reeves Callaway, the celebrated builder of "super cars." I first heard of Reeves in the early 1990s when one of his early production cars, dubbed "Old Lyme," a stunning lime green convertible based on a Corvette, debuted at the L.A. Auto Show and ended up in my father's car collection. My dad had just stepped down as publisher of the *Times* and was building a world-class assemblage of vintage Duesenbergs, Packards, Mercedes and super cars from Porsche and Ferrari. The Callaway Corvette stood out like a green lollipop in a buffet of silver and black desserts. Even my wife, not known for her love of muscle cars, was wowed by its sleek design and delicious colors, declaring it her favorite of the collection. After our dinner at the Pebble Beach event, Reeves showed us his latest creation, a road version of the Callaway C-12 GT car, which won the class pole at the Le Mans 24-hour race in France. Drop-dead gorgeous, with a price tag of $225,000, this car would do zero-to-sixty in four seconds. My father was equally wowed and ended up buying two of them for his museum, although to my deep regret, he never let me drive either one. That night, I instantly sparked to the creativity and passion that Callaway evokes.

On the other end of the car world is the famous customizer George Barris. Now in his eighties, Barris still hasn't let up on the throttle much. He goes to his San Fernando Valley shop every day to oversee the still-thriving business, and his memory fires up like a supercharged Cobra as he name-drops and recounts stories from the past. A half-dozen one-off cars made for clients long ago gleam in his overstuffed showroom, while in hundreds of framed photos on the walls, the big hairdos of the celebrity clients and the huge chromed engines and flaming orange tailfins of the cars tell stories of a bygone era. Out back in the shop, younger men hammer and grind away at the newest Barris creations: a pimped Mustang Cobra, a chopped-off convertible Hummer, low-riding pickups, and a streamlined hybrid Prius.

These inventors have spent a lifetime welding and grinding, pounding and painting, machining and casting, shaping and fiberglassing, all to create the components of a lifestyle of speed and thrills that define Southern California culture.

HOBIE ALTER, Surfboard/Catamaran Inventor; Laguna Beach, ca. 1950

To go where no man has gone before—that is the essence of life. Since I missed out on being a part of Lewis and Clark's Corps of Discovery, there is nothing I would rather be than the space-shuttle commander on a one-way trip to Alpha Centauri.

Dick Rutan

Dick Rutan set a milestone in aviation history in 1986 by flying the *Voyager* airplane around the world without stopping. But that feat is just one facet of this gung-ho test pilot and aircraft builder.

After a decorated Vietnam-combat career in the Air Force, Rutan settled into the wide-open Antelope Valley, where his Air Force experience and the "anything goes" culture of Southern California combined to shape him into a real can-do pilot and inventor—as well as highly opinionated rebel, as I discovered when I met him for lunch at the wind-swept Mohave airfield prior to our photo session. Not one to long for R&R, Rutan prefers what he calls "F&F" (freedom and flexibility): that part of the day when he's not sleeping ("a waste of time") or working for someone else ("usually some moron"). Improving the quantity and quality of his own F&F has apparently been one of his life's missions—when he wasn't pushing the envelope of aviation history.

In 1981, Dick and his brother Burt set out to tackle the last great aviation milestone: circumnavigating the globe without stopping or refueling. Burt had a notion for a design, and Dick figured he could build it and pilot it. Over five and a half years, the brothers collaborated on a revolutionary design for a plane they called *Voyager*. Dick constructed the super-light frame almost entirely of graphite-honeycomb composite. Before its seventeen fuels tanks were filled, the plane weighed only 939 pounds.

On December 14, 1986, Rutan and Jeana Yeager, another record-breaking pilot who was also Rutan's romantic interest, were ready to attempt the history-making flight. Just after dawn, *Voyager*'s twin engines roared to life, propelling it down the dry lakebed of Edwards Air Force Base. But its wing tips were damaged during takeoff, so Rutan had to jettison the winglets or risk an aborted flight. By maneuvering the plane to build up sufficiently high side forces, he was able to break the wing tips free. The first crisis was averted.

After *Voyager* gained altitude, ahead were nine days of physical and mental challenges combined with extreme fatigue, spent in a cockpit the size of a phone booth. In addition to navigating, the pilots had to constantly shift fuel from tank to tank to balance the weight. At several points, they had to evade menacing storm fronts, including a typhoon six hundred miles wide, which brought them perilously close to running out of fuel. Then, within hours of the finish line, the main engine quit, sending the aircraft into rapid descent. They lost five thousand feet as they struggled to start the backup engine. And yet, after 26,366 non-stop miles, Rutan set the storm-battered *Voyager* down on the dry lakebed where the flight had begun, completing what has been called aviation's "last first."

President Ronald Reagan awarded the brothers the Presidential Citizen's Medal of Honor. *Voyager* is now proudly suspended in the Smithsonian National Air and Space Museum.

The massive publicity allowed Rutan to hit the lecture circuit, spreading his message of hard work and achievement. His subsequent adventures have included an attempt to make the first-ever flight around the world in a balloon, and the historic landing of a Russian biplane at the North Pole—both of which ended in narrow escapes from death.

At nearly seventy, Rutan remains a real character, his candor and ego ripened by years of fame. After our lunch, I told him how much I enjoyed listening to his considered opinions. "Heck," he replied, "My brother is even more headstrong and opinionated than I am." Together they must be quite a pair.

- Born in 1938 in Loma Linda and raised in Fresno; credits his passion for flying to a ride on a Cessna that his mother treated him to while a young boy; he and younger brother Burt got solo pilot's licenses at sixteen.

- At nineteen, enlisted in the Air Force; flew 325 combat missions over Vietnam, including 105 as a MISTY pilot, flying F100s fast and low over the Ho Chi Minh Trail to target enemy supplies; although nearly a third of MISTY pilots were killed, Rutan was hit by enemy ground fire, forced to eject from his burning plane, evaded enemy capture and was rescued; retired in 1978 as a Lieutenant Colonel, having been awarded the Silver Star, five Distinguished Flying Crosses, sixteen Air Medals and the Purple Heart.

- Moved to the high-desert town of Mojave to join Burt in his experimental aircraft factory as production manager and chief test pilot; set numerous world speed and distance records in the Long-EZ, one of the company's first successes; eventually realized he couldn't work for his younger brother and set up his own factory down the street.

**DICK RUTAN,
Test Pilot and Airplane Designer;
in the Mohave Desert beside an
F-100 with a reflection
of the Long-EZ, 2007**

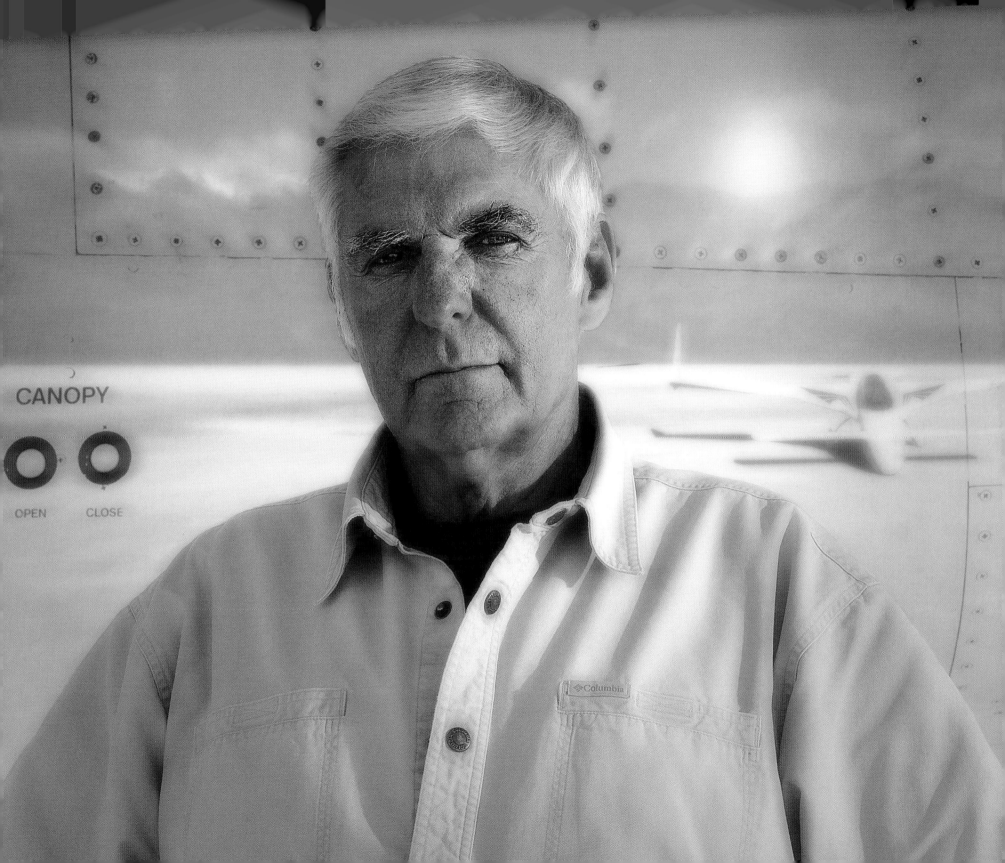

My dream was to create cars that were more proportional, looked better and were improved from what anyone else had done. Not only a passion but a living . . .

George Barris did more than just pimp the rides of the rich and flashy and invent iconographic picture cars for Hollywood movies. He brought fantasy to the streets of California and to the movies and television shows Hollywood exported to the world.

Decades before reality shows like *Monster Garage* and *Pimp My Ride* began lionizing the tattooed masters of the blowtorch, there was a kid named George Barris in the San Fernando Valley who blazed the trail of car customizing. He opened his first shop in Lynwood in 1946 and spent his days chopping, welding, painting and detailing. On weekends and at night, he joined the illegal scene, racing for pink slips (winner gets the car!). Tom Wolfe quoted him in his groundbreaking story on Barris, *The Kandy-Kolored Tangerine-Flake Streamline Baby*. "Some nights there'd be a thousand kids lining the road to watch—boys and girls, all sitting on the sides of their cars with the lights shining across the highway." It was quarter-mile drag racing on city streets until the cops broke it up, a real-life 1950s version of the film *The Fast and The Furious* with bobby socks and leather jackets. As Chubby Checker's Twist wowed a generation of teenagers, so too did George Barris' Kustom creations.

Along with brother Sam, Barris developed a reputation by modifying Mercuries, chopping their roofs and dropping the frame closer to the ground to make them streamlined. Soon, it wasn't just teenagers who wanted the flashy rides; adults, including celebrities, lined up for Barris' creations. The cars he created for famous actors and singers created a national reputation for Barris. There was a 1960 Cadillac stretch limo for Elvis, complete with privacy curtains, gold records, a television, a bar, a barbecue and a record player. Then there was one for the Beach Boys, a Morris Mini reconfigured into a open, red-and-white-striped custom surf car. Barris' client list grew to include James Dean, Sammy Davis, Jr., John Wayne, Liberace, Dean Martin, Cher, Clint Eastwood, John Travolta, Eddy Vedder and Kid Rock.

Barris' Hollywood success story had another dimension: he designed unique vehicles for TV shows and movies. After building stunt cars and a string of customized hot rods for youth-oriented B-movies, he was approached by the producers of a new TV comedy to design a signature car for a family of oil-rich country bumpkins. "In Fontana," he recalled, "I found a '22 Oldsmobile that had been cut into a hauling truck. I brought it back to the shop and turned it into the car on *The Beverly Hillbillies*."

The producer of the *Batman* television show then approached him. He needed a signature car to fit the spirit of the comics' "Pows!" and "Kabooms!" and he needed it in three weeks. Rising to the challenge, Barris crafted the first Batmobile, which featured a Batphone, a Batscope, sound and weapons systems, and bat-shaped rear parachutes. The car was a huge hit, requiring him to make five copies for the long-running series. Other television producers then demanded the Barris touch for shows like *The Munsters*, *The Monkees*, *My Mother the Car*, *Knight Rider*, *Starsky and Hutch*, and *The Dukes of Hazzard*. Barris produced cars for films too, including *Back to the Future* (1985), *Dick Tracy* (1990) and *The Flintstones Movie* (1994).

Meanwhile, Detroit was taking note. Features like concealed headlights, tailfins and bubbletops made their way into production lines, and Ford and GM hired Barris to design and build concept vehicles. A cover story on Barris in *Motor Trend* proclaimed that he had "changed the face of Detroit." Whether he did or not, he stoked the passions and stirred the imaginations of car enthusiasts for decades.

- Raised in North Carolina in the 1930s in a family of Greek immigrant restaurateurs; began carving wooden cars at age ten; moved to Sacramento with his family as a teenager.

- As a high-schooler, customized his parents' 1925 Buick, repainting it a slick new color, adding gold knobs from the family kitchen cabinets, and applying new trim on the seats and visors; joined by brother, Sam, learned to weld, using professional paint spray guns and turning jalopies into hot rods.

- Moved to Los Angeles in 1943 to live like a self-styled Bohemian artist working on canvasses made in Detroit; while working at an auto-body repair shop, took classes at Otis Art Institute; fashioned a 1936 Ford into a thing of beauty, with features such as handle-less doors that opened with electric buttons; was soon deluged with requests to work on other vehicles.

- Once on a whim, at a promotional event at the old Pacific Ocean Park Fun Zone, brought out his air spray gun and sprayed girls' bouffant hairdos with his signature Kandy Kolors for fifty cents apiece.

- Built package kits that enabled DIY car buffs to remake a Buick, Gremlin or Firebird; then diversified into motor homes, speedboats, motorcycles, golf carts, snowmobiles . . . even miniature toy cars.

**GEORGE BARRIS,
Car Customizer;
flanked by his Batmobile and
Monkeemobile, Los Angeles,
2007**

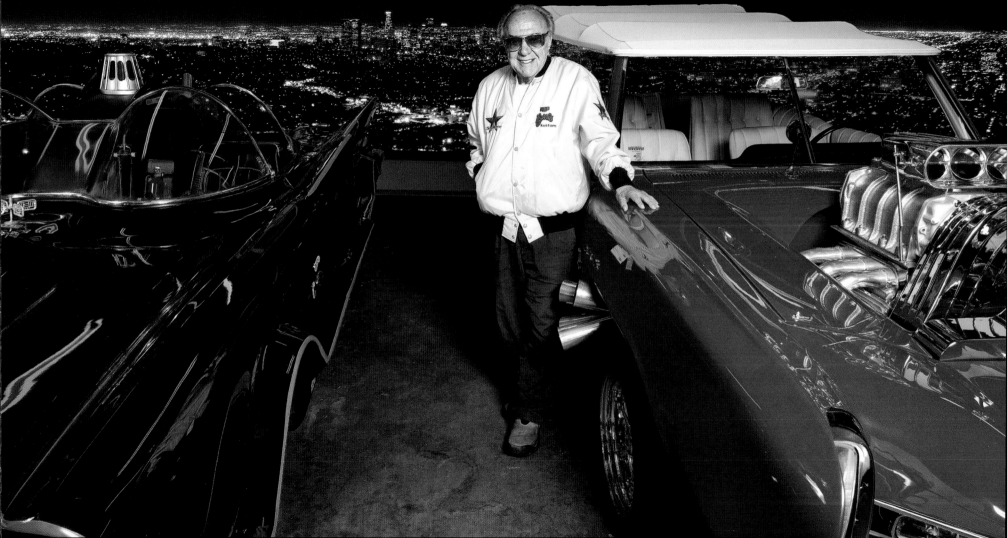

I liked having fun too, but it turns out that it took a lot more hard work than you would imagine to make the things that let all of us have that fun.

Hobie Alter

Hobie Alter invented the modern surfboard and the Hobie Cat, helping to create a Southern California-inspired way of life that promoted adventure in the sun-drenched ocean.

The sport of surfing grew slowly after its introduction to the mainland from Hawaii in 1907 by George Freeth. The heavy surfboards were hard to carry and maneuver, and without wetsuits, only the hardiest guys persisted. By the 1950s, lighter balsa boards had replaced the original redwood ones, but surfing was still a niche hobby enjoyed by only a few hundred enthusiasts.

For Hobart Alter, a dream was born in his parents' garage in 1950, when at seventeen, he applied his talent for woodworking to the sport of surfing. He shaped and sold eighty boards during his high school summers. Encouraged by his father to go into the surfboard manufacturing business, he pooled twelve thousand dollars, and in 1954 opened Southern California's first surf shop. "I got a little place in Dana Point," he recalls, "It was right on the Coast Highway, and people would see the surfboards in the window and bought them. People asked me several times what would happen to my dream once I'd sold the two-hundredth surfboard and reached every surfer on the West Coast. Well, I guess I showed them!" Out of one store, he sold 1,700 balsa boards, shaping every one himself.

In 1958, he and buddy Gordon Clark began experimenting with the newly invented polyurethane foam. Foam boards were lighter, didn't absorb water, and were easier and faster to ride than any other boards. Adoption by the surfing public was immediate and unqualified, revolutionizing the sport, relegating wooden boards to museums. Clark eventually took over the foam operation, renaming it Clark Foam, and he has maintained the lion's share of the world market for surfboard blanks ever since.

Alter's business and the sport grew together. By 1960, beach culture was becoming mainstream and surfing waves was suddenly "cool." The Neoprene wetsuit was widely available, Hollywood was making Gidget movies, the Beach Boys were starting to release records—and Hobie surfboards were setting records. From 1961 through 1965, Hobie boards were used by more winners of major surf contests in the U.S. and Hawaii than any other surfboard, and the Hobie Surf Team roster was becoming a Who's Who of surfing. Joining Hobie were other champions such as Phil Edwards, Joey Cabell, Gary Propper, Corky Carroll, Mickey Munoz and Joyce Hoffman. Soon Alter expanded his product line to include beach apparel, sunglasses, skateboards and bodyboards, and opened more retail stores.

Hobie's second breakthrough came in 1968 when he set out to invent a sailboat that one person could easily launch into the surf. On the same beach where I would photograph him years later, he launched the prototypes for the Hobie Cat, a lightweight, fast playboat based on the Polynesian twin-hulled catamaran. The first fourteen-foot model sold for only a thousand dollars and reinvented personal sailing. When the sixteen-foot model was released in 1971, it became even more popular, and remains the most popular class of sailboat in the twenty-first century.

By the mid-1970s, Hobie was running dozens of stores and selling his products around the globe. But it had stopped being fun, so when the camping-equipment company, Coleman, offered to buy him out, he agreed to sell. Since then, while his sons carry on the Hobie design and licensing operation, Hobie spreads his time between golfing in Palm Springs, skiing in Idaho and sailing off Orcas Island in Washington. When inspiration strikes, he still dreams up and creates new adventure products, including a thirty-three-foot fiberglass sailing sloop with a retractable keel, a sixty-foot ocean voyaging power catamaran, and an improved remote-control glider airplane.

■ Born in 1933 and raised in Ontario and Laguna Beach, California.

■ Developed an early passion for riding waves, then a novelty sport; shaped his first surfboard in high school wood shop with a drawknife; after his dad backed the DeSoto out of their Laguna garage to make room for a shipment of balsa wood, turned the garage into his own production line for friends.

HOBIE ALTER,
Surfboard/Catamaran Inventor;
with balsa wood board,
Laguna Beach, ca. 1950

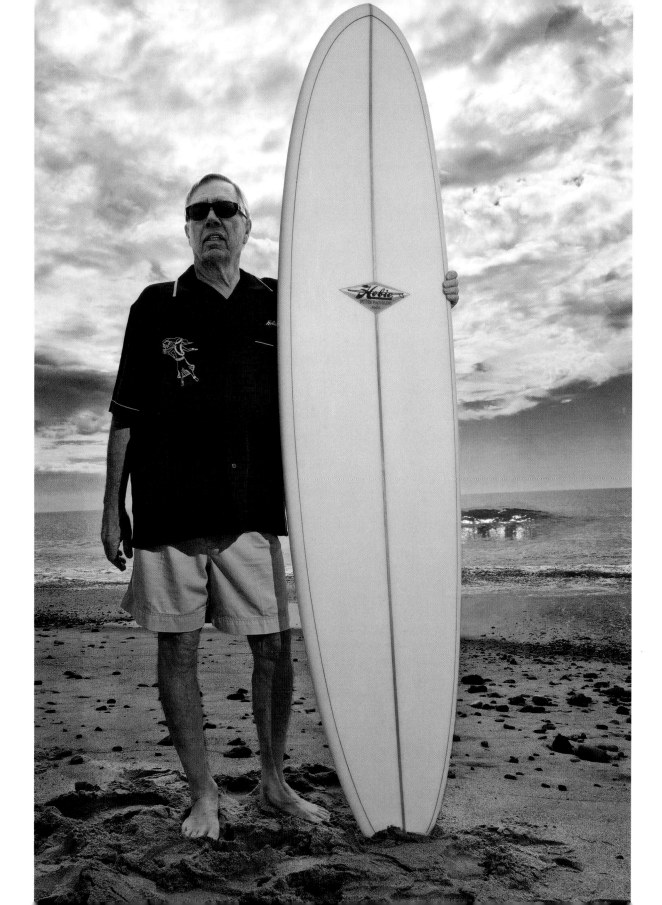

The difference between dreamer and genius, between lunatic and visionary is very thin . . . I like the idea of doing something no one has done, of doing something for the history books. I am tenacious.

Dan Gurney has been a world-famous, record-setting race driver, a storied car manufacturer, race team owner and inventor. With such a wealth of experiences to choose from, he still names winning the illegal "Cannonball Run" as a career highlight.

During high school years in Riverside, Gurney learned to handle a car by weaving through the orange groves at high speed. After returning from the Korean War with a dream of "doing something special," he did. Dan launched himself into professional race driving, where he went on to become the top driver in America, the most popular international Formula 1 Grand Prix driver ever. He started in 312 events in twenty countries with fifty-one different makes of cars, claiming forty-two career pole positions, fifty-one wins and an additional forty-seven podium appearances. He drove Formula 1 for Ferrari, BRM and Porsche, and raced in Indy Car, NASCAR and Sports Car series.

In 1966, while on the podium at the French Le Mans after his first win in the Eagle that he co-designed, Gurney was given the customary magnum of champagne. Rather than drinking from the bottle, he spontaneously shook it up and sprayed teammates and spectators, starting a tradition now ubiquitous at every race podium.

A week later, Gurney won the checkered flag again, this time battling Jim Clark's Lotus and Jackie Stewart's BRM in the Belgian Grand Prix. His victory was shared by millions of his countrymen back home, who proudly watched television highlights of the first American victor in the Formula 1 in over forty years.

Chapter two in Gurney's story began a few years later, when he gave up driving and bought out Carroll Shelby, his partner in All American Racers, to devote himself full time to designing and manufacturing race cars. Building up the Santa Ana-based team and facility, he began producing world-beating cars. AAR went on to win eight championships and capture seventy-eight race victories and eighty-three pole positions, including the Indy 500, the 12 Hours of Sebring and the 24 Hours of Daytona.

Dan's retirement from driving had a single, memorable relapse. In 1971, he was coaxed into co-piloting a Ferrari Daytona in an illegal coast-to-coast race that his journalist friend Brock Yates had dreamed up. The caper was meant as a whimsical gesture of defiance against speed laws and a tribute to Erwin George "Cannon Ball" Baker, an earlier racer who did multiple speed runs across the U.S., including an eleven-day barnstorm on his Indian motorcycle in 1914. Evading police cruisers, dawdling motorists, rainstorms and fifteen other teams, Gurney and Yates pulled into Redondo Beach as the race winners, thirty-five hours and fifty-four minutes after leaving New York City.

When I visited Dan at his Santa Ana headquarters, the retired racer, now in his mid-seventies, still counts "the Run" as a favorite memory, and he broke out into a wide grin as he recounted the cross-country trip. His company, now managed by his son Justin, expanded into building unmanned military drone airplanes used in the Iraq war. If bicycle builders such as the Wrights could build the first plane, I've no doubt that Dan Gurney could make almost anything fly. This automotive pioneer, who came to California sixty years ago with a "can-do spirit," is now finally able to exhale a bit and ponder his accomplishments.

In the foreword to a book about his Eagle cars, Dan wrote: "When you spend your life in motor racing as a driver, car builder or team owner—sometimes fulfilling all three roles at the same time—you do not have the luxury of time to contemplate your failures and achievements in the context of history." Dan need not worry about how history will judge him; he will remain forever in the winner's circle.

- Born in Long Island, New York in 1931, the son of a Metropolitan Opera star; moved to Riverside, California, as a teenager, smack into the middle of the new hot rod culture; fell in love, not just with the speed and look of the cars, but with the history of racing and the lore of the drivers.

- Inspired to become a car builder by the realization that "having the best skills as a driver doesn't let you win all the time. When I started, no one knew much about vehicle dynamics."

- In 1962, partnered with designer Carroll Shelby to build an American car that could compete with the European makes that then dominated road racing. Goodyear sponsored the team, dubbed the All American Racers. They called their car the Eagle. After four years of hard work, they scored their first win—at the French endurance contest, the 24 hours of Le Mans, with Gurney and A.J. Foyt at the wheel.

- Introduced the full-face helmet to Indy Car and Grand Prix racing; played a key role in launching the rear-engine revolution in Indianapolis; co-founder of the Long Beach Grand Prix in 1974; invented a wingtip, "the Gurney Flap," that created downdraft to enhance cornering; and designed the Alligator, a revolutionary single-cylinder, limited-edition motorcycle.

DAN GURNEY,
Race Car Driver and
Manufacturer;
beside his 1997 Eagle Champ car,
2007

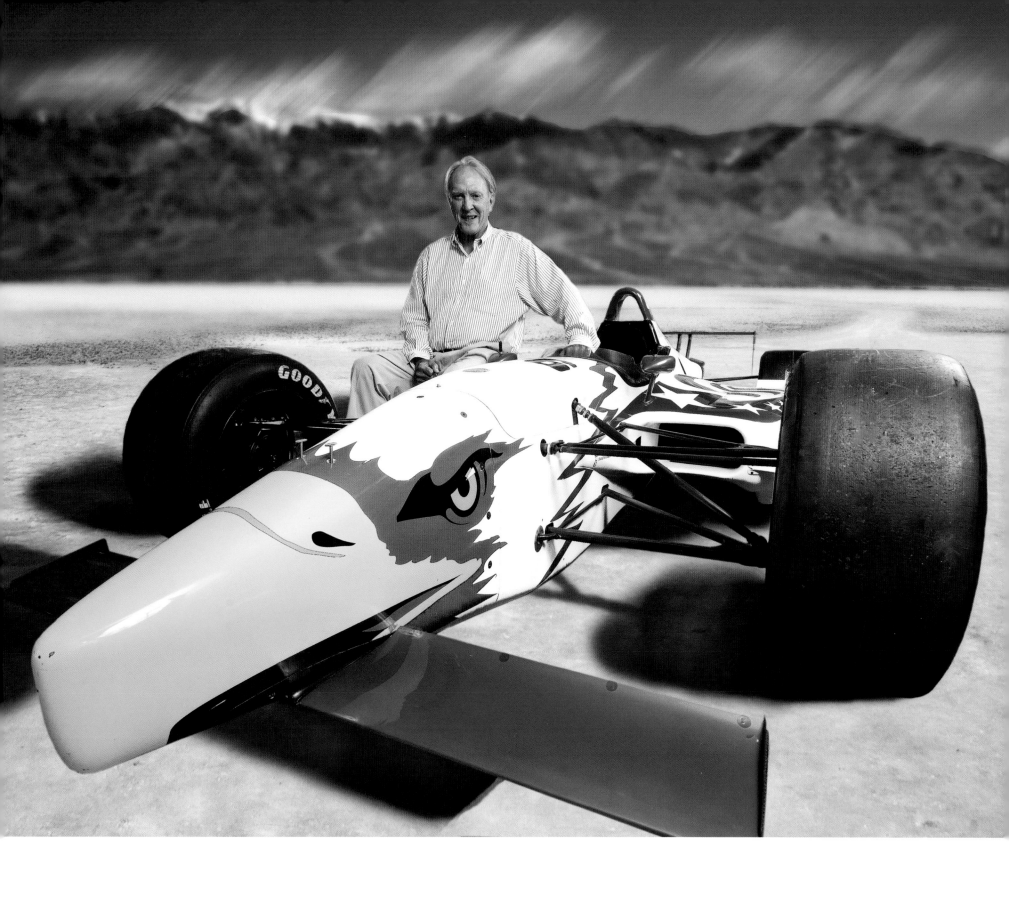

Dream no small dream; it lacks magic. Dream large.
Then make the dream real.

Donald Douglas witnessed the dawn of the aviation age as a boy, then moved west to invent one great aircraft after another. His planes helped win World War II, establish passenger air service and even get us to the moon. Douglas Aircraft grew from a backroom operation into an international giant, becoming Southern California's largest employer during the 1940s.

Working from the back of a barbershop in Santa Monica in 1921, Douglas was designing a torpedo bomber to pitch to the Navy when his start-up company's first backer pulled out. His plans were momentarily grounded, but his dreams were only beginning to soar. Donald borrowed five thousand dollars from his father and fifteen thousand dollars from a handful of Los Angeles businessmen that included both of my great-grandfathers, Otto Brant of Title Insurance and Trust and Harry Chandler, publisher of the *Los Angeles Times*. A few months later, Douglas delivered the first torpedo seaplane, the DT-1 (Douglas Torpedo). The Navy wanted more, so Douglas assembled a team on a former movie soundstage on Wilshire Boulevard and built 114 of the torpedo bombers over the next few years.

Douglas Aircraft Company was airborne, producing a succession of other military observation and cargo planes. One, the World Cruiser, established a round-the-world flight record and put the company on the world map. When the stock market crashed in 1929, the company's worth was at twenty-five million dollars.

Then came the Great Depression, and military spending dropped precipitously. Salvation arrived via an order from a new company that wanted to compete with Boeing's first metal-winged plane, the 247, in the passenger transport business. The buyer was TWA. The commercial airliner Douglas designed for TWA was the DC-1, a twelve-seat, twin-engine aircraft that cost the then-enormous sum of $306,000. It proved to be the most advanced plane in the air, and TWA ordered twenty more. Douglas modified it to make the DC-2, and four years later, he launched what is considered the first of the modern airliners, the DC-3.

At the outbreak of World War II, Douglas again turned his attention to building aircraft for the military, this time on an enormous scale. His workforce swelled from 3,500 to more than 160,000 as Douglas plants in Santa Monica, Long Beach, El Segundo, Chicago, Tulsa and Oklahoma City churned out nearly thirty thousand airplanes between 1942 and 1945. The end of the war brought new challenges. Douglas closed out-of-state plants, shrank the workforce and retooled for a new era: rocketry. Throughout the late 1940s and 1950s, the company built a wide range of air-to-air and surface-to-surface missiles. The program eventually culminated with the construction of huge launch rockets, beginning with the Thor and including the Saturn S-IV/S-IVB, part of NASA's moon missions in the early 1960s.

But Douglas' move into the next frontier of commercial aviation—jetliners—proved too cautious. Longtime rival Boeing brought out its 707 a full three years before Douglas could introduce his DC-8. Douglas Jr. took the reins but was unable to stem the company's decline. As bankruptcy loomed, Donald Sr. was left with one last maneuver. In 1967, he merged the company with that of his long-time friend and major shareholder, James McDonnell. Douglas remained an honorary chairman of the new McDonnell Douglas Company until his death in 1981.

- Born in Brooklyn in 1892, the son of a Scottish bank clerk, he was schooled at the Trinity Chapel School in Manhattan.

- Encouraged by his father to pursue a career on the seas, he enrolled in the U.S. Naval Academy, but was so inspired by a demonstration of the Wright Flyer plane that he had witnessed as a teenager, only five years after the Kitty Hawk flight, that he transferred to M.I.T. and graduated with an accelerated degree in aeronautical engineering.

- Spent six years laboring for early stage aircraft manufacturers including Glenn Martin, where he worked on the first Navy dirigible and a twin-engine bomber for the Army.

- Married Charlotte Ogg in Riverside and fathered two sons before resigning his job in 1920 to pack up his family and head to Los Angeles, where he intended to start his own aircraft company—with only six hundred dollars to his name.

- Picked potatoes and washed cars to make ends meet before convincing a wealthy playboy named David Davis to put up forty thousand dollars to build a biplane called the Cloudster. The plane set a West Coast altitude record and became the first to carry a payload exceeding its own weight.

- Won a silver medal in the six-meter sailing competition in the 1932 Olympics in Los Angeles.

DONALD DOUGLAS,
Airplane Manufacturer;
with a DC-3 model from the 1930s,
Los Angeles, ca. 1953

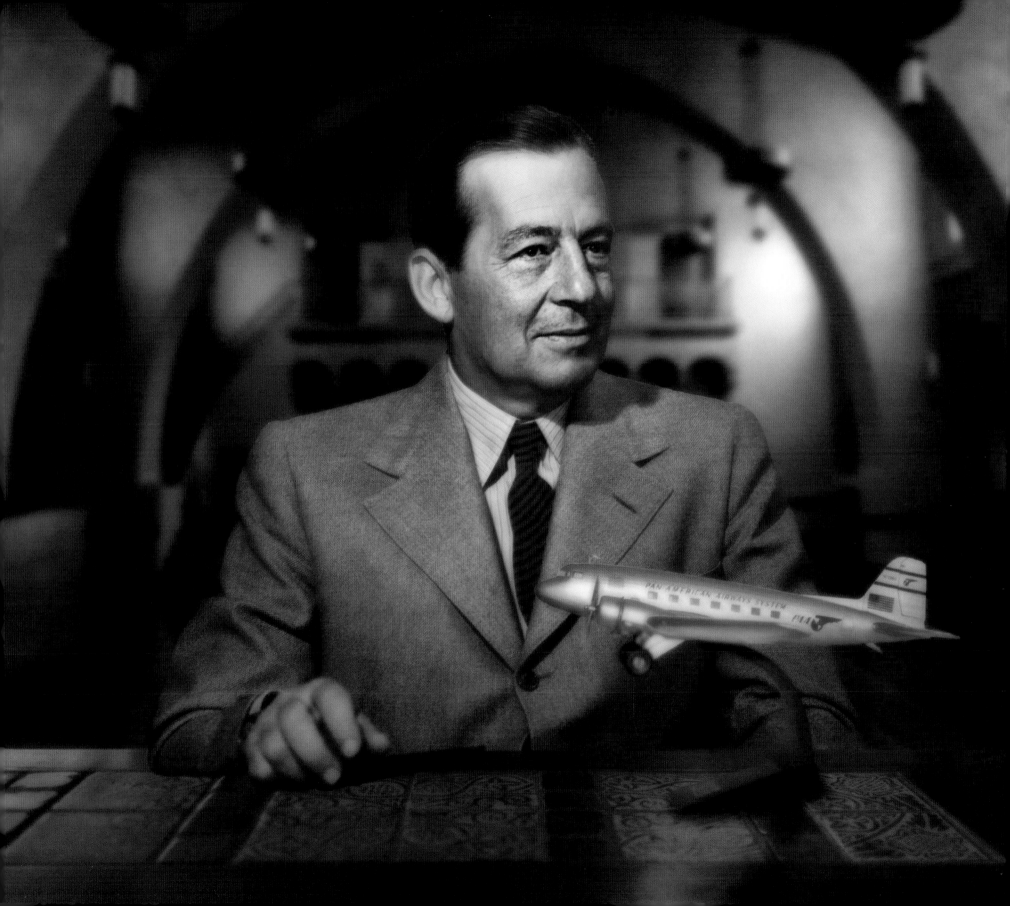

Southern California is a place for people who like to build something with their own hands: Northrop, Grumman, Douglas, Boeing, Lockheed, JPL, Dan Gurney. This legacy of engineering craft and the remarkable automotive DNA are tremendous elemental ingredients in the fabric here. Now ninety percent of the automotive manufacturers in the world have design studios here. I kick myself for not getting out here sooner!

Reeves Callaway could have followed his father into the family business of the Callaway Golf company, but instead dreamt of life in the fast lane—the ultra-fast lane. As a champion race car driver and head of his own engineering company, his legacy has been a spectacular string of automotive speed and engineering successes, culminating in his Callaway supercars—some of the most stunning and exclusive cars ever built.

After working steadily for years in Connecticut producing aftermarket turbochargers for sports cars, Callaway set out to build and market his own limited-edition ultra-high-performance sports car. The Callaway Corvette has been a specialist version of the great American sports car, which he has continually repowered, restyled and reengineered.

His notoriety dramatically accelerated in 1988 when he entered one of his twin-turbo Corvettes, dubbed the "Callaway Sledgehammer," into an annual contest by car magazines to find the fastest road-driven automobile. He astonished the enthusiast world by boosting his car up to 880 BHP, driving it across the country on public roads to and from the test site, and then powering the car to 254 MPH, shattering the previous street-speed record.

After this success, Callaway launched into building his own supercar. Starting from scratch, he developed a carbon monocoque chassis to build the Callaway C-7 in 1996. The low-slung two-seater, primarily intended for race tracks, had a 680 HP engine and did 0–60 in 2.8 seconds. In its racing debut, it led the Daytona 24-hour race before retiring. Then came the Callaway C-12 series in 1998. Looking like a ground-effects race car, it took the class pole position at Le Mans in 2001, beating Porsche, Ferrari and all other brands.

In 2001, Callaway's second wife, Sue Zesiger, a senior editor at *Fortune* magazine covering the auto world, convinced him to move west. "Five minutes after I arrived at John Wayne Airport and headed to Laguna Beach to live," Reeves admits, "I knew I was going to love it here. Everyone in Southern California just gets it. They don't just like to look at a great car—they want to own one. And that makes my life here much easier." The car culture here readily turbo-charged his business and aesthetics.

"When I was living in Connecticut and Germany, I made cars that were meant to be racing war machines. Fast, closed coupes. Once I moved west, our designs have been about openness, fun, sleekness. The vision of the C-16 Speedster exemplifies this. It has been formulated from our life in Southern California: it is topless, with no windshield, no mirrors. My cars are a product of where they are made. You naturally see the automobile differently here. It liberates your thinking so that you end up creating cars with a look of independence, freedom and great style."

This engineering dreamer is now working on such cutting-edge designs as a miniature V16 engine and the "Callaway Special"—envisioned as the world's first 300-MPH road car.

■ Born in 1949 in Connecticut and raised in a privileged setting—his father, Ely, was the CEO of Burlington Industries, the world's largest textile company, and in the 1980s, the founder of Callaway Golf Company in Carlsbad, California.

■ Earned a fine arts degree at Amherst College, then made a U-turn to follow his heart into car racing, where he won a National Championship in the Formula Vee series.

■ Working out of his home garage, began his manufacturing career in 1997 by designing turbocharger systems for BMWs, then expanding to performance kits for other prestige sports cars.

■ Landed a big break in 1985 when GM hired him to produce a twin-turbo Corvette, which became the fastest road car ever sold in America; produced five hundred of this rare beast between 1987 and 1991.

■ His Martini Callaway racing program in the FAA GT3 series won the manufacturer's championship in 2007 and the driver's in 2008.

REEVES CALLAWAY,
Automobile Engineer
and Manufacturer;
driving his C-16 Speedster, 2007

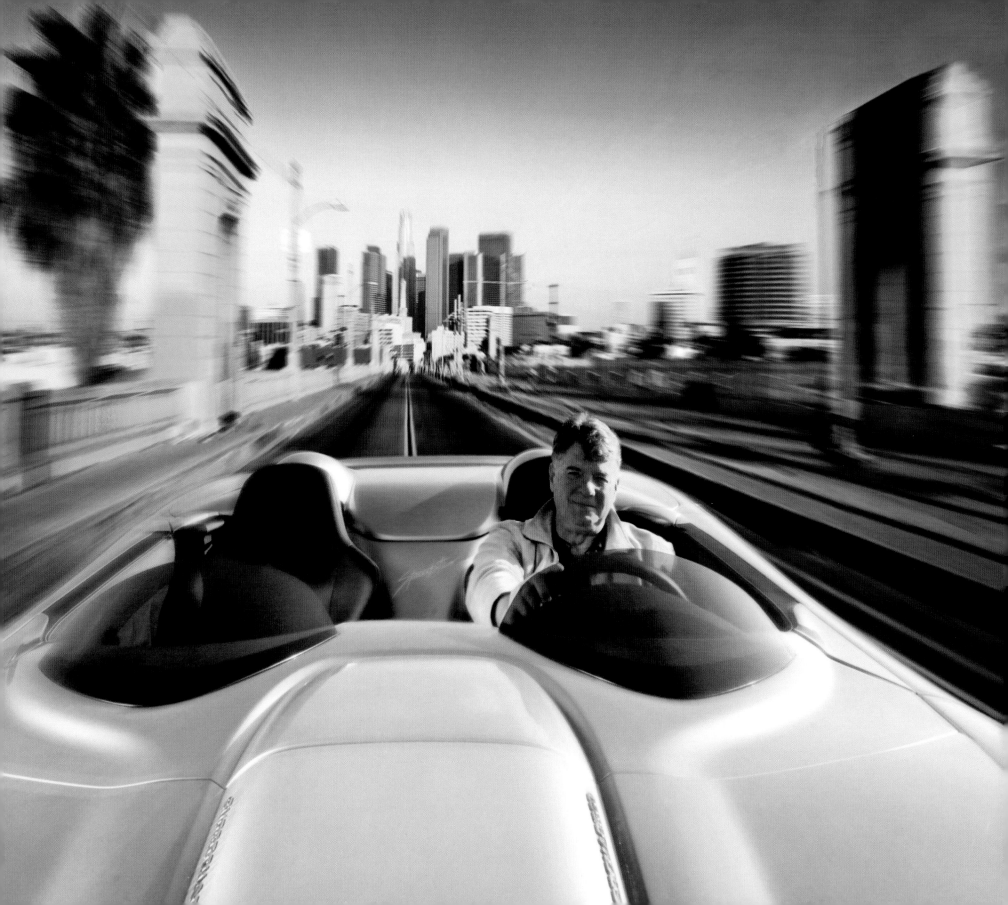

THE ARTISTS

THE ARTISTS

Ed Ruscha—Artist ■ Rudi Gernreich—Fashion Designer
Nobu Matsuhisa—Sushi Chef ■ Jim Morrison—Musician, Poet
Gajin Fujita—Artist ■ Raymond Chandler—Novelist

"Here human energy and purpose, having reached the limits of physical advance, are bound to flow back upon themselves and in doing so must either stagnate or create," declared Altadena poet Hildegarde Flanner.

Many immigrants to Southern California have not only opted to create, but have been compelled to do so. The wide-open and distinctive spaces here have long nurtured the creative temperament, presenting a large and blank canvas for artists of all types. The sunshine on its golden hills and its dramatic coastline have inspired generations of plein-air painters, photographers and poets; the rich medley of languages and tastes has inspired chefs, fashion designers and writers; our dark and seedy corners have fostered novelists, lyricists and filmmakers; and a diverse landscape, attitudes and popular culture have encouraged architects and graphic artists.

Excited by the visuals, freed from conventions, and energized by the ethnicities, L.A. artists have conceived new forms of art, and sometimes this creative output has been seen as shocking or superficial; sometimes as playing catch-up to the traditional centers of culture in New York, London or Paris. Nevertheless, Los Angeles and its surrounds have accelerated into a position of global leadership. Trends start in Southern California, museums from around the world exhibit its works, and artists of all kinds flock to the Southland to pursue their work.

The particularities of the city—this place of tall palms and wide beaches, gleaming red Ferraris and flamed low-riders, Farsi dialects and Latino takeout, fake boobs and dyed poodles, pink stucco and aqua swimming pools—are often the catalysts for their creations. The City of Angels makes art happen, pushes it through the birth canal of its creators' consciousness, displays it proudly in its galleries, museums, cinemas, sidewalks, loudspeakers—and is reinvigorated because of it.

The people in this chapter, producing a diversity of artistic forms ranging from paintings to sushi plates to songs to novels to clothes, have all been motivated to say something new, to strive for artistic excellence, and to touch the soul. They all certainly have touched mine.

I am a huge fan of Ed Ruscha's graphic works and an owner of one of his Hollywood sign prints. So it was a thrill to finally get the chance to meet him on the photo shoot. An assistant showed me into his huge Venice studio, a warehouse that has been partitioned into a working studio and a shipping and storage room. I wanted to pry into the dozens and dozens of art pieces that were lined up end-to-end in shelves, but I was ushered quickly onto his back porch to await the artist's arrival. I repositioned an old folding chair, set up my camera and light and waited.

Soon Ruscha ambled out, reminding me of playwright and actor Sam Shepard, with his laconic movements and soft-spoken, deep voice that still hints of his Oklahoma origins. I had hoped to find in him some of the understated humor I enjoy from his works. But he was more aloof, a serious persona. I should have expected that; his paintings may come across as straightforward and witty, but they are ultimately weighty with meaning. His images of gas stations and factories, word plays and glass shards occupy a metaphorical space that lies between objects and ideas, the literal and the symbolic.

It was nearly impossible to live in L.A. in the 1990s and not hear the buzz about an artist of a different sort: Nobu Matsuhisa and his restaurant on La Cienega. When a friend, who was a regular at Matsuhisa's, first took my wife and me there, he insisted that we not order from the menu but instead let Nobu serve us dishes that he thought we would like. The results were spectacular: sometimes spicy, never ordinary, always a visual and taste treat. Nobu himself was such an unassuming, gracious host that I had to return with my camera years later. In our interview, the motivations that have taken him to the top of the restaurant world became clear: not commerce but the enjoyment of pleasing his guests and elevating the profession with new gastronomic inventions.

In the late 1960s, when the Fillmore in San Francisco and L.A.'s Whisky a Go Go were at their peaks, I was thousands of miles away, hunkered down in high school at a boarding school in New England. The closest I got to the revolution of new music coming from the West Coast were the posters on my dorm wall and the LPs on my turntable. Having grown up in Los Angeles, I was particularly attracted to The Doors, an L.A. band, whose lead singer, Jim Morrison, was one of the leading poets and intellects of the rock scene. When I was sixteen, my best friend and I happened to be in New York City on a long weekend when the band was scheduled to perform at Fillmore East. I had to see Morrison perform live. He more than delivered. With his poetic lyrics, sensual voice and deep passion, he was particularly mesmerizing doing what seemed like a twenty-minute version of "Light My Fire." Having been arrested for sexual lewd-

ness at an earlier concert in Miami, New York police officers were poised to act just off stage, while he worked himself into a frenzy of what looked like a hallucinogenic trip, sexually gyrating with his microphone stand. The New York police were cool enough to recognize an artist when they saw one; Morrison was left alone. And I was given a lifetime memory. He was an artist who spoke to my generation of young adults. Deep yet not despairing, poetic yet vibrant. And his words continue to challenge the world.

At the Los Angeles County Museum of Art, I saw a large canvas that blended L.A. graffiti with classical Japanese woodblock imagery. Its contrast of cultures, precision of technique and dramatic pictorial qualities enchanted me. The artist's name was Gajin Fujita. When I tracked him down through his Venice gallery, LA Louver, he invited me to his studio in East L.A. Although he lives elsewhere, Fujita chooses to paint in the family's modest Boyle Heights home, where he grew up. Perhaps he needs the contrasts and legacy that the house exudes. When I arrived, I stepped from a neighborhood of tamales and Tejano music into a Zen world of quiet orderliness. A thirty-something, ponytailed Gajin and his mother greeted me with Asian formality. Shoes were left at the door. As his mother withdrew to the kitchen to prepare tea and present a plate of perfectly peeled and arranged orange slices, Fujita gave me a quick tour. Their tiny living room doubles as his studio, a place of contrasts that mirror those in his art. Japanese antiques are side-by-side with a hardware-store-size rack of spray cans in a rainbow of fluorescent colors. Six-foot-tall, gold-leafed panels leaned up against the dark wooden walls, awaiting his overpainting with Japanese cranes or geisha or whatever his sensibility will produce. The backyard is an eight-foot strip of concrete yard, yet it is here where Fujita works his spray-paint magic. Certainly, many more famous artists live in Los Angeles today. But few have the talent to blend the multicultural influences that define the city.

Southern California has both stimulated its artists to create and, in turn, has been redefined by the works conceived here. Two artists from the past particularly exemplify this synergy. An Austrian immigrant, Rudi Gernreich soaked up the attitudes of untamed 1960s Los Angeles to create a succession of startling new fashions—including the topless bathing suit and the Thong. Where else but L.A. could he so seamlessly have blended the calm of the seaside and the unrestrained sexuality of a generation?

A few decades earlier, novelist Raymond Chandler (no relation to me) paint-ed an atmospheric portrait of Los Angeles, the perfect setting for his noir world of private dicks and vengeful murder. He constructed the L.A. of detective Philip Marlowe, to be a city of contrasts, a place of neon lights and dark canyons, rain-slicked freeways and melting blacktop parking lots, chauffeured old money and desperate low-lifers. "The streets were dark with something more than night," he wrote in his introduction to *The Simple Art of Murder*. Chandler raised L.A. into its own character in his novels and this character has in turn defined noir L.A. ever since.

I take pleasure and sustenance from the art of iconic L.A. dreamers.

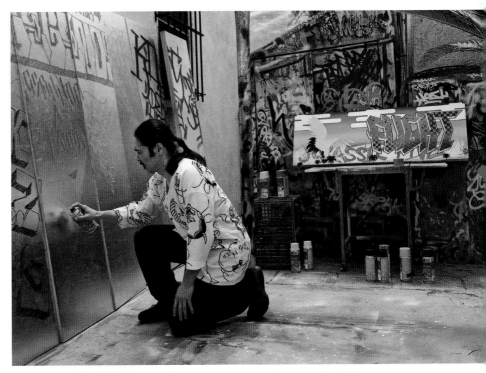

GAJIN FUJITA, Artist; in his backyard studio, East Los Angeles, 2007

Words come to me in dreams . . . There is some wicked truth behind dreams. They are so out of your control. They're involuntary. There's got to be some protein to them, something important happening in dreams—especially the words that come out of them. It's a diabolical time.

Ed Ruscha is arguably Los Angeles' most renowned contemporary artist . . . and its most iconographic. He has been a master at challenging viewers with his imagery, the evocative words and phrases in his works, and his continual experimentation with media and materials.

After high school in Oklahoma City, Ruscha was ready for a change from the Bible Belt and gum-popping girls. He had customized his 1950 Ford into a hot rod and drove it to L.A., burning thirteen quarts of oil on the way out. He threw himself into the local creative scene and dreamed of making a living doing nontraditional art that resonated with the imagery of his adopted city.

Ruscha's first gallery show was at the Pasadena Art Museum in 1962. With Roy Lichtenstein, Andy Warhol, Wayne Thiebaud and a few others, he exhibited in a seminal show, curated by Walter Hopps, called "New Painting of Common Objects." It was the first exhibition of work soon to become known as "pop art," which became the biggest revolution in modern art since cubism.

While Ruscha has never wanted to inhabit the pop art scene in the way Warhol and Lichtenstein did, his work has shared two of its most important attributes: its deadpan irreverence and its references to popular culture. For the most part, Ruscha has relied on images of Southern California as his subjects, models and muse, imbuing his work with his sly humor.

Ed has portrayed our often-banal architecture in paintings that include: *Los Angeles County Museum on Fire*, various versions of *Standard Station*, and the Hollywood sign. He has made photographic art books, including *Every Building on the Sunset Strip* and *Thirty Four Parking Lots in Los Angeles* and *Nine Swimming Pools*.

L.A.'s car-oriented landscape, with its overabundance of billboards, has inspired his most famous and long-lasting series of paintings using words and phrases as the main visual element. "Words have temperatures to me," Ruscha said in a 1973 interview, reprinted in his book, *Leave Any Information at the Signal* (2002). "When they reach a certain point and become hot words, then they appeal to me. 'Synthetic' is a very hot word. Sometimes I have a dream that if a word gets too hot and too appealing, it will boil apart, and I won't be able to read or think of it." Some of his more famous word paintings are: *Brave Men Run in my Family*, *Talk About Space*, *Wonder Sickness*, *Just a Moment Now*, *I Was Gasping for Contact*, *Noise*, *Ripe*, *Dare* and *Desire*.

Ruscha has been shown, collected, written about and admired worldwide, having had several hundred exhibitions of his works. He has been selected to represent the United States a record three times in the Venice Biennale, one of the most prestigious international art events.

During our photo session, I requested that Ruscha select one of his works to be photographed with, and he returned with the *Woman On Fire* canvas. I lightheartedly suggested that in light of his decades-long success as a trailblazing artist, the painting should instead say "Man On Fire." His only response was a gentle, oblique smile.

- Born in Omaha, Nebraska, into a Catholic family, in 1937; spent his youth in Oklahoma.

- Moved west to Los Angeles in 1956, enrolled at the Chouinard Art Institute (now known as CalArts) and immediately took to the city, its weather, unique architecture and signage.

- Began his career as a layout artist for an advertising agency, honing the commercial graphic techniques that have been cornerstones for his later works: fonts, perspective drawing and airbrushing.

- Inspired by Marcel Duchamp's *Fountain*, in the shape of a urinal, and the then-unknown Jasper Johns' paintings of targets and flags, realized that commercial and popular vernacular could be incorporated in fine art, giving him the confidence to resign from the ad agency to pursue his dream of being an artist.

ED RUSCHA,
Artist;
in his studio, Venice, 2007

A woman today can be anything she wants to be—
a Gainsborough or a Reynolds or a Reynolds Wrap.

Rudi Gernreich is best remembered as the designer of a topless swimsuit for daring women. Yet he was responsible for an impressive series of fashion firsts. He was the world's most avant-garde designer in the 1960s, an artist whose vibrantly colored patterns and revealing creations helped lead the fashion revolution that changed the way women dressed.

Throughout the 1940s and 1950s, wealthy women who could afford famous French designer clothes wanted elegant chic and nothing too bold, and run-of-the-mill department stores featured ready-to-wear outfits that were more Doris Day than Brigitte Bardot. In this conservative climate, Gernreich struggled to achieve even modest success as he set out on his own and pushed gently on the boundaries of accepted taste. When the groovy 1960s finally arrived, Rudi was the right person in the right city at the right time. His groundbreaking aesthetic, at the center of the youth movement, brought him to the forefront of the high-fashion world.

In 1964, Gernreich pushed his art to the bleeding edge by introducing a small item that thrust him into worldwide fame. He started with a woman's one-piece swimsuit but completely exposed the breasts on either side of a pair of V-shaped over-the-shoulder straps. The reaction to the monokini, as he called it, was explosive; the topless bathing suit became a symbol of the 1960s sexual revolution, a commercial and media sensation and the object of scorn by conservative and religious groups. Gernreich's muse, Peggy Moffitt, who modeled it, defended the creation. "Rudi was using the bosom as a shape, not as two breasts spilling out of the body," she told *Time*. "The topless was an expression of the freedom that every woman wants." Well, not every woman. Irate mothers picketed stores that sold them, and scandalized women everywhere scorned the breast-baring design.

Gernreich followed this up with two more practical and lasting creations. The first was the no-bra bra. It was a riff on his earlier unstructured bathing suit that shed all stiff supports and padding. The second was a woman's bathing suit that covered the breasts but left the buttocks exposed—the Thong. Both designs remain part of the basic fashion vernacular today.

"Style today is a kind of flaunting of one's personality," he proselytized in *Time*. "The important thing is to get a total feeling for what's new and then make it part of yourself." What was new for Gernreich was a succession of inventions through the 1960s that included the first use of see-through cutouts in his clothes; the application of vinyl and plastic as fabrics; the first knitted tube dresses and designer jeans; the first use of zippers and clasps as decorations; and the adoption of high chromatic colors and psychedelic patterns. By the end of the decade, Gernreich pioneered an even more lasting trend by inventing a new category of fashion: unisex clothing.

His most extreme fashion statement was made in Japan in 1970. Before the American exhibit opened for the World's Fair in Osaka, Gernreich threw a celebratory fashion show for a group that happened to include my parents. At the end of Gernreich's parade of unisex styles, suddenly the music changed and three totally bald and totally naked female models strutted onto the stage. One was painted gold, one was silver, one was red. Even their contact lenses were the matching color. My mother remembers being shocked but ultimately finding the artistry of it to be sensational. My father's reaction was slightly less ethereal.

By always pushing the frontiers of clothing (and the lack thereof) both technically and stylistically, Gernreich left a legacy as one of fashion's greatest innovators and modernists.

- Born in 1922 and raised in Vienna; disliked school because of its "rigid militaristic atmosphere," preferring to hang out in his aunt's dress shop where he was working to help support his family after his hosiery-executive father died; fled Austria with his mother as Hitler rose to power; settled in Los Angeles in 1938, at age sixteen.

- Enrolled in art classes at Los Angeles City College, picked up work as a freelance fabric designer, and joined a local modern dance troupe as both a dancer and costume designer, which helped him realize that clothes needed to look good on a mannequin, but also in motion.

- In his public life, was careful to abide by the customs of the time, keeping a low profile about his homosexuality and liberal politics. Secretly, he co-founded the first modern American gay liberation advocacy group, the Mattachine Society; bequeathed most of his estate to support education and litigation in gay rights.

RUDI GERNREICH,
Fashion Designer;
with child model, Los Angeles,
ca. 1967

For me, cooking is most about giving my customers little surprises that will lead them to make discoveries about their own latent tastes. It's about communicating my kokoro [heart] through every single dish I make.

Nobu Matsuhisa, after emigrating from Japan, built a multimillion-dollar empire of sushi restaurants in cities around the world. From modest origins he has become a stellar example of a dream come true in the City of Angels.

His success came neither easily, nor without tragedy. He had worked in Alaska for six months, with barely a day off, to open his first restaurant on borrowed money, while his wife and young daughter stayed in Japan until he could afford to bring them to the United States. Nobu was at home when he got a phone call that a fire had broken out in its kitchen. He rushed there only to find the entire building destroyed by flames. Nobu was heartbroken, recalling later, "I had no insurance . . . and was deeply in debt. I thought about suicide."

"From this tragedy, I managed to learn patience, love and appreciation," Matsuhisa told me. "I had a friend living in Los Angeles who said to me to come here. I came like a runaway, with nowhere else to go. I had to start from the beginning again." He worked for nine years at someone else's restaurant, but continued to dream of having his own place again. He struggled to repay the loans from the Alaska restaurant and then finally, in 1987, borrowed sixty thousand dollars and opened Matsuhisa on La Cienega Boulevard. This time, the only thing on fire was the word of mouth among Angelenos. By adding Latin ingredients to sashimi, including hot red peppers and warm olive oil, his inventions created a fiery buzz, a taste he acquired while living in Peru. "I made sushi myself right at the sushi bar and by getting comments on my creations directly from my customers, I was able to experiment with adding things with the South American influence. I just tried to make my customers happy," Matsuhisa recalled.

His artistry was a hit, allowing him to pay off debts and finally sink his roots into the city. "In Japan, if you have good success, people are often jealous and pull at you," Matsuhisa told me. "In Los Angeles, I have been so free to pursue my American dream. Doing a good job here is accepted, not hindered."

Actor Robert De Niro had been pressuring him for years to open a second venue with him in New York City. "I didn't really want to start more than one restaurant," he admitted, "but the people working for me were so talented, and I wanted to promote them. So each new restaurant gives me the opportunity to advance members of my restaurant family."

Nobu New York opened to raves. Other locations followed, some with partners including fashion designer Giorgio Armani and musician Kenny G. Matsuhisa now serves his special sushi in Malibu, San Diego, Aspen, Las Vegas, Dallas, New York (at three restaurants), Miami Beach, Honolulu, London (two restaurants), Milan, Dubai, Tokyo, Melbourne, Nassau, Athens and Mykonos. His celebrity status has brought invitations to prepare private dinners for American presidents, to cater the food for Oscar parties and to appear in the Austin Powers film *Goldmember* (2002).

Although he spends nine months of the year traveling and only three with his wife at his home in Beverly Hills, Matsuhisa does not complain. His ego also seems unaffected by such success; he was still the unpretentious chef I remembered meeting at my first visit to his original restaurant years ago. For the photo, I asked that he hold a plate of seventeen pieces of sushi (at the time, each represented one of his restaurants), and he made them personally. Soft-spoken and unassuming, his focus remains on pleasing his patrons. "There is no greater compliment to a chef's skills," he said, "than to be able to make a diner enjoy something he or she couldn't eat before."

■ Born in 1949 and raised in a suburb of Tokyo by his mother (his father, a lumber merchant, died when he was seven); dreamed as a teenager of being a sushi chef.

■ Learned the craft of preparation of raw fish in his first job in Tokyo, but wanted to work abroad; joined a sushi restaurant in Lima, Peru, as head chef where, unable to find authentic ingredients, began to invent new dishes, combining local flavors with Japanese sushi standards.

■ Eager to be his own boss, relocated to Anchorage, Alaska, where he saw opportunity in the scarcity of fine dining.

■ Named one of America's 10 Best Chefs by *Food & Wine* magazine; dubbed "the man who may be the best Japanese chef in the world, creating dishes that have no equal in a cooking style that's part Peruvian and part Nobu's alone," by the editors of *Zagat Guide*.

NOBU MATSUHISA,
Sushi Chef;
in his original Beverly Hills
restaurant, 2007

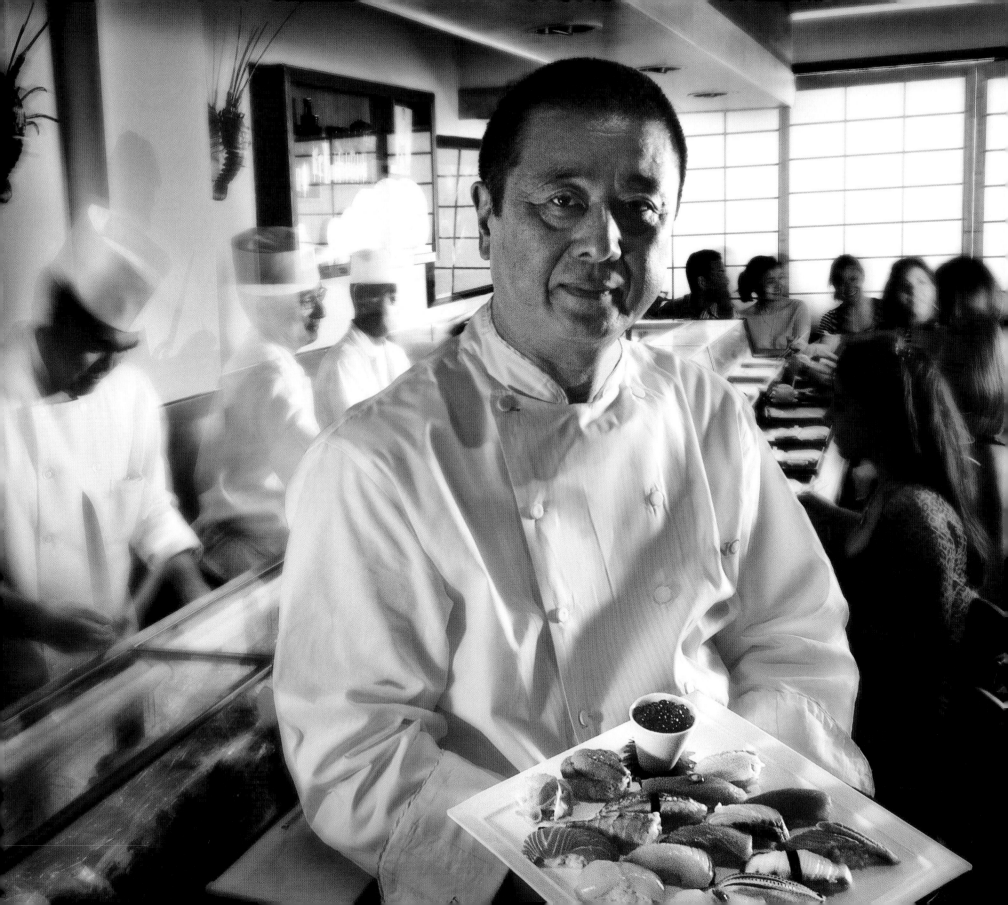

The most important kind of freedom is to be what you really are.
You trade in your reality for a role. You trade in your sense for an act.
You give up your ability to feel, and in exchange, put on a mask.
There can't be any large-scale revolution until there's a personal revolution,
on an individual level. It's got to happen inside first.

Jim Morrison, as the lead singer and lyricist for The Doors, was the poster boy for the best and the worst of the 1960s, gaining worldwide acclaim for his contemplative music and rebellious philosophy before succumbing to drink and drugs at the age of twenty-seven.

Intending to make experimental movies when he first arrived in Los Angeles, he met fellow UCLA student and musician/keyboard player Ray Manzarek, and instead formed a rock band. Within weeks, they had added Robbie Krieger as the guitarist and John Densmore as the drummer. For the name of the band, Jim was inspired by Aldous Huxley's book *The Doors of Perception*, and its many references to the doors that open the mind.

Los Angeles gave Morrison's intellectual and mystical nature the flourishing creative milieu that he couldn't find in the South. He released a torrent of poignant and introspective lyrics that distinguished him from most contemporary rock musicians. His muses were Nietzsche and James Joyce rather than other rock lyricists. Morrison's music, like his own life, was preoccupied with themes of death, revolt, sex and mind exploration. He was passionate about bringing a more profound edge to his songs, making them closer to great literature and poetry than the conventional rock concerns with love, girls and freedom.

The Doors introduced their new sound at a long-running gig at the Whisky a Go Go on the Sunset Strip. Although sensitive and withdrawn in his private life, Jim learned at the Whisky to let go his inhibitions on stage. With his skintight pants, sexual dance movements and impassioned singing, girls went crazy and record labels took notice.

Their first album was an instant smash. The single "Light My Fire" reached number one in the summer of 1967. Their subsequent albums *Strange Days*, *Waiting for the Sun*, *The Soft Parade*, *Morrison Hotel*, *Absolutely Live* and *L.A. Woman*, were all chartbusters.

As Morrison questioned authority and power, he alienated parents and captivated the youth. "When you make your peace with authority, you become authority," he wrote. He became increasingly rebellious and had frequent run-ins with the Establishment. A few radio stations banned his songs and some venues cancelled his performances.

Like so many on quick flights to fame, Morrison increasingly felt that he was invincible. His onstage behavior became erratic and often out of control, as did his off-stage use of drugs and alcohol. During a Florida concert in 1969, he was arrested for exposing himself onstage. When he finally damaged his relationships with his own band members, he retreated into writing poetry, self-publishing two volumes in 1969. By 1970, he still managed to get back into his La Cienega Boulevard studio for one last album, whose title single was "L.A. Woman."

Just as that album was being released, the twenty-seven-year-old star fled Southern California for Paris to try to concentrate on his writing. Less than four months later, the charismatic troubadour was found dead in his bathtub of an apparent heart attack. The brief but spectacular flight of this Icarus had ended.

- Born in Melbourne, Florida, in 1943, into a strict U.S. Navy family; his father's postings kept the Morrisons always on the move.

- As a four-year-old, experienced what he later called the most important event of his life: while traveling in New Mexico, his family came upon the carnage of a horrible traffic accident involving several Native Americans; believed that the spirits of the dead had entered his own soul; the song "Riders of the Storm" was just one of several works this incident inspired.

- Attended high school in Alexandria, Virginia, where his intelligence and offbeat personality were first recognized; pulled weird stunts like carrying a rotting fish onto a crowded bus on a hot day just to provoke responses; was passionate about writing poetry and reading literature and philosophy; admired German philosopher Friedrich Nietzsche, whose existentialist views further shaped Morrison's nontraditional ideas.

- Enrolled at Florida State University; eager to be at the center of the youth revolution, moved to Los Angeles and took film classes at UCLA.

JIM MORRISON,
Musician and Poet;
Elysian Park, 1968

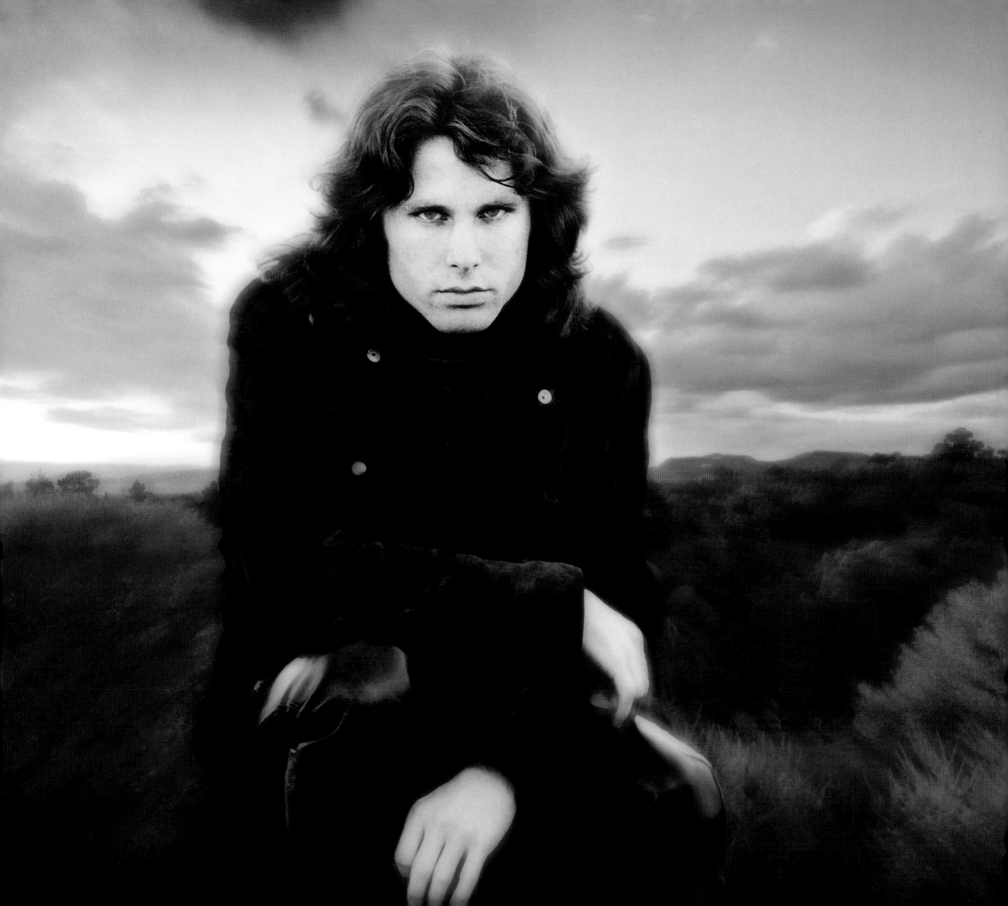

I'd be doing this stuff even if I weren't getting paid.
I always think that my art, or art in general, comes from within.

Gajin Fujita has attained international success as a painter who blends traditional Japanese imagery with the graffiti, symbols and words of urban Los Angeles. His persona, as reflected in his works, is an embodiment of the L.A. scene, combining the hip with the traditional, and the native with immigrant culture.

Dozens of more-famous painters work in Los Angeles, but none so embody the city's symbolism and DNA.

Growing up in Boyle Heights, Fujita faced a major obstacle: avoiding the seduction of gang life. By joining instead a graffiti-tagging group, he found an activity that agreed with his own demeanor. "For me the tagging appealed to my competitive side," he told me. "Our tagging crew is called K2S: Kill to Succeed. Spraypainting was like a sport, like fighting without the violence, like street basketball or breakdancing. We wanted to show the other crews that we were the best, and to challenge ourselves with the works."

Then a family tragedy provoked him to make art his career. "My dream of becoming a working artist came about when my father passed away in 1996," he said during our photo shoot. "I was twenty-four years old and I realized I needed to step up to take up his torch as an artist, keep the torch lit and support my mother and younger brothers."

After getting his MFA, Fujita's skills and reputation grew. Yet it took one more moment of revelation to refine his vision and propel him into artistic prominence. On a visit to his ancestral homeland of Japan, Fujita visited Kyoto's famous Golden Pavilion Temple. As he admired the real gold that covers the shrine's exterior walls, the graffiti artist asked himself, "Who would be ballsy enough to tag on something like that?" Thankfully no one has, but the heretical idea inspired Fujita to experiment with tagging over gold in his own art. When he got home to his studio, he covered his primed frames with gold leaf until they shone with the brilliance of imperial Japanese screens. Then he took out a spray can and violated their traditional heritage with words and images of L.A. street graffiti. The refined contrasted with the garish; the old culture smashed into the new. Fujita had at last found his voice. And Los Angeles had shaped an artist who matched its own bifurcated identity.

Fujita has refined his techniques even more. He first tags over the gold backgrounds—or he is assisted by his tagging buddies—with various names, words and expressions. At this stage the works scream "Urban L.A.," and look as though they have been defaced rather than enhanced. Then the more considered gestures occur as Fujita overpaints or stencils skillfully rendered Asian figures—such as a demure geisha, a fanciful dragon or an entwined couple—that recall Japanese wood-block prints. For the final touch he adds more contemporary L.A. imagery, including palm trees or oversized graffiti lettering that reads "Burn," "Lust" or "Spirit." The effect is truly distinctive and exciting, his personal synthesis of Eastern roots and urban Southern California.

Fujita's first solo show was in 2002 at the prestigious Venice gallery, LA Louver. Subsequent gallery and museum shows here and abroad have brought him credibility in the international art scene and financial rewards have followed. Able to fulfill his vow to support himself and his family, he carries his father's torch proudly.

- Born in 1972 to Japanese immigrants, a mother who conserves Asian antiques and a father who was an abstract landscape painter; raised in the mostly Hispanic neighborhood of Boyle Heights.

- Made his first images with spray cans on the streets of East L.A., as a member of a graffiti-tagging group; enrolled in Fairfax High's Magnet Center for Visual Arts, which he acknowledges saved him from being pulled into gang life; riding a bus two hours a day to and from school exposed him to a variety of inventive lettering and compositions in the graffiti he passed, which pushed him to make his own street art more visually thoughtful.

- Initially rejected his parents' Japanese roots; after high school that changed: "I was at the Otis Art Institute, experimenting with my spray-can techniques, when I took an Asian-art history class, where I learned about the Ukiyo-e wood block prints and the traditional Japanese imagery. That is when I first started blending my L.A. street heritage with my Japanese ancestry."

- On a full scholarship at the University of Nevada to get his Master of Fine Arts, found the catalyst to propel him into an art career: a coach; art critic and teacher Dave Hickey played to Fujita's love of sports and motivated him as a man rather than instructing him as a painter, urging him to become a full-time artist.

GAJIN FUJITA,
Artist;
in front of one of his wall murals,
Los Angeles, 2007

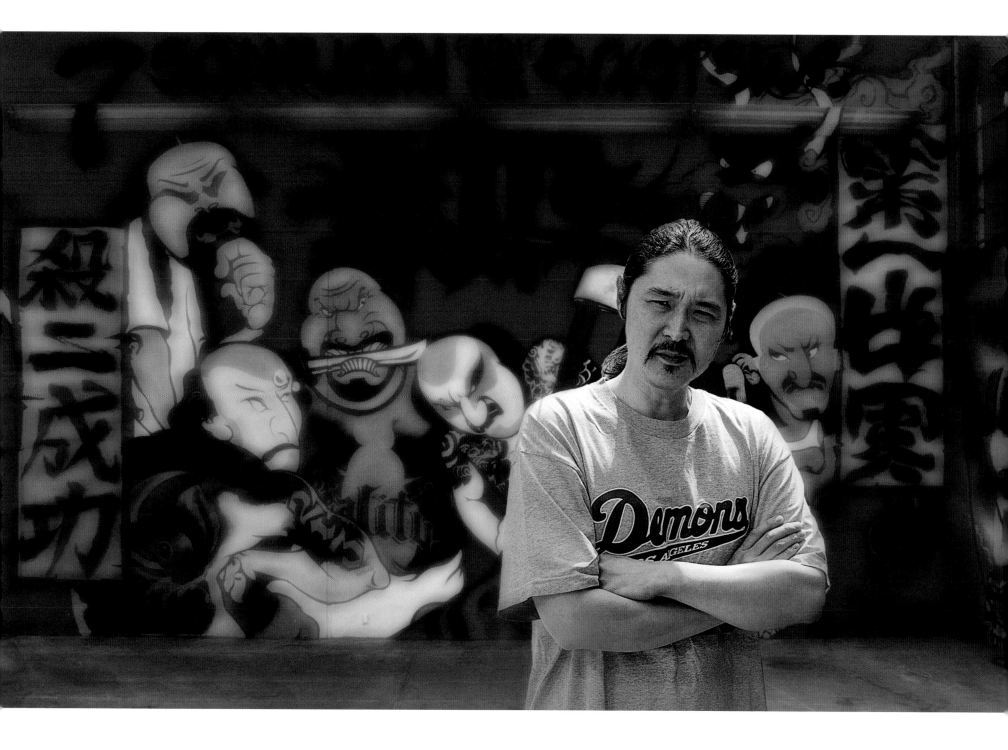

If my books had been any worse, I should not have been invited to Hollywood, and if they had been any better, I should not have come.

Raymond Chandler
was the mystery writer whose stories of the fictional private eye, Philip Marlowe, raised noir fiction to new heights, and whose evocative descriptions of Los Angeles in the 1930s and 1940s created a lasting characterization of the brooding city.

For most of his life, Chandler never expected to be a world-famous writer. At age forty-four, he was an unhappy vice president in the accounting department of a Los Angeles oil company when he was fired for absenteeism and drinking. That gave him the needed push into a career as a full-time writer. He started with short stories for pulp fiction magazines, creating lines including: "She smelled the way the Taj Mahal looks by moonlight;" "I'm an occasional drinker, the kind of guy who goes out for a beer and wakes up in Singapore with a full beard;" and the car "moved away from the curb with as much noise as a bill makes in a wallet." To his surprise, his work sold and paid him enough. This middle-aged, reclusive man at last had found not only a vocation, but a passion.

His typewriter provided the solace that other pursuits never did, so Chandler finally was able to dream of being accomplished. "Between the one-syllable humors of the comic strip and the anemic subtleties of the litterateurs [sic]," he wrote in the introduction to *The Simple Art of Murder* (1950), "there is a wide stretch of country, in which the mystery story may or may not be an important landmark." Chandler spent the rest of his life struggling in that stretch of country to elevate the artistic quality of his stories.

His descriptions of L.A. were so vivid because Chandler really got to know its streets and rhythms, having lived in more than thirty-six apartments and houses in the region. With no children or family and few friends, Chandler was restless and detached; he and his wife, Cissy, moved once or twice a year.

By the mid-1930s, he had invented his alter ego, the hard-nosed Los Angeles detective Philip Marlowe, a complex and sometimes sentimental figure who has no family or friends, yet is admired in every case he takes. Marlowe lives without most amenities, except for Scotch, yet plays square with his clients, even refusing them or their money if an assignment doesn't meet his ethical standard.

Marlowe debuted in Chandler's first novel, *The Big Sleep*, in 1939, with internal monologues including: "What did it matter where you lay once you were dead? In a dirty sump or in a marble tower on top of a high hill? You were dead, you were sleeping the big sleep, you were not bothered by things like that. Oil and water were the same as wind and air to you. You just slept the big sleep, not caring about the nastiness of how you died or where you fell. Me, I was part of the nastiness now." With prose like this, complex plotting, vivid characters and clever metaphors ("Dead men are heavier than broken hearts"), his novel excited critics, readers and eventually Hollywood. Warner Brothers optioned it, hired novelist William Faulkner to adapt it, and finally released the picture, starring Humphrey Bogart and Lauren Bacall, in 1946. Marlowe returned in *Farewell, My Lovely*; *The High Window*; *The Lady in the Lake*; *Little Sister* and *The Long Goodbye*.

When Hollywood hired him as a screenwriter, he collaborated with directors including Billy Wilder on James M. Cain's novel *Double Indemnity* (1944) and Alfred Hitchcock on *Strangers on a Train* (1951). Chandler's only original screenplay that was produced, *The Blue Dahlia* (1946), was not a big success. His final screenplay, *Playback*, was written for and rejected by Universal Studios. Chandler converted it into his seventh and final completed novel. He died in 1959, midway through writing *Poodle Springs*. More than three decades later, it was completed by admirer Robert B. Parker and also became a bestseller.

- Born in 1888 in Chicago; at age thirteen, moved to England with his mother after his alcoholic, womanizing father abandoned them; after an undistinguished college career, worked as an accountant, poet and journalist; lived in the shadow of his possessive mother.

- In 1912, thought a change of locale might make a difference, so borrowed money from his uncle and returned to the United States; eventually landed in Los Angeles.

- Still at loose ends, worked at odd jobs like stringing tennis rackets and picking fruit; enlisted in the Canadian army during World War I, serving in France and England; returned in 1918 to L.A. and found work as an accountant in the burgeoning oil industry.

- Married in 1924 to Cissy Pascal, who was eighteen years his senior.

- Eventually settled in La Jolla in 1946; when Cissy became terminally ill and died, turned once again to drink and never again turned away for long.

**RAYMOND CHANDLER,
Novelist;
with his cat, Taki, La Jolla, 1948**

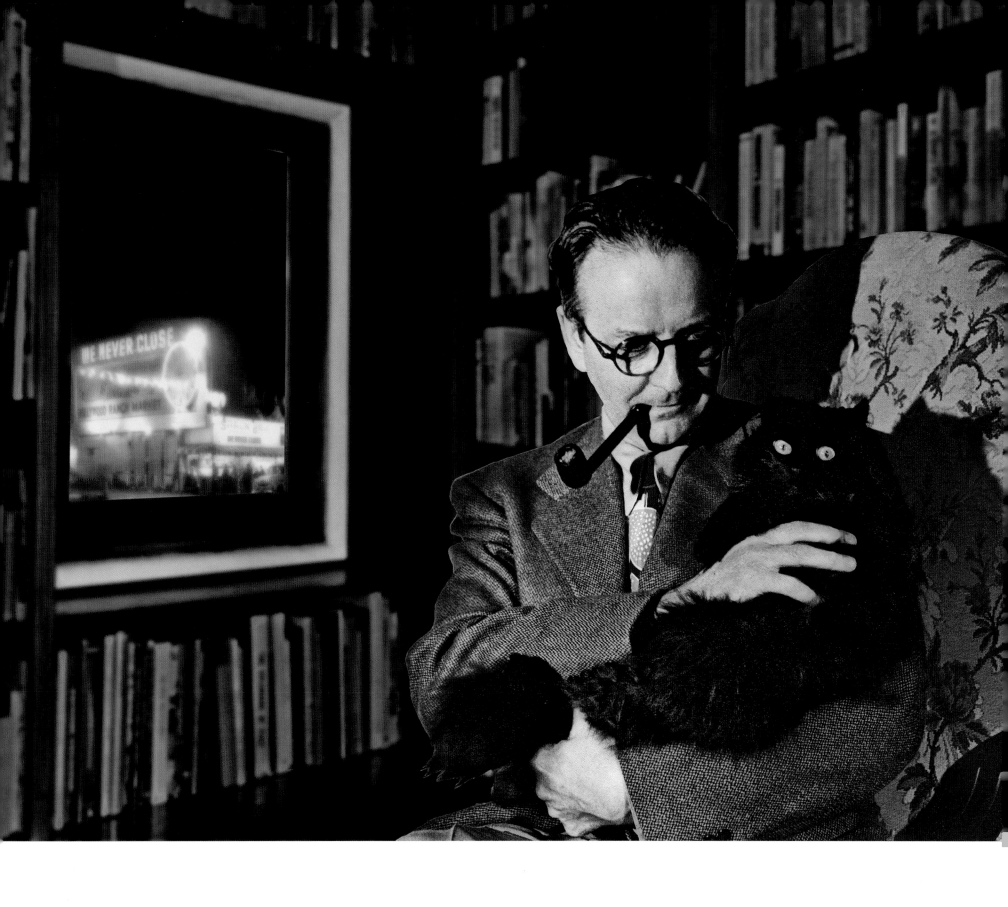

THE FOLK HEROES

THE FOLK HEROES

ARNOLD SCHWARZENEGGER—Politician, Actor, Bodybuilder ■ AIMEE SEMPLE McPHERSON—Minister
HUELL HOWSER—Television Host and Producer ■ CHARLES HATFIELD—Rainmaker ■ ANGELYNE—Billboard Model

The mythology that creates folk heroes develops not solely from the extraordinary nature of the individuals' accomplishments, but from the exaggerated manner in which their deeds are built up to mythic proportions and the way their exploits serve to fulfill the public's topical needs of the day. Mixing fact and fiction, frontier newspaper correspondents embellished the activities of outdoorsmen like Davey Crockett and Daniel Boone to bring hope and self-reliance skills to early Americans. Pulp novels spun larger-than-life stories with the West's famous cowpokes and outlaws like "Wild Bill" Hickok, Annie Oakley and Jessie James, tantalizing eastern city-dwelling readers with daring adventures in wide-open spaces.

In the twentieth century, as the gravitational center of the country's media moved west to Southern California, some unique Angelenos have used the Southland's media to catapult to folk-hero status. While their deeds may not seem to match those of earlier American folklore, their mesmerizing personalities and media portrayals have few equals.

The dreams of these five gregarious individuals have often been inseparable from their desire for the spotlight. Whether on movie or television screens, sky-high billboards, or countless iterations of the daily newspapers, their need for external validation has been central to their characters. And in turn, these fascinating characters are etched into the Southern California consciousness.

California's Governor Arnold Schwarzenegger began his quest for oversized accomplishments as a young boy in Austria, with audacious dreams to move to America, become an actor, and marry a Kennedy. The springboard to his aspirations turned out to be bodybuilding, which led Schwarzenegger eventually to Los Angeles, where the rest of his goals were realized.

Aimee McPherson was the country's most famous evangelist in the 1920s and 1930s who, while delivering a uniquely uplifting interpretation of the scripture, created a preaching style infused with entertainment. Using radio and the country's newspapers, she also made her own persona part of the attraction, manufacturing scandals, sensationalism and sex appeal,

attracting more headlines than Hollywood's biggest celebrities.

Charles Hatfield was a self-proclaimed "rainmaker" in the early part of the twentieth century who repeatedly filled the newspapers with stories of his pluvial exploits, bringing hope to a drought-ridden West.

Southern California's most enduring and well-loved television personality is Huell Howser. This prolific producer and host of PBS shows like *California's Gold* serves up a big helping of Southern hospitality, supreme optimism and contagious enthusiasm, a welcome antidote to the usual media onslaught of crime, wars, disasters and financial woes. His Tennessee drawl and willingness to enthuse over nearly any facet of California life and landscape has endeared him to statewide audiences for years. Indeed, viewers treat Howser like their favorite cousin. It's amazing, as he would say, to walk down the street with him and see how strangers gush.

I first met Howser in 1979. He was working with the *Grand Ole Opry* when he walked into my office at 20th Century Fox Television looking for a studio to distribute some of their country music TV shows. Huell's upbeat disposition immediately attracted me to him, and so began our close friendship. Today, after nearly three decades doing human-interest stories, Huell has become a walking library of off-the-beaten-path places. When he swings by my house to take my wife and me out to dinner, there's always a glint in his eye that promises yet another adventure. This eternally gregarious character regularly shows us another hidden haunt, rich with history, architectural details and characters. A night out with Huell means fending off all his admirers so he can befriend a waiter from Nicaragua, or the bartender who was a fighter pilot or the lounge singers who tell us stories about Hollywood's good old days. Huell's inquisitive nature and empathy for overlooked people and places has led to a television career unrivaled in its longevity and its audience's affection.

The private life of Huell also has produced more than his share of the unexpected. For the first few years after he moved to Los Angeles, I used to tease Huell about his bachelor apartment, with its perpetually empty refrigerator, barren walls and style-free furniture. His closet looked like a Brooks Brothers sales rack: a dozen

identical oxford dress shirts in the standard white, blue and yellow. Sometime in the late 1980s he began to develop his own aesthetic though. His dress shirts morphed into short-sleeved, embroidered *guayaberas*. A more extraordinary transformation happened in his apartment, however. "I just got back from a downtown salvage yard," he announced one day on the phone. "Can you come over and help me with what I just bought?" And there in his Hancock Park high-rise was a hundred-pound steel or copper industrial part, origin unknown, that he now wanted to turn into a coffee table, a wall light or a dining table. Once the initial bewilderment passed, I delighted in his newfound vision of industrial-parts-as-art-as-furniture. Each time his call came I answered with tools and my handiness. Today his apartment and two houses in the desert are showcases of industrial castoffs made into aesthetically provocative furniture. His refrigerators, it should be noted, however, still have no food in them.

As different from Huell as West Hollywood is from West Covina is the other folk hero I have chosen to include here: Angelyne, the buxom billboard model. Long before Paris Hilton and the current crop of "fame-for-fame's-sake" celebrities, this pink-attired, voluptuous publicity hound plastered Hollywood billboards with gigantic images of herself, and in so doing, pioneered a self-advertising path into the folklore of Los Angeles. Her talents may be as slim as her waist, but she has managed to achieve her dream of becoming famous in a town full of wannabees. She delivered a sexy, mysterious and ultimately mythical presence to a land built on celebrity worship.

Meeting and photographing Angelyne turned out to be a story in itself. Tracking her down proved to be no easy feat, as the frequency of her billboards had dwindled, and her Web site had no valid contact information. I finally found a phone number on an online photo of one of her old billboards and left word of my interest in photographing her. Weeks of negotiations with three different twenty-something representatives followed. I learned that no matter the circumstances, Angelyne does not allow herself to be photographed without getting paid. I was at first unwilling to pay a nickel, since none of the other individuals in this book were compensated, but I relented when it became apparent that this is her only livelihood. At last, it was time for the photo shoot.

She rolled up to my house in her pink Corvette, already attired in a peek-a-boo pink vinyl mini, but then refused to come out of the car until her handler collected her cash fee in advance.

When Angelyne finally made her entrance, it was worth the wait. Although she must be in her sixties, her cleavage, legs and hourglass figure were still stunning. She was barely five feet tall, but carried herself like a Hollywood legend, the one she had created in her own mind.

My lights and camera were in position for the first of what I assumed would be a dozen different set-ups. She took her place as directed and struck the first pose with a professional's ease, pushing out her curves to full effect. But after I clicked the first photo, she dropped her pose and rushed over to the camera to ask if that picture was okay. Her idea of a photo shoot, it turned out, was allowing the photographer to save only one picture. I was horrified at this restriction, but she was adamant. I could shoot another shot, but only after she watched me delete the previous one from my digital camera. So we went through that dance a few times. I kept trying to convince her to let me try another pose, while keeping the one photo I had chosen from the first one. Finally, for an additional fee, I was allowed to keep three shots from three poses.

After this unorthodox and stressful shoot was completed, we sat down to talk, and to sip the champagne and pick at the pizza her representative had requested for her. One moment she played the role of a confident celebrity touting her worldwide success and the number of movies and TV shows she has been in; and the next, an insecure diva trying to hawk one of her self-published fan magazines or CDs. I suspect that her modeling work had diminished to a trickle and, like Norma Desmond in *Sunset Boulevard* ("I am big! It's the pictures that got small"), her vulnerable side was only skin-deep. Still, in a cutthroat town where stars come and go like the Santa Ana winds, I admire someone who has remained in the public eye for nearly thirty years through such innovative self-promotion. And of all the individuals whom I have photographed for this book, more people asked me about what Angelyne was like than any of the others. Annie Oakley probably inspired no more curiosity.

I was always dreaming of very powerful people, dictators and things like that. I was always impressed by people who could be remembered for hundreds of years.

Arnold Schwarzenegger has attained world-class status in three careers: bodybuilding, acting and politics, and created three memorable personae: Mr. Universe, The Terminator and the "Governator."

His rags-to-riches rise, from impoverished immigrant to wildly successful American, was no accident; from the outset, he's been driven by a relentless determination to succeed. It has been reported, for instance, that he lists his goals each January on index cards, then pursues them throughout the year as relentlessly as his movie characters track down bad guys.

Childhood friends from Austria recall that he often said his goals in life were to move to the U.S., become a movie star and marry a Kennedy. At age fifteen, he discovered the propellant for his ambitions. "I want to be the best-built man in the world!" he proclaimed to his parents. Despite a lack of encouragement from his father, Arnold persevered.

"I always knew America was the place for me," he reflected about his childhood dreams in his address to the 2004 Republican convention. "I would watch American movies, transfixed by my heroes, like John Wayne. Everything about America seemed so big to me, so open, so possible."

He pumped himself up into the world's leading competitive bodybuilder, which took him to Santa Monica, home of the original Muscle Beach. But rather than resting on his laurels like other one-note musclemen, Schwarzenegger started businesses, became a star in Hollywood action movies and married Maria Shriver, a Kennedy cousin. But riches and worldwide fame were not enough.

Just as his film career was starting to cool, he invented another outlet for his oversized ambitions: public service. He'd used his star power to attract support for George H. Bush during the 1988 Presidential election and chaired Bush's Council of Physical Fitness and Sports; in 2003, it was the downturn in the California economy that gave Schwarzenegger an opportunity. The state had been battered by the dot-com crash and the Enron-led energy crisis, sending Governor Gray Davis into a special recall election. On the *Tonight Show with Jay Leno*, Schwarzenegger announced his candidacy. Though he'd never held public office and had no experience running anything larger than his film production company, his name recognition brought him an immediate advantage. The "Governator," as news media dubbed him, marched out of the election victorious, capturing forty-eight percent of the vote.

After a divisive beginning, in which he mocked his Democratic opposition in Sacramento as "girlie men," Schwarzenegger realized that bipartisan politics would be his strong suit. He steered a moderate course after that, adding a Democrat as his new chief of staff and taking the lead in environmental causes.

"California, I believe, is an empire of hope and aspirations," he declared in his first State of the State address. "Never in history have such big dreams come together in one place," he stated. "Never in history has such an array of talent and technology converged at one time. Never in history has such a free and diverse community of people lived and worked under one political system. This is a wonderful place—California—this empire of aspirations." And for a time, at least, its emperor was an über-dreamer, whose array of aspirations and accomplishments made him perfect for the leading role.

- Born in 1947 in the small Austrian town of Graz, to a police chief father and housewife mother, in a house with no phone, refrigerator or toilet.

- Realized at fifteen that bodybuilding was his ticket to fame and began intense weight training; supplemented his training by taking anabolic steroids, which were then legal.

- At age twenty-three, won his first Mr. Olympia title; over the next decade, won five Mr. Universe titles and seven Mr. Olympia titles.

- Graduated from the University of Wisconsin with a degree in business and economics and began a series of business ventures that made him a millionaire by the time he was in his late twenties.

- Leveraged his physique to land films; played himself in *Pumping Iron* (1977), a bodybuilding documentary; then the title role in *Conan the Barbarian* in 1982; overcame his two-dimensional acting with a larger-than-life persona; became a bona fide box-office star as the murderous android in 1984's *The Terminator*.

- His movie career continued with *Twins* (1988), *Total Recall* (1990), *Kindergarten Cop* (1990), *Terminator 2: Judgment Day* (1991), *True Lies* (1994), *Batman & Robin* (1997) and *Terminator 3* (2003). In 1991, the *Hollywood Reporter* named him the number-one box-office star in the world.

ARNOLD SCHWARZENEGGER,
Politician, Actor, Bodybuilder;
Los Angeles, 2008

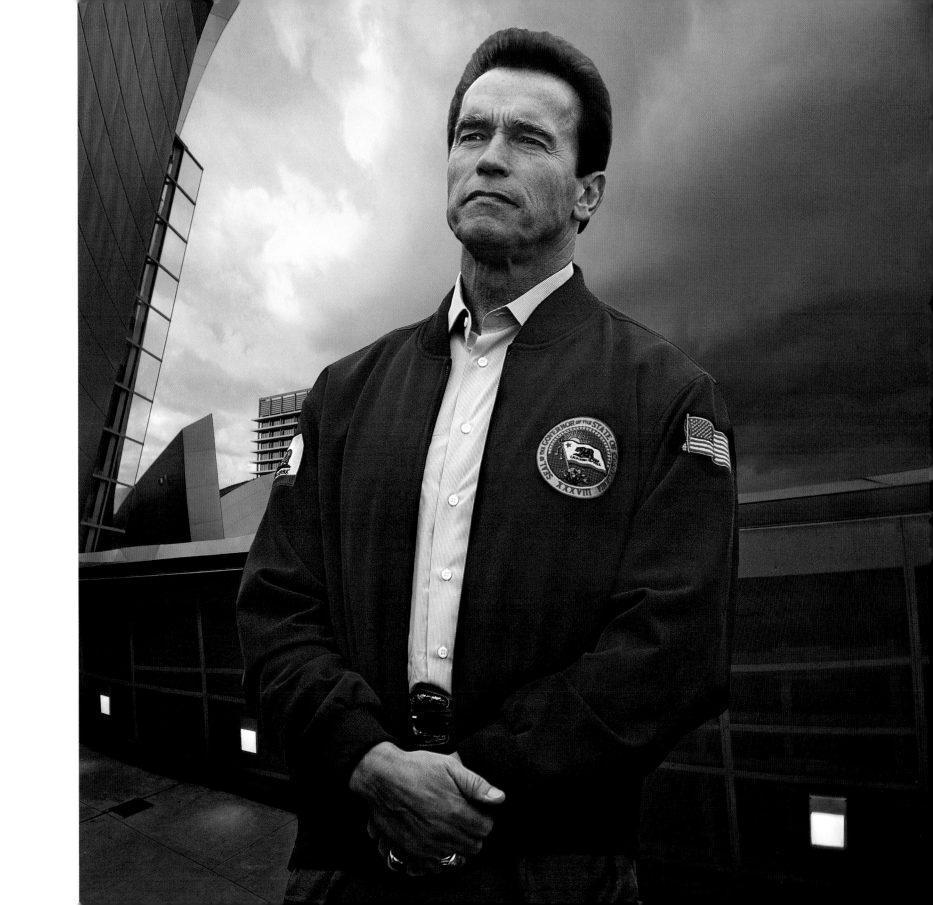

As I ponder and pray in the stillness, I dream as a dreamer of dreams. A steepled church stands before me—a church with open doors. Within it I see the preacher stand; hear his voice in earnest call. But 'tis the throng that flows through the street outside that holds my anxious gaze.

Aimee Semple McPherson was one of the most influential and dramatic evangelists of the twentieth century. Her flair for publicity, piety and pageantry made her an enormous media sensation and beloved Angeleno.

After traveling the country delivering her sermons in tents, Sister Aimee, as she was known, claimed that a message from God compelled her to come to Los Angeles. She arrived in 1922 as a thirty-two year old with a hundred dollars in cash and a dream of becoming a religious sensation. Four years later, her magnetic personality had attracted a large and devoted congregation that contributed more than a million dollars to build her a house and the five-thousand-seat Angelus Temple in Echo Park where she relentlessly pursued her ambition.

Her talent for combining traditional scripture with emotion, sensationalism (speaking in tongues and faith healing), and entertainment (vaudeville routines and dramatic costumes) brought huge crowds to her services, which she filled to capacity three times a day, seven days a week, and turned Sister Aimee into one of the city's biggest celebrities. From Los Angeles, she went back on the road, filling huge cathedrals and civic halls. Her national following throughout the 1920s was tremendous; on average she made the front pages of the country's biggest newspapers three times a week. Not even Charlie Chaplin nor Mary Pickford could equal that. She used every opportunity, from boxing matches to Rose Parade floats, to reach as many people as possible with her message of hope. She wanted to offer everyone access to the privileged relationship with God she claimed to enjoy.

Her private life was apparently not so fulfilling: a series of failed marriages took their toll. In 1926, a personal crisis became an international event when Aimee suddenly disappeared while ocean swimming near Venice Beach. Search parties and mourners crowded the shore. Newspapers and radio stations fed eagerly on the tragedy. A month later, her mother received an alleged ransom note asking for five hundred thousand dollars. The nation was breathless with hope of her safe return. Five days later, Aimee surfaced in a Mexican border town, claiming that she had been kidnapped, drugged and held for ransom in a shack, before escaping through the desert to freedom. But the simultaneous disappearance of Kenneth Ormiston, a radio operator for the Temple, led to the suspicion that she had not been kidnapped at all, but instead had spent the month on a romantic hideaway. The Los Angeles district attorney charged Aimee and her mother with obstruction of justice, but later dropped the charges without explanation.

But still, when Sister Aimee returned home, her celebrity status reached new heights. Some fifty thousand fans packed Union Station to welcome her train as a band played, several hundred honor guards waved gold banners, and an airplane dropped rose petals. As Aimee rode in slow procession to Angelus Temple, another hundred thousand supporters lined the route.

Her popularity continued for more than a decade, helped in part by such "events" as the receipt in 1936 of a blackmail note demanding ten thousand dollars lest motion pictures of her and a friend in the nude be made public. Aimee released a publicity photo of herself piously reading this note, the basis for my photo portrait. Police investigated but could find no blackmailers.

Sister Aimee touched millions of lives, and continued to project the image of a motherly, caring and practical messenger of God until she was found in a hotel room in Oakland in 1944, dead of an overdose of prescription drugs. Her most lasting and real contribution is the Foursquare Gospel Church, now with more than two million members around the world.

■ Born in 1890 as Aimee Elizabeth Kennedy and raised on a farm in Southern Ontario, Canada, in an atmosphere of deep Christian faith and Salvation Army teaching.

■ At age seventeen, was converted to Pentecostalism by a local minister, Robert Semple, and married him soon afterward; widowed and pregnant two years later when he died of dysentery that he contracted while preaching in Asia with Aimee; remarried in her early twenties to Harold McPherson, bore a second child and tried to settle down, but found her devotion to God far more compelling than her devotion to her new husband; tormented by a powerful call to the ministry, gathered her children and struck out on her own as a traveling evangelist.

■ Drew huge crowds to her church services, spread the word with a monthly magazine, became the first woman granted a broadcasting license for her own radio station, and ran a Bible institute called L.I.F.E. (Lighthouse of International Foursquare Evangelism).

AIMEE SEMPLE McPHERSON,
Minister;
Los Angeles, 1936

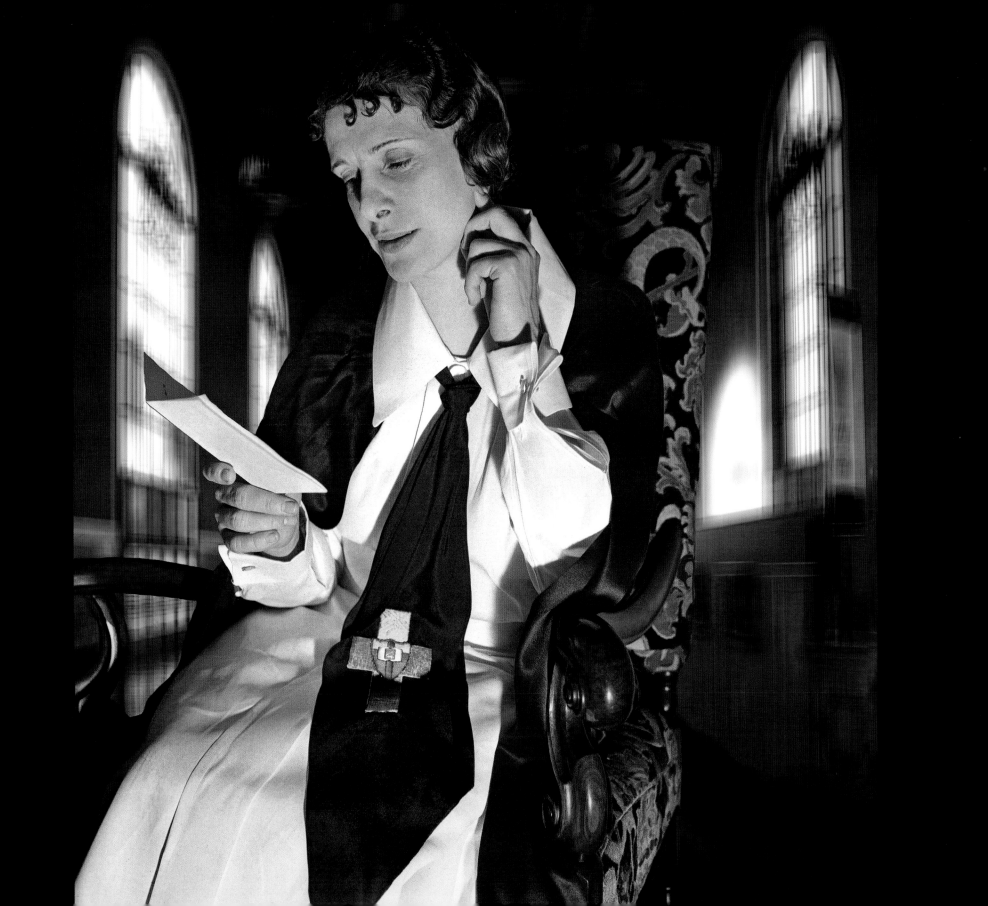

I grew up in a small town in Tennessee and everything I knew about Los Angeles was from watching the Disneyland opening on TV, Annette Funicello beach movies and 77 Sunset Strip. When I came here in 1980, I quickly realized that I was in the middle of something big. I found the same juices that have flowed in all of L.A.'s immigrants: the dream for opportunities, for new beginnings.

Huell Howser is an affable and enthusiastic king of local television, the host of several long-running PBS shows devoted to the unique personality of California—from its monumental natural wonders to offbeat local food joints. His pronounced Southern drawl, and "That's amazing!" pronouncements have made him a memorable and beloved Los Angeles icon.

His career breakthrough came when he sold his half-hour series *Videolog*, about interesting people and places in the Southland, to KCET-TV in 1987. The response was immediate and enthusiastic. Angelenos loved his simple production values (including talking to his cameraman as he walked), upbeat subject matter and heartfelt passion. "One of the main philosophies of my series is that all we have to do is take off the blinders in order to see the diversity, the human stories around all of us," Howser told me. "I don't go to these places with a preconceived notion of what I am going to find. I just let it happen."

Videolog's success allowed Howser to create a formula that he uses to produce and own his shows; he pitches ideas directly to sponsors, gets funded and then secures airtime on PBS stations throughout California. He has had seven series airing simultaneously, including *California's Gold*, *Visiting . . . With Huell Howser*, *Road Trip*, *California's Missions* and *California's Golden Parks*. "My success here exemplifies the California dream. I am the perfect host of *California's Gold*, for instance, because as an immigrant myself, I represent the promise and the opportunity that presents itself to anyone who comes here."

Howser has managed to defy the odds, by not only staying on the air, outlasting other on-camera personalities and trends, but also by avoiding the cynicism that often develops in journalists over time. "I do stories about people and things everyone can relate to," Huell says, "which can encourage viewers to plan their own trip, to talk to their own neighbors, to reaffirm that there are a lot of good things in our state. Sometimes we in the media look so hard for the big stories that we miss the obvious ones that are right in front of us.."

He is often asked why a southerner is hosting a show on L.A. Huell inevitably responds with a brief lecture on our city, first posing the question: "What does someone from Southern California sound like?" Then before the questioner can answer, he points out that his Tennessee roots are no different from those of people from dozens of regions and countries, people who have made our city their home.

Huell sums it up this way: "One of the most satisfying comments I have ever received was from a viewer who told me: 'My mother doesn't even speak English but watches you every night. She just feels good after she watches. People on the show are so nice. And happy.'"

- Born in 1945 in Gallatin, Tennessee, the only son of strict Southern parents—a father who was a lawyer and a stay-at-home mother.

- After attending Southern Methodist University, in Dallas, then the University of Tennessee, began his television career in Nashville, where he covered the local stories on "pigs, people and places," which the serious reporters avoided; rather than feeling dejected to be in the backwater of journalism, instead saw an opportunity to distinguish himself by tapping into the emotional qualities of human-interest topics.

- Moved to L.A in 1980 to do short, two-minute local-interest segments on KCBS-TV's nightly newscast.

- Got a Hollywood agent who found him a job as the host on a dreadful reality show, *The Wedding Day*; fired his agent, started his own production company, and pitched his shows exclusively to the Public Broadcasting Service.

- Has a chili dog named for him at the famous Pink's hot dog stand in Hollywood, and has been parodied in an episode of *The Simpsons*.

HUELL HOWSER, Television Host and Producer; on the roof of his apartment building overlooking Hollywood, 2006

*I am not a rainmaker. The term is too broad. I merely assist Nature.
I only persuade the moisture to come down.*

Charles Hatfield was one of Los Angeles' first folk heroes. A master self-promoter and charismatic dreamer, he gained notoriety by promising to deliver the much-needed elixir of rainwater—or at least the hope of it—to Southern California's desert cities.

At the turn of the twentieth century, Los Angeles had already established itself as a mecca for cults and charlatans. And it was in the midst of one of its droughts. This confluence gave Charley Hatfield the perfect opportunity to achieve his dream of fame and fortune.

By 1902, this smooth-talking promoter who "could talk more and say less than anyone I had ever known," as one local government official described him, had developed a secret mixture of twenty-three chemicals ("the character of which must necessarily remain secret," he insisted) that, when allowed to evaporate in a large outdoor tank, would produce rain clouds—or so he claimed. His first clients were local cattle ranchers. Within a few days of evaporating his formula on Mount Lowe, storm clouds formed over the L.A. basin, producing rain. Although, the weather bureau reports of the day apparently had already forecast the storm, the grateful ranchers were made believers and paid him a hundred dollars. The Rainmaker was on his way to notoriety in his new career.

By 1904, Southern California was facing its worst drought in thirty years. Conditions were so bad that local churches called for a day of prayer for rain on January 31. The following week, Hatfield released his potions; two nights later, the rains came and didn't stop until more than an inch had fallen. The weather bureau called the storm the result of a northern California cloud system that had swung south, but Hatfield's newspaper ads convinced readers that the rain had come through his pluviculture powers.

A few years later, the drought was back. This time, the L.A. City Council came forward to reward the weather magician. They offered him a thousand dollars if he could deliver eighteen inches of rain in the coming year. When the rainfall that year exceeded eighteen inches, Hatfield collected his money and increased his self-promotion. Soon he was being hired by clients all over for such diverse assignments as stopping a forest fire in Honduras and making rain in Texas, Idaho and Kansas. Eventually he claimed five hundred successes.

Hatfield's biggest success nearly proved his undoing. In 1915 the San Diego City Council voted to contract Hatfield for a ten-thousand-dollar fee, payable when their Morena reservoir was filled. Hatfield, with his brother, built a twenty-foot tower and evaporating tank beside Lake Morena, sixty miles east of San Diego, and prepared for the winter rains.

Soon heavy storms began and continued unrelentingly for five days—riverbeds overflowed, bridges were washed out, phone lines pulled down, homes and train tracks were flooded. The Morena reservoir, which had been empty for nearly twenty years, was nearly full. A second storm arrived with worse consequences: the Lower Otay Dam burst, wiping out the town of Otay and killing at least twenty. The disaster came to be known as "Hatfield's Flood." When the rains finally stopped, property owners' legal actions against the city created their own tempest. In return, the City Council reneged on paying Hatfield's fee: "We told you," they said, "merely to fill the reservoir, not to flood the community." The dispute ended up in the courts years later, with the judges ruling that the rains were the result of an act of God.

Experts have since hypothesized that Hatfield's rainmaking successes resulted from a talent for selecting the right periods of high probability for rain, rather than his skills in meteorological chemistry. Still, no one disputes Charley's standing as a dreamer willing to tackle the West's most persistent problem with a solution that created his posse of believers.

- Born in 1875 and raised in Fort Scott, Kansas; moved to Southern California in the 1880s with his family in search of milder winters and a more prosperous life.

- As a young man, was an extrovert who made friends easily; right out of Pasadena High School, tried to enlist in the 1898 war with Spain, but was rejected for being too thin; in his twenties, honed his people skills as a sewing-machine salesman.

- After reading about a climate-changing theory popular at that time called "pluviculture," embarked on a plan to perfect its implementation.

- Among his notable failures was the time in 1906 when he agreed to provide rain in Alaska for the Yukon Territory Council for a ten-thousand-dollar fee. The rain clouds never came.

- The 1929 stock market crash and the Great Depression also collapsed his clients' budgets, and his business never recovered.

- Lived just long enough to see the 1956 Burt Lancaster film *The Rainmaker,* which his story inspired; never one to miss a public appearance, showed up on the bone-dry evening of the movie premiere holding an umbrella.

**CHARLES HATFIELD,
Rainmaker;
Los Angeles, 1935**

*I used my billboards as my agent. From them, my dreams
for success were reached when I become an icon of Hollywood.
Nobody else has become famous for being such a part of city.
My image has become synonymous with Hollywood and Los Angeles.*

Angelyne is a buxom bon vivant who, through self-promoting billboards, has achieved her ambitions: "My dream was to inspire the world to hot-pink, positive energy. And I wanted to get people's attention with my sexuality." With her voluptuous curves, her provocative hot-pink outfits and her pink Corvette, Angelyne has become a celebrity by just being herself.

In a city brimming with celebrities, you have to admire someone who's figured out that you can just advertise your way to fame.

Angelyne's first taste of prominence came in the 1980s when she was in a rock band and first saw herself on a billboard. The sixty-foot photo enlargement must have provoked an epiphany: she realized she could use billboards to hoist herself above the competitive fray of actresses, models and singers. She left the band, but not the billboards.

She refined her public persona with revealing pink outfits, hired a manager to field calls for modeling and appearances, and launched her self-promoting campaign. For the next two decades, she starred in an ongoing series of sultry poses, mostly in West Los Angeles and Hollywood. The signs held no advertising copy—just her manager's number under the big hair and big curves. They were the perfect antidote for the L.A. traffic.

Angelyne added a pink Corvette to her repertory and was regularly sighted tooling around town with her big blond hair, skimpy pink outfits and world-class cleavage.

Everyone noticed the billboards, and wondered who this mysterious model was—and how can she afford all the advertisements? It was long rumored that a wealthy sugar daddy, possibly a husband, was responsible. Some also called to hire her: in her prime in the 1980s and 1990s, she claims to have appeared in more than a hundred movies, a thousand television shows, and hundreds of magazines around the world. I could find a record of only ten films and three television shows, but it's entirely possible that many more were done for overseas markets such as Japan and Europe.

Additionally, Angelyne has recorded four albums, launched a Web site, painted self-portraits in which her eyes are nearly as large as her breasts, and published a few issues of a magazine about herself. This lady certainly has taken self-publicity to new heights, and without a doubt, she did achieve her dream of notoriety.

One of her last successful stunts was running for the governor of California in the 2003 recall election, where she received 2,533 votes with her slogan: "Bigger Breasts Than Any Candidate Except Arnold." For once, Angelyne was selling herself short.

■ Determinedly dodges inquiries about her age and background. My educated guess is that she was born in the late 1940s as Angelyne Sangiorgio in Idaho of Italian-American descent.

**ANGELYNE,
Billboard Model;
Tail of the Pup Hot Dogs,
West Hollywood, 2006**

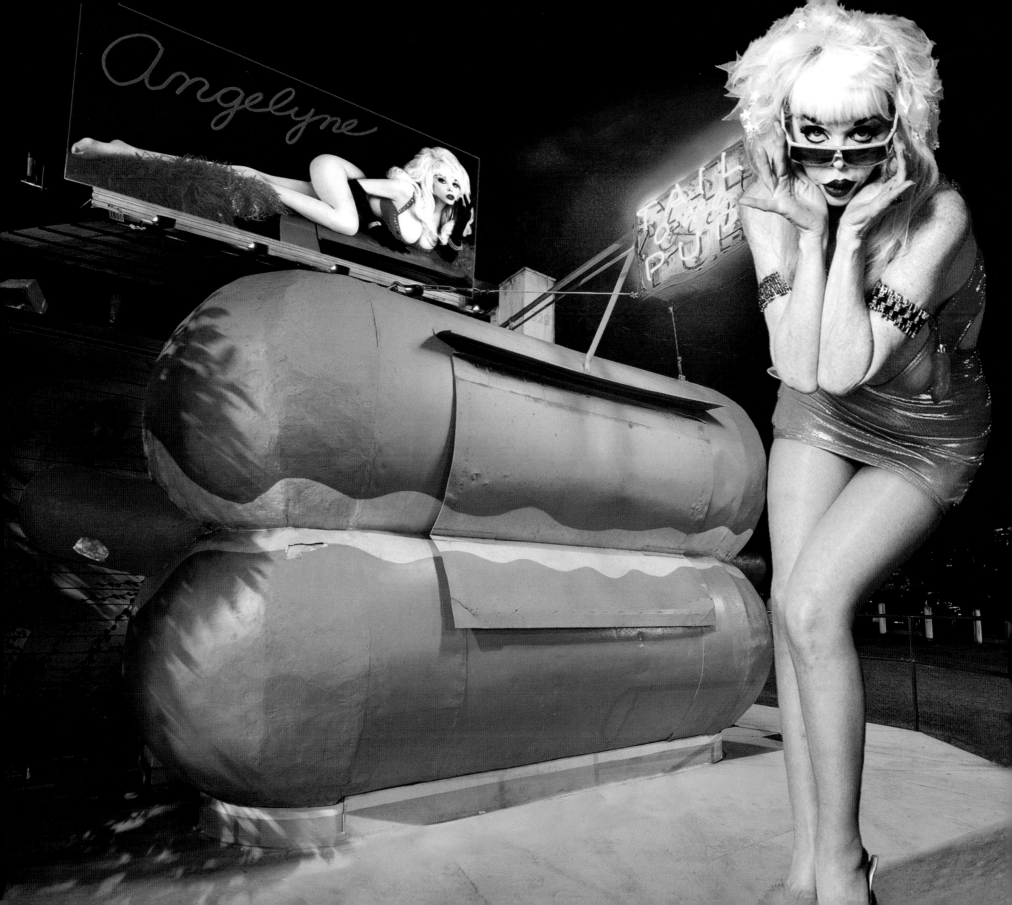

SMALL OR LARGE
WAREHOUSE SPACES
FOR RENT
(213) 626-6000

THE ACTIVISTS

544

THE ACTIVISTS

Helen Hunt Jackson—Author ■ Tom Bradley—Politician, Policeman ■ Andy Lipkis—Environmentalist, Conservationist
Charles Lummis—Author, Editor ■ Ben Caldwell—Arts Educator, Producer ■ Upton Sinclair—Author
Lewis MacAdams—Poet, Author, Environmentalist, Filmmaker ■ Antonio Villaraigosa—Politician

Southern California, like all major urban regions, has been beset with its share of societal and environmental ills, but it has also had more than its share of activists dedicated to improving the region's way of life.

Authors Helen Hunt Jackson and Charles Lummis were among the earliest leaders of social reforms in the Southland. In the nineteenth century they devoted their writing and personal advocacy to alleviating deplorable conditions among the indigenous tribes who'd lost their lands and cultures at the hands of settlers.

The class struggle in the early twentieth century between the industrial owners and the working poor motivated social reformer and author Upton Sinclair to tirelessly organize unions and tell the story in his books.

Post World War II, when the ballooning population fueled various quality-of-life issues such as traffic, crime and racial discrimination, Tom Bradley was a leading reformer who tackled these problems. At the neighborhood level, Ben Caldwell, founder of an inner-city arts and music center, has worked for decades to bring inspiration and opportunity to African American youth.

As rapid growth and urban density take their toll on the Southland, conservationists like Andy Lipkis, who founded TreePeople, and Lewis MacAdams, the founder of Friends of the Los Angeles River, have spent their lives committed to solving the environmental challenges.

My journey to explore the life of Charles Lummis, the city's first important journalist and activist, took me to the San Gabriel Mission. In 1884, Lummis arrived there at the completion of his epic 3,500-mile solo trek on foot from Ohio to Los Angeles. He was welcomed by my own great-great-grandfather, Harrison Gray Otis, who had been publishing Lummis' dispatches from his 143-day journey in the *Los Angeles Times*. After some refreshments, the two walked side by side into the City of Angels, then just a dusty pueblo of twelve thousand citizens, where Harrison treated Charlie to his first big meal since leaving Ohio. The following day, Lummis started a job as the first city editor of the four-page *Times*, and launched decades of activism on behalf of Southern California's native and Hispanic people and culture, including founding the first group to restore then-decrepit missions.

My quest to learn about Helen Hunt Jackson led me to the Santa Clarita Valley and the historic Rancho Camulos adobe, which she used as the home of the title character in her best-selling novel *Ramona*, Southern California's most popular book in the late nineteenth and early twentieth centuries. Visiting the Rancho Camulos, with its thick adobe walls and picturesque courtyards, evokes the simple yet romantic times of early California when Hispanic tradition brought the chivalry, fiestas and grace captured in *Ramona* to the untamed landscape. Although Jackson's hope for her novel was to awaken the public to the mistreatment of the native tribes, its lasting appeal derives more from romanticized descriptions of activities in the early California ranchos.

Mayor Antonio Villaraigosa grew up in an East Los Angeles neighborhood called City Terrace, a place right next to the San Bernardino freeway that I had passed dozens of times but had never visited. This working class area probably hasn't changed much since he spent his early days here—small stuccoed homes with tiny all-concrete yards, kids playing in the streets, families trying to make ends meet. From the hill above his childhood home, there is a great view of downtown L.A. and its City Hall. Growing up in this challenging environment, Tony Villar never imagined that he would one day run his hometown.

As fate would have it, the day we scheduled for the photo shoot turned out to be the same day the mayor's meteoric political career showed its first signs of vulnerability. The story had just broken about his affair with a local newscaster. Although Villaraigosa was separated from his wife, Corina Raigosa, the public and media reaction to the news was incendiary. Our session had to be postponed, and when we did get together two weeks later, his self-confidence was still a little shaky, but he made the time and effort to let me get the photo and interview I wanted.

My interest in Upton Sinclair, the prominent author and socialist from the first half of the twentieth century, led me to Myrtle Avenue in Monrovia and to the impressive Spanish Colonial house where he lived and wrote from 1942 to 1966. No longer open to the public, the house, from the outside at least, appears to be a surprisingly luxurious residence for a die-hard socialist. My conservative ancestors, who fought hard to preserve the Southland as a bastion of industrial freedom and to keep the *Los Angeles Times* an open shop, are likely rolling over in their graves at my inclusion of Sinclair in my book. I'll concede that my admiration is for his contributions as a writer and social reformer, rather than his radical politics.

I first met Los Angeles' first African American mayor, Tom Bradley, during

the 1984 Los Angeles Olympics, which proved to be a gold-standard-setting event, and one of which he was naturally proud since he secured it for the city. What I hadn't expected from all the television coverage I had seen was Bradley's ability to turn on the personal charm. I saw him again at an event marking the twentieth anniversary of the Music Center. I was in my thirties and filling in for my grandmother Dorothy, who was bedridden and unable to attend. The mayor delivered a powerful speech, and following such an eloquent man at the podium on the stage at the Mark Taper Forum made me even more nervous than usual. I managed to get through my speech, and Tom made a point of coming up to me afterwards to compliment my presentation. Although he didn't say it, I got the impression that he knew exactly how nervous I was, and he also proved to me what a classy guy he was.

Leimert Park is an historic and vibrant African American neighborhood in the Crenshaw district of Los Angeles. Called the "black Greenwich Village" by resident and filmmaker John Singleton, the area is alive with jazz clubs, art galleries, and museums, and since the mid-1980s, a community arts center run by a vivid and enduring figure, Ben Caldwell. While he may not have the renown of some of the other activists included here, I found him to be just as dedicated and admirable, a man who has made an incredible impact on the city. Overlooking shady Leimert Park, his arts center is a non-stop hub of music, art, filmmaking and more. Ben keeps it all moving forward with a hipness and purpose earned from decades of inner-city cultural entrepreneurship. He traded his dream to be a filmmaker in Hollywood for a more satisfying dream of making it in the "hood," earning humanitarian and psychic riches rather than residuals and net profits.

Since founding TreePeople thirty-four years ago, Andy Lipkis has supervised the planting of two million trees in Southern California. The day I went to photograph him at his headquarters on a hidden gem of parkland just off Mulholland Drive above Beverly Hills, hundreds more seedlings in containers were parked awaiting homes. As if anxious to get all those trees planted, he could barely sit still as he spoke about the many opportunities for improving the urban environment. Our planned twenty-minute interview and photo session turned into more than an hour. His enthusiastic pitch for improving Southern California's forests, air and water was extraordinarily compelling. When he finally had to return to work, he tried to summarize his mission:

"My dream is to make a healthy and sustainable city. Working in partnership with nature, we *can* help nature heal this city."

My photo session with the legendary Lewis MacAdams, founder of Friends of the Los Angeles River (FoLAR), entailed an adventurous tour of the river. Our first point of entry near Griffith Park required sliding down a steep bank, bushwhacking through dense willow trees, and wading through two-foot tall kudzu-type plants to reach open water. By then our street shoes had filled with water and mud. Lewis was unfazed. He gestured to the running river and spoke about the years of effort he has given it and the affection he has for this historic lifeblood of the city. As a small harbinger of his effectiveness, he proudly announced that carp were now living in the river in quantities that allow them to be fished.

Then with squishy, wet feet, we headed downtown and drove into a concrete tunnel under the Sixth Street Bridge, which ends just above the riverbed. The passageway had been claimed as a living space by what looked like a permanent population of the homeless. Even Lewis appeared nervous as we left my car at the river's edge and descended through the garbage and muck toward the middle of the flow, where the final photo was taken. Ignoring the hazards, he continued to proselytize for the restoration of the river. Later I learned that his impassioned advocacy has helped propel an historic civic effort that is planning to remove sections of the river's concrete, restore its habitat and build adjacent parks and bike paths.

All the individuals profiled here have dreamt of a better future for Southern California and worked indefatigably to achieve it. Their selflessness makes them some of the most inspirational individuals I have ever encountered. I hope they can touch your hearts as they have mine.

I did not write Ramona; *it was written through me. My lifeblood went into it—all I had thought, felt and suffered for five years on the Indian question.*

Helen Hunt Jackson was a proliflc writer and devoted advocate for Native American rights. Her historical novel, *Ramona*, became Southern California's flrst bestseller and its most enduring classic.

It wasn't the pleasing climate or palm trees that made the greatest impression on this New England writer when she first saw Los Angeles in 1873—it was the impoverished state of the Native Americans that she met. Once ignited, her activism was unstoppable. She spent the next few years documenting the U.S. government's mistreatment of native people for a survey she published called *A Century of Dishonor*. She sent a copy to each member of Congress with the chastisement: "Look upon your hands: they are stained with the blood of your relations," printed in red on the cover.

She returned to Los Angeles from the nation's capital as an appointed agent for the Department of the Interior, assigned to ascertain the conditions of the local Mission Indians. With the assistance of entrepreneur Abbot Kinney, she visited many tribal villages, finding case after case of injustice, discrimination and poverty. Her fifty-six-page report, completed in 1883, called for the government to purchase new reservation land and build more schools and hospitals. The U.S. Senate passed a bill that contained many of her recommendations, but it never made it through the House. Undaunted, Jackson aspired to find another way to bring help to the Native Americans. She decided to turn to storytelling, encouraged by the success of her friend Harriet Beecher Stowe, who rallied public sympathy for African Americans with her bestseller *Uncle Tom's Cabin*. "If I can do one-hundredth part for the Indian that Mrs. Stowe did for the Negro, I will be thankful," Jackson wrote.

A visit to Rancho Camulos (pictured behind her in the photo) in the Santa Clarita Valley, one of the last remaining Spanish homesteads where the authentic early California lifestyle still existed in all its gracefulness and simple splendor, inspired her to concoct the tragic love story of an orphaned Mexican American beauty named Ramona who falls in love with a handsome Native American sheep shearer named Alessandro. Woven into the plot were multiple accounts of the persecution of the natives culled from real life incidents. While she was writing the novel, Jackson continued to lobby Congress, finally securing a reservation for the Mission people.

When her novel *Ramona* debuted in 1884, the book's compelling love story and romanticized depiction of the early Spanish period of the Southland, rather than the suffering of the Indians, made it an instant hit. Just as *Ramona* was beginning to sweep the country, the fifty-four-year-old author contracted a blood disease that proved fatal.

Hunt's novel went on to become so popular that for decades afterward, hundreds of thousands of tourists descended upon Los Angeles eager to see the sites described in *Ramona*. Union Pacific built a rail stop at Camulos so fans could disembark. Nearly forty years after the novel first appeared, an enormous musical pageant based on *Ramona* debuted in an outdoor amphitheater in Hemet, the site of several scenes in the novel, with more than four hundred actors, dozens of horses, and intricately staged gunfights and stunts. Still held over three weekends each spring, the pageant is the largest and longest-running outdoor play in U.S. history. Her novel has also been adapted to film five times, the first being D.W. Griffith's legendary 1910 version, and was adapted for television in Mexico in 2000. The name Ramona can still be seen on street signs and commercial establishments throughout Southern California.

- Born Helen Fiske in 1830; raised in Amherst, Massachusetts, by a minister father who was an Amherst College professor and a mother who was a writer; both died while Helen was a teenager; attended boarding schools in New York where she became lifelong friends with schoolmate Emily Dickinson, the poet; at age twenty-two, married U.S. Army Capt. Edward Hunt, who died eleven years into the marriage; bore two sons, one of whom lived less than a year and the other died in his early teens.

- Moved to Newport, Rhode Island, to pursue a writing career, using the pseudonym "H.H." to conceal her female identity; became one of the most prolific authors of her day, publishing thirty books of children's stories, fiction, travel sketches and poems, plus hundreds of articles and essays; was dubbed "the greatest woman poet of the day" by fellow writer Ralph Waldo Emerson.

- Inspired by a speech given by the chief of the Ponca Indians, began the life of an activist, writing letters, petitioning, and fundraising for Native Americans.

- Married a banker and railroad executive, William Jackson, whose wealth allowed her the freedom to come west to more zealously pursue her writing and activism.

HELEN HUNT JACKSON, Author; in front of the Rancho Camulos adobe, the inspiration for the setting of her novel, *Ramona*, 1882

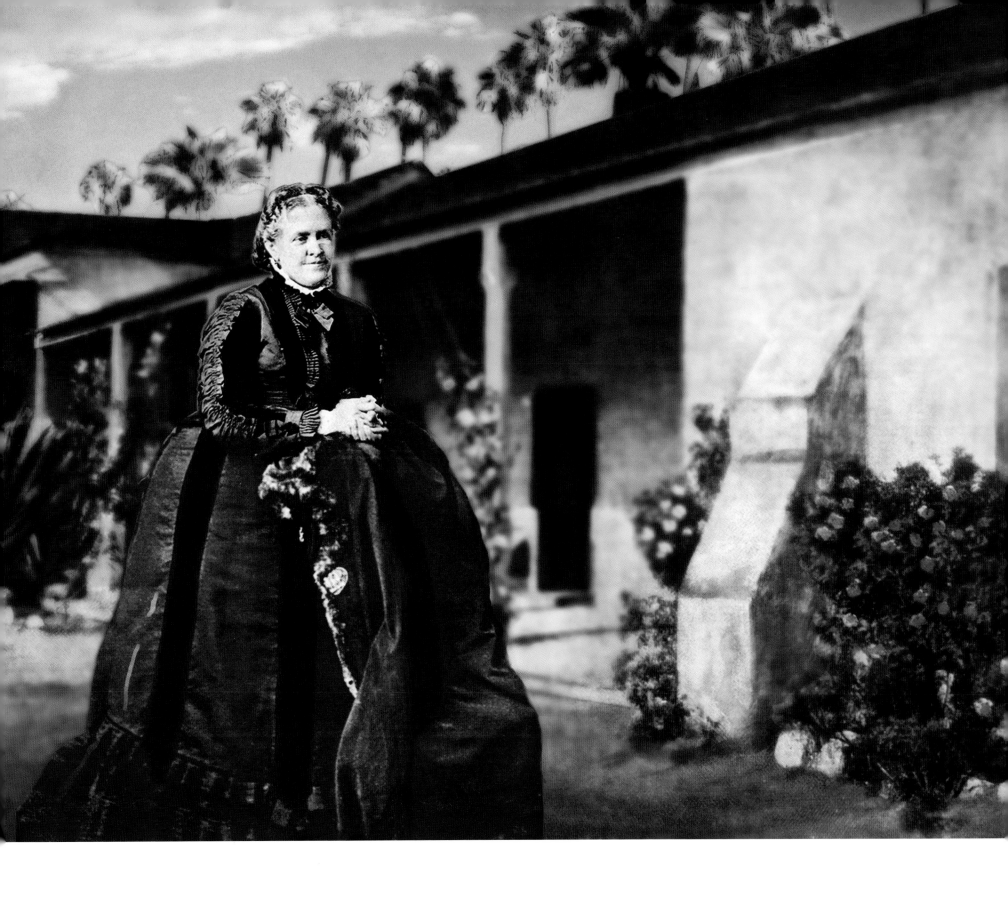

People cut themselves off from their ties of the old life when they come to Los Angeles. They are looking for a place where they can be free, where they can do things they couldn't do anywhere else.

Tom Bradley, as a twenty-one-year veteran of the police force, two-term councilman and five-term mayor, helped to reshape Los Angeles in the latter half of the twentieth century.

His entire life was a series of firsts. After setting multiple precedents in high school and college, he pioneered a path for others when he became the L.A. Police Department's first African American lieutenant. He then earned a law degree, but turned down a lucrative career as an attorney to remain in the department to solve some of its internal issues, including racial segregation. "When I came on the department, there were literally two assignments for black officers," he later told a reporter. "You either worked Newton Street Division, a predominantly black community, or you worked traffic downtown . . . You could not work with a white officer."

In 1963, urged by colleagues from a liberal Democratic club he had joined, Bradley ran for the 10th District City Council seat, centered in the multiethnic Crenshaw area, where the majority of voters were white. At forty-six he became the first African American elected to the Los Angeles City Council. Two years later, when the city erupted with the Watts riots, Bradley played a key leadership role by helping the city regain its calm, calling for reforms in the wake of the LAPD's flawed handling of the crisis, and aiding the inner-city communities that had erupted.

Bradley believed that his vision for improving the city could be realized as mayor, so in 1969 he challenged incumbent Sam Yorty for the city's top job. Although he was leading in the polls and media endorsements, Councilman Bradley lost the election to a wily Yorty, who used last minute race-baiting and scare tactics to come from behind. Four years later, Bradley ran again, this time successfully, and went on to become a legend in the city's history.

During his five-term, twenty-year era as mayor, Bradley was at the helm of momentous changes, as Los Angeles grew to become the second-most-populous U.S. city. But he remained a low-key leader rather than a publicity seeker, preferring persistence to style, behind-the-scenes negotiations to press conferences, and hard work to headlines. He worked tirelessly to position the city for growth: presiding over harbor and airport expansions (the international terminal at LAX was named in his honor), traveling the globe to push for international trade, launching the subway and light rail systems, and leading massive redevelopment that included a shopping center in Watts and the downtown arts district. During his tenure, he twice ran unsuccessfully for California governor, losing by less than one percent on the first attempt.

Arguably the city's most shining moment in the late twentieth century—the 1984 Summer Olympic Games—was the result of Bradley's leadership in bringing the event to town and helping to ensure its success. With traffic and crime nearly non-existent, lampposts awash in colorful banners, and the polished execution of the Games, the city showed itself off as the gold medalist in the role of fiscally responsible and accomplished Olympics host.

Throughout his career, Tom Bradley built bridges between races, religions and cultures, without ever losing his connection to his African American constituents.

- Born in 1917 in Calvert, Texas, the oldest son of sharecroppers and the grandson of a former slave; picked cotton with his parents until his family moved to Los Angeles in 1924 where his parents found steady work, his mother as a maid and his father as a railroad porter.

- Excelled as an athlete in football and track, and as a scholar, becoming the first black to be elected to president of the Boys League and inducted into a national academic honor society; earned an athletic scholarship to UCLA, where he starred on the track team and in his studies.

- Joined the L.A. Police Department in 1940.

- Earned a law degree at night at Southwestern University School of Law; married Ethel Arnold, whom he had first met at a Baptist church, and fathered two daughters.

- Was reprimanded in 1989 for accepting a consultancy fee from a Los Angeles bank that received an unexplained two million dollars from the City.

- Public criticism of the police response during the 1992 Rodney King riots led to the removal of his nemesis, Police Chief Daryl Gates, but the damaging event set back his own agenda for growth and inter-racial cooperation, ultimately prompting him to retire from office.

TOM BRADLEY,
Politician, Policeman;
on his first day in office,
Downtown, 1973

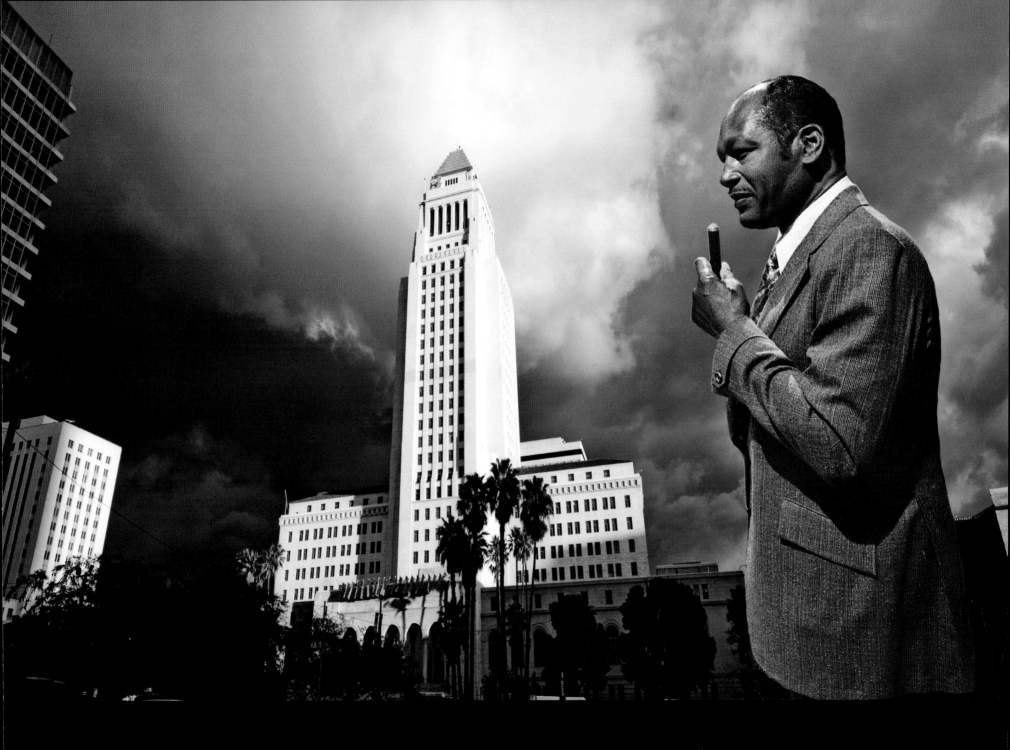

We have the ability to retrofit L.A. to function as a watershed; to capture rainwater in cisterns and use ground water recharging. We can prevent floods, reduce up to half of the water we import, save gobs of energy and make a more climate-resistant city. Transforming the city, that is my dream.

Andy Lipkis is one of the most persuasive, inspirational and knowledgeable do-gooders ever to inhabit Los Angeles. His success in planting two million trees as the founder of TreePeople is just one facet of this remarkable friend of the environment.

He found the catalyst for his life's mission at age fifteen. "My parents sent me to summer camp in Big Bear, where I grew to love the forests," he recalls. "The Forest Service announced that part of the forest there was dying due to smog and would be gone by the year 2000 unless something was done. So I decided to do something." He organized fellow campers in bathing suits to turn a patch of bare and polluted land into a meadow with smog-resistant trees. The trees they planted, he learned, would not only survive in the smog but also help to reduce it.

While at college, Lipkis led a movement to rescue and plant eight thousand seedlings. During the frantic effort, Andy and his band of volunteers were dubbed the "tree people." The name stuck, and in 1973, Lipkis started the non-profit organization TreePeople to continue his tree-planting dreams.

TreePeople quickly became a pre-eminent force in the urban forestry movement and a major source of environmental education. To celebrate the 1984 Olympics in Los Angeles, Andy audaciously vowed to lead a campaign to plant a million trees. He convinced Mayor Tom Bradley to usher in a military convoy that contained one hundred thousand seedlings. Andy eventually reached his million-tree goal. Since then, a million more trees have been planted and maintained by fifteen thousand members and volunteers.

TreePeople's reach goes well beyond the Southland—it has helped foster more than two hundred tree-planting groups world-wide, and overseen a program to airlift bareroot fruit trees to Africa.

Andy's other cause is water conservation. "What's the value of water we throw away? Five hundred million dollars a year! That's half of L.A.'s entire budget!" he points out. "Twenty percent of the state's electricity goes to move water down to Southern California. The opportunity to recapture water and money here is there for the taking. Planting more trees is part of the solution: a hundred-foot oak tree can hold up to fifty-seven thousand gallons of runoff, clean it and send it down to the deep aquifers for storage."

Andy is not just dreaming about water conservation solutions, but starting to implement them. He speaks passionately of Tree-People's Westchester pilot program for a passive collection system. "It has one hundred twenty-thousand-gallon storage tanks built underneath school playgrounds. Kids helped design it. It captures its own water. Every school, every neighborhood, every home could be retrofitted to do the same."

Lipkis' vision for healing the city through intelligent management of its own natural resources is proving prescient: city engineers—and even the mayor—are finally working on initiatives to do exactly that.

■ Grew up in the 1950s in Southern California; wrote his first press release at age twelve while working for Eugene McCarthy's 1968 presidential campaign; the same year, set up a sidewalk recycling center outside his suburban home.

■ While at college in Sonoma, learned that the California Department of Forestry planned to dispose of thousands of seedlings; convinced a *Los Angeles Times* reporter to pressure the governor's office to intervene; days later, when eight thousand small trees were delivered to the driveway of his rented house, scavenged thousands of milk cartons in which to keep them alive, got the *Times* to run another story, this time containing a plea for donations; received hundreds of letters with ten thousand dollars in gifts, enough to purchase thousands more trees, hire trucks to move them to three Southern California forests and solicit volunteers to help plant them.

ANDY LIPKIS,
Environmentalist,
Conservationist;
at TreePeople headquarters,
2007

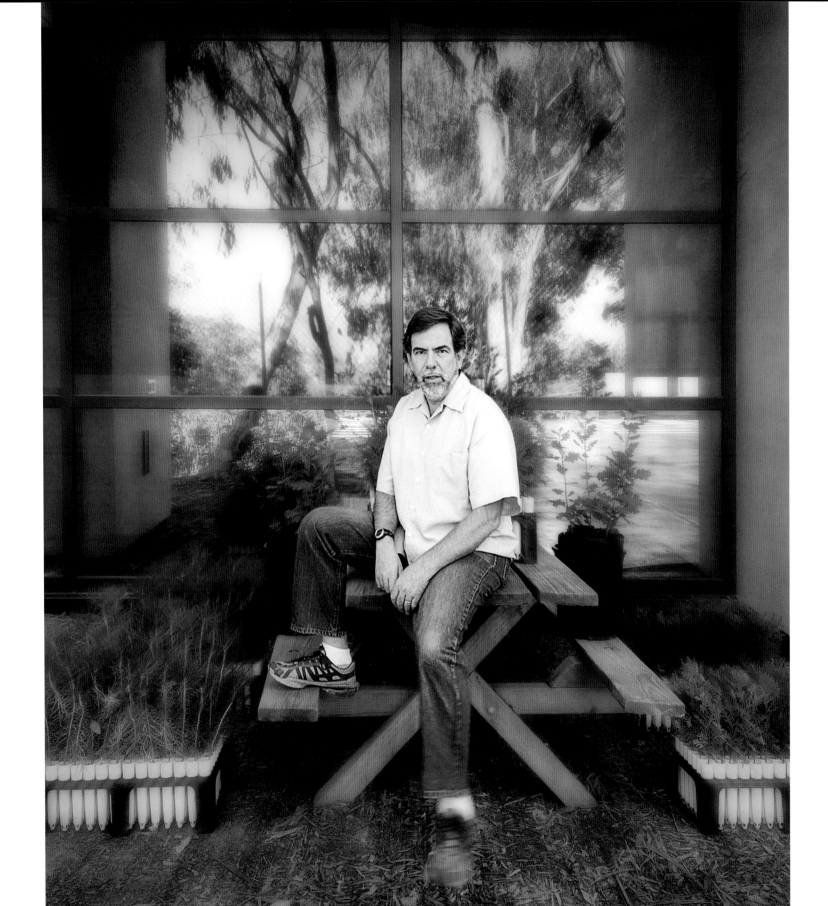

The great lesson I learned is that man was meant to be and ought to be, stronger than anything that can happen to him. Circumstances, Fate, Luck are all on the outside; and if he can't always change them, he can always beat them.

Charles Lummis

Charles Lummis was the turn-of-the-century Renaissance man: journalist, author, civic and Native American activist, library leader and founder of the Southwest Museum. Typically attired in his trademark well-worn green corduroy suit, soiled sombrero and red Navajo sash, Lummis was one of the most colorful and well-known personalities of his day.

At twenty-five, as a nature-loving journalist living in his wife's Ohio home, he decided upon his first great adventure: walking from his home to the office of his new job as the first city editor of the new *Los Angeles Times*, wiring dispatches along the way.

In 1884, he set off on his dangerous trek across an untamed continent. Along the way, he suffered debilitating blisters and a broken arm, was held up at gunpoint by bandits, nearly perished in the snows of New Mexico, and encountered wild bears, marauding Indians, and an entire colorful mélange of western characters and landscapes. By the time his journey ended 143 days and 3,500 miles later, Lummis had fallen in love with the Southwest and its Spanish and Native American inhabitants. His subsequent book of his escapades, *A Tramp Across the Continent*, gained him a national following.

Through his personal advocacy and his writing at the *Times* and in *Out West* magazine, Lummis established himself as a leading crusader for various local causes. He started a group to restore the California missions, which had been largely left to ruin; fought for recognition of Spanish American contributions to the city; created a travel campaign and slogan to "See America First" and formed a new Indian rights group called the Sequoya League. He used his personal relationship with Harvard-chum President Theodore Roosevelt to force the U.S. Department of Indian Affairs to change its policies, including one that required forcibly cutting the hair of native men on reservations. He also helped secure a new home in Palm Springs for a small band of Indians who had been evicted from their Warner Hot Springs homeland.

Using local stone, Lummis hand built an attractive home for himself, calling it El Alisal for the giant sycamore that grew beside it. His house became the scene of constant parties for writers, artists and dignitaries, often with Spanish dancing and music performed by a private troubadour. Today El Alisal houses the Historical Society of Southern California and is open to the public.

Eventually, the hard work and socializing took their toll on Charlie—he became a drinker, a womanizer, a manic-depressive and destitute. His two marriages crumbled; his second wife, Eve, accused him of having had as many as fifty affairs.

El Cabesudo (the hard head), as he was nicknamed by the natives, was not inclined to lose his courage or intellectual curiosity for long. He sobered up and managed to found the Southwest Museum, imbuing it with his collection of Native American artifacts. He took up his pen again, reworking one of his earlier books, *Some Strange Corners of Our Country*. He renewed his advocacy on behalf of the older cultures of the Southwest. All the while, his door at El Alisal remained open to visitors or people in need. The photo here was taken in the library at El Alisal when Lummis was sixty-nine. Only months later, the colorful tramp was dead.

- Born in 1859 to a well-to-do family in Lynn, Massachusetts; lost his mother to disease when he was two; raised and home-schooled by his schoolmaster father; excelled at Latin, Greek and rhetoric, and enrolled in Harvard University; was a classmate of Theodore Roosevelt; too restless to finish, dropped out during his senior year.

- Constant assignments at the *Los Angeles Times* led to a mild stroke that temporarily paralyzed his limbs and forced him to resign his newspaper job after only two years; continued to write regular columns for the paper throughout his career.

- Became a prolific freelance writer, concentrating on stories about the Southwest and Indian cultures; received a reprisal of a load of buckshot after one article about corrupt and murderous locals.

- Hired as editor of a regional magazine, *Land of Sunshine* (renamed *Out West*), which published works by authors such as John Muir, Jack London and Mary Austin; built it into the Southwest's premier magazine, writing more than five hundred articles himself.

- Appointed head of the L.A. Public Library in 1905; converted it into one of the foremost systems in the country, introducing postgraduate library training, a research and western history department, and an archive of sketches and photographs of the state's leading citizens.

CHARLES LUMMIS,
Author, Editor;
Pasadena, 1928

I wanted to be the one who was a true believer, who stayed in the community, who helped our youth. And I have. That has been my dream.

Ben Caldwell has presided over a corner of South Central Los Angeles for twenty-three years, running an arts organization and cultural center to bring training, creative immersion and hope to the inner-city African American community.

Caldwell came to L.A. with a dream of making it in Hollywood. Instead, he found his true calling a few miles down the road, but light-years away on the psychic highway.

After working briefly in the movie business, he retreated to Washington, D.C., to teach film at Howard University. The professionalism at the predominantly African American college inspired him. "It was the first time I had seen a black institution that was so well organized. They had better facilities and classes than UCLA," he observed. "It showed me what was possible." But the stodginess of some administrators and policies made him restless. "One day this eighty-year-old administrator at Howard said to me: 'Young man, if you don't like this institution, why don't you start your own!'" The call to action hit a nerve, and Caldwell returned to L.A. with a dream to do just that. He settled in the Leimert Park neighborhood of the Crenshaw district, where there were few places for youth to escape the plague of gangs and drug use, and set about starting his own answer to the problem.

Across the street from the area's namesake park, he leased two adjacent stores and, in 1984, opened his storefront cultural center, the KAOS Network. Under his direction, the center offered filmmaking classes, art and music programs, and supervised drop-ins at a hands-on studio. "We were incubating ideas, working with other artists—filmmakers like Charles Burnett and Julie Dash, and hip-hop artists like Journalistic 5, Black-Eyed Peas, Pharcyde, Yoyo, Lebo M, and Freestyle Fellowships," Ben explained. KAOS was an instant success, gathering credibility as a happening place to learn and appreciate the arts.

In 1994, Caldwell expanded the KAOS Network mission, partnering with Aceyalone, a key figure in the legendary L.A. hip-hop group, the Freestyle Fellowship, to start Project Blowed, a weekly open-mike session for hip-hop emcees and performers from all creeds and cultures. Every Thursday night, the corner building cranked up the volume and turned into what has been described as "a gladiator school for MCs," bringing together the most gifted and diverse hip-hop artists. Blowed has launched the careers of such talents as C.V.E., Ellay Khule, Busdriver, and Pigeon John.

When I visited twenty-three years later, Ben's enthusiasm was still going strong and KAOS was still smokin'. Each week, more than 150 young people—painters, graffiti artists, documentary filmmakers, singers, dancers, deejays and emcees—were learning new technologies and skills.

Ben has managed to make KAOS self-sustaining with a minimum of governmental funding and has worked to ensure its continuity by buying the center's buildings and by bringing in a new generation of teachers and leaders. "KAOS is an oasis within our community," he declares.

- Born and raised in Arizona in the 1950s; enrolled at UCLA in 1971 to get his masters in filmmaking; for his thesis, did an experimental film based on a poem by jazz great Wayne Shorter.

- While at UCLA, landed internships at Columbia Studios with studio head Peter Guber and then at Ralph Bakshi Productions, animator of classics like *Fritz the Cat* (1972), *American Pop* (1981) and *Cool World* (1992); became disillusioned by mainstream Hollywood: "Seeing that the black community was only being used as tokens, seeing the blaxploitation junk that was getting made, and seeing all the closed doors, I learned I didn't want to do the big Hollywood thing."

- Established a base in Leimert Park, an African American cultural hub, with galleries exhibiting artists such as Carrie Mae Weems, Alonza Davis and Betye Saar.

BEN CALDWELL,
Arts Educator and Producer;
Leimert Park, 2007

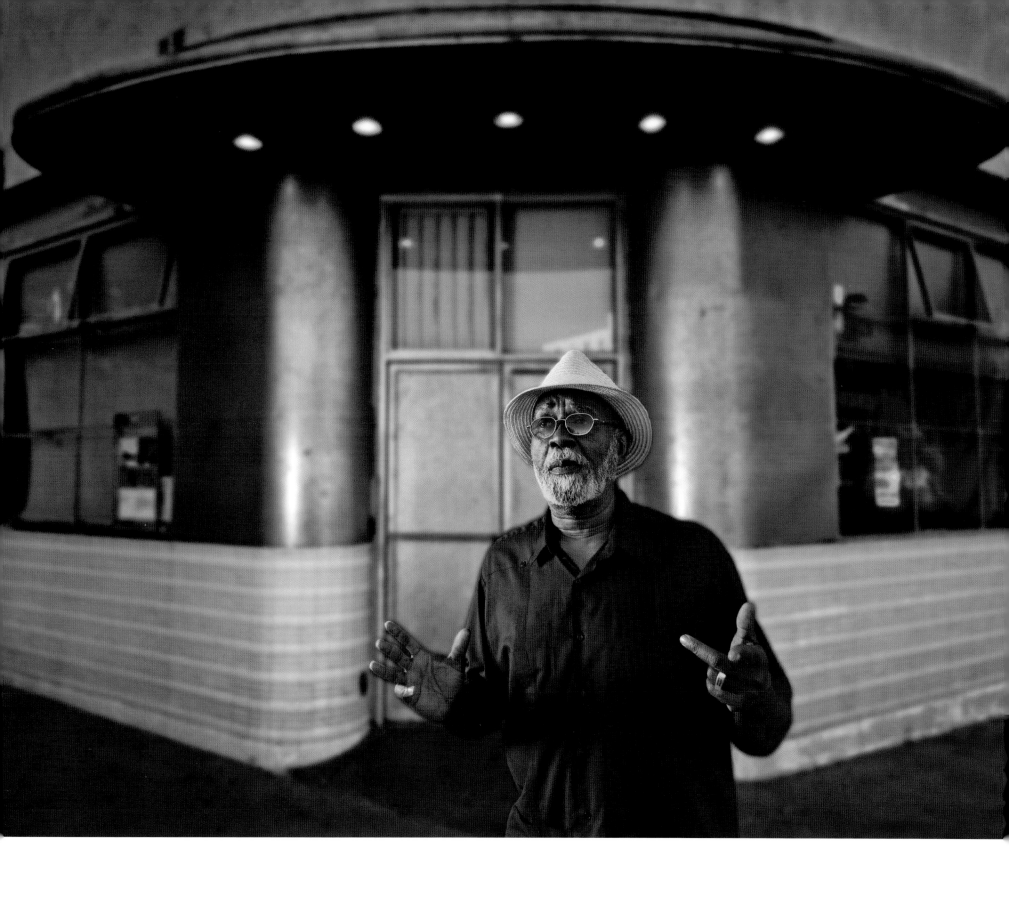

The proletarian writer is a writer with a purpose; he thinks no more of "art for art's sake" than a man on a sinking ship thinks of painting a beautiful picture in the cabin; he thinks of getting ashore— and then there will be time enough for art.

Upton Sinclair was a tireless social crusader and author of more than ninety books. He was a rare combination of passionate reformer and acclaimed novelist, who nearly was elected governor of California in 1934.

After writing professionally since the age of fourteen, he ironically deemed his first book a failure. That book, *The Jungle*, a 1906 muckraking novel, exposed the contaminated conditions in the meatpacking industry, and endures as his most successful. His goal had been to call out the inequities for the wage earner under capitalism, yet readers were moved instead by his descriptions of the unsanitary factories that produced the country's beef products. "I aimed at the public's heart, and by accident I hit it in the stomach," he complained. That lament would reoccur through his prolific writing career: his carefully constructed plot lines and vivid characters would often overwhelm the socialistic sentiments that he weaved into his stories.

After losing his first wife to a utopian commune, the thirty-seven year old Sinclair found a new bride and moved west to Pasadena for a fresh start. Although Southern California in 1915 had some harsh conditions for the working class, it was a breath of fresh air for this eastern urbanite, offering a more tolerant climate for new ideas. Sinclair founded the state's chapter of the American Civil Liberties Union and started writing again. The first novel he penned in Los Angeles was *Oil!*, the story of an oil wildcatter and a poor goat herder (which was adapted into the 2007 movie, *There Will Be Blood*).

While continuing to press for change using his pen, Sinclair decided to pursue a more direct route to helping the working class by attempting to get elected to public office. He ran on the Socialist ticket, first for a U.S. Congressional seat, then the Senate, and then for governor, never attracting more than a small but committed minority following. Undaunted, he felt that the publicity his candidacy brought to the causes he touted justified the efforts. Having resigned from the Socialist party in the late 1920s, Sinclair became a Democrat and, in 1934, ran for governor again, this time on a more centrist platform known as the End Poverty in California Movement. He set out his policies in a book with the confident title *I, Governor of California and How I Ended Poverty: A True Story of the Future*. Conservatives, led by my great-grandfather, Harry Chandler, then publisher of the *Los Angeles Times*, were not convinced that his socialist days were in the past and bitterly opposed him. Sinclair ended up coming in second, earning thirty-seven percent of the votes and a good lesson about voter perceptions. "The American people will take Socialism, but they won't take the label," he remarked later about his two gubernatorial bids. "Running on the Socialist ticket I got sixty thousand votes, and running on the slogan to 'End Poverty in California' I got 879,000." After this defeat, Sinclair returned to writing. His next book was humbly titled *I, Candidate for Governor and How I Got Licked*.

In 1940, Sinclair shifted his writing into a new direction for literature with an innovative device of mixing fact and fiction, social commentary and drama. His eleven-volume *Lanny Budd* series of historical novels featured a protagonist who traveled the world and came into the middle of key moments in history to interact with such real-life leaders as Adolf Hitler, Hermann Göring, Franklin Roosevelt, Georges Clemenceau, Lloyd George, Woodrow Wilson and Benito Mussolini. The Budd novels won instant and continuing praise from many quarters. One of the books, *Dragon's Teeth*, about the rise of Nazism in Germany, won the Pulitzer Prize for fiction in 1943.

- Born in 1878 in Baltimore, Maryland, to a poor, alcoholic father and a mother who came from wealth; moved to New York City at age ten, and entered New York City College at age fourteen, funding his education and supporting his parents by writing stories for newspapers and magazines; at nineteen, transferred to Columbia University, while writing one action story a week for various boys' weeklies.

- After college and marriage to his first wife, Meta Fuller, embarked on his lifelong passion to help the working class.

- His breakthrough novel, *The Jungle*, caused President Theodore Roosevelt to demand an investigation of the meatpacking industry, which led to the passage of the Pure Food and Drug Act and the Meat Inspection Act of 1906.

- While writing *Boston*, a non-fiction account of the Sacco-Vanzetti case, faced what he would later call "the most difficult ethical problem of my life;" committed to the Socialist stance that the two men were innocent heroes of the class struggle, was told in confidence by the men's former attorney that they were guilty and had carefully faked their alibis; ultimately, chose not to believe the attorney and went forward with his assertion of their innocence.

UPTON SINCLAIR,
Activist, Author;
Los Angeles, 1931

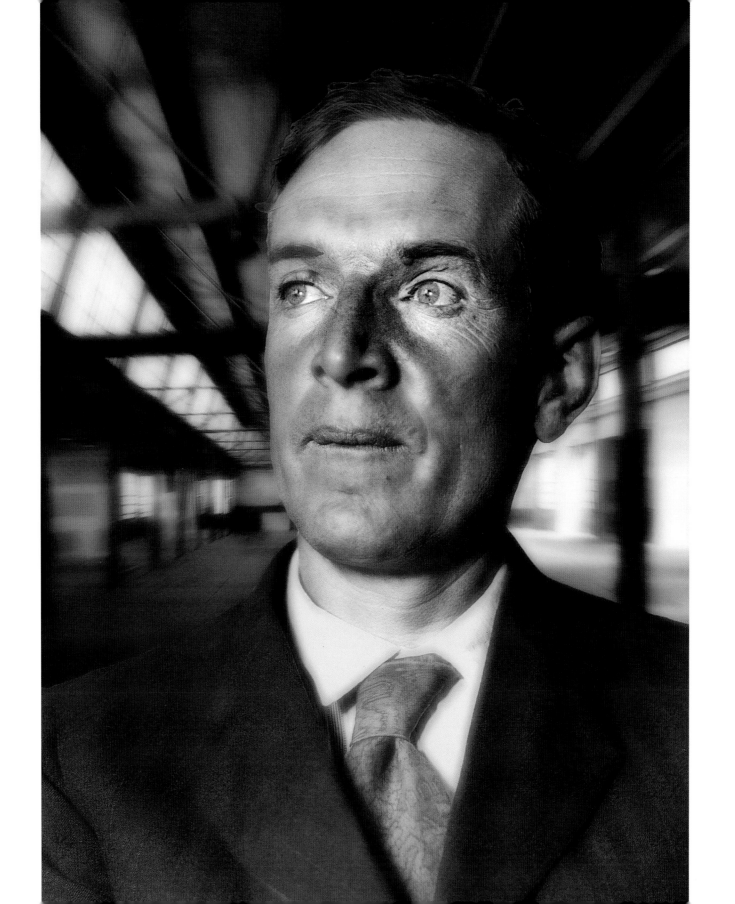

For years I thought I
was going to find the
Old Man of the River,
a guru who knew everything
 there was to know
about it. He was going to draw me a map.
Then I'd know what to do
with the information
that was written in my soul.
I never found him until I
caught my reflection
in a puddle of rain water.
It was me all along,
balding skull,
worried eyes
in awe of eight egrets
as they lift into the evening then
 turn northeast into the clouds
gathering about Mt. Washington.
I built this river not with my hands,
but with my imagination;
I built this river, not with my dreams
but with my drama;
though now I feel it ebbing, drying
up and cracking like a mud man's mask.
I built this river with my karma
Just so I would have a park bench
 to sit on
When I had no other place.

Lewis MacAdams is an artist and activist who expresses himself through writing, filmmaking, and environmental advocacy. His largest canvas is the Los Angeles River, which he has devoted himself to restoring.

MacAdams' epiphany occurred in 1985 in downtown Angeles while he was waiting for a bus to take him home to Venice. When he happened to turn around and catch his first glimpse of the Los Angeles River, he was struck by how terrible it looked with its graffiti, polluted water and fenced-off access. It seemed deeply wrong that the city had turned its back on its historic source—the raison d'être for the original *Pueblo de los Angeles.* "It was a strange feeling, but I just knew I would have to do something to help the river. It was one of those things you can't explain," he remembers. "Since I was young, I'd been on the cusp of poetry and politics, and this seemed like a way to bring those together."

MacAdams founded Friends of the Los Angeles River (FoLAR) to bring the long-neglected, fifty-mile waterway back to life. In the twenty-two years since, FoLAR has become the river's most important advocate, leading the fight against riverfront industrial development, helping to create a pair of adjacent state parks, the Cornfield and the Taylor Railroad Yards, and becoming a key supporter of the Los Angeles River Master Revitalization Plan, which was passed by the City Council in 2007. MacAdams envisions the river as "the unifying force in Los Angeles" as soon as its banks are appealing to residents and its water habitable to wildlife. He and his team run an ongoing program to monitor water quality, sponsor La Gran Limpieza, an annual clean-up effort, and a K-12 school curriculum called River Guide. He cajoles city officials and developers into adopting his vision for a healthier, more accessible river, and his passion, credentials and persistence get results.

"I'm interested in the river as a metaphor for our health," he explains, pointing out that only the hardiest non-native fish can now survive in its waters, whereas decades ago, the Los Angeles River was among the southernmost runs for steelhead. "They are the aristocrats of the river fish; they're very picky and need fresh water and good shade to survive," he notes. "When the steelheads return to the Los Angeles River, the work of FoLAR will be done."

- Grew up in Dallas, where he got into philosophy and local activism in high school; at Princeton University, studied literature and creative writing and published his first book of poetry; earned his masters at State University of New York at Buffalo.

- Came west in 1969 to follow the path of the Beat generation poets, landing in Bolinas, just north of San Francisco; while writing poetry, worked on environmental issues as a member of a local water resources board; hired as director of the poetry center at San Francisco State University.

- Moved to Los Angeles in 1980 to make documentaries on subjects close to his heart, including *What Happened To Kerouac?,* a video version of the one-man show *Eric Bogosian's FunHouse,* a documentary on a poetry contest called *The Battle of the Bards,* and *The Lannan Literary Series,* twenty-six shows about great poets.

- Penned a dozen books of poetry and twice won the World Heavyweight Poetry Championship in Taos, New Mexico; worked as a journalist for *L.A. Weekly, Los Angeles Magazine* and *WET,* a bi-monthly chronicle of the avant-garde; in 2001, wrote *Birth of the Cool,* a cultural history of hip.

LEWIS MacADAMS,
Poet, Author,
Environmentalist, Filmmaker;
in the Los Angeles River channel,
2007

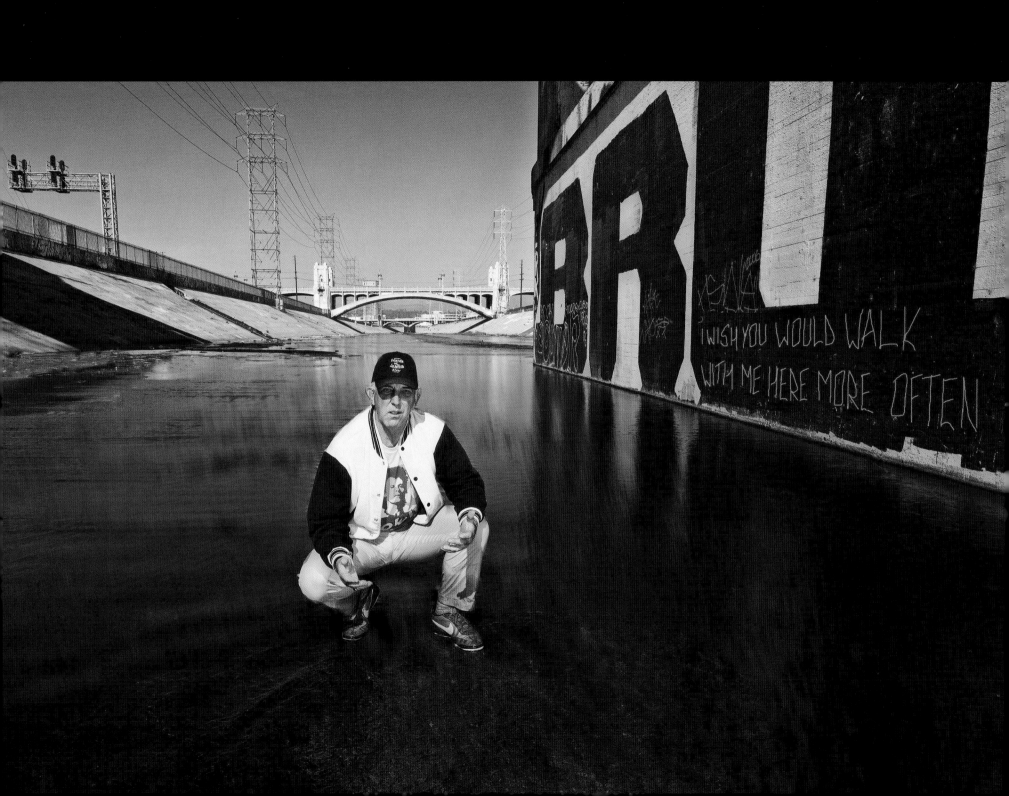

The American dream gets played out in Los Angeles on a scale and scope next to none. This is THE city of hope and promise. It doesn't care who your father is. It has an openness, a tolerance for all types. It allows everyone to just go for it, to let your dreams come true.

Antonio Villaraigosa is the politically ambitious L.A. mayor known for his skill in building broad bipartisan coalitions while tenaciously pursuing his vision for improving the quality of life in the city.

Growing up in a working class house in East L.A., young Tony Villar could see downtown and City Hall in the distance, but never in his wildest imagination did he dream of being able to work there, let alone be the mayor. That dream came to him in stages as he left the barrio to earn a history degree at UCLA and then a law degree. By the time he married Corina Raigosa and fused her name with his, he was heading the local ACLU and government employees union. In 1994, he successfully ran for the state assembly, where four years later, his colleagues elected him the first Assembly Speaker from Los Angeles in twenty-five years. He could have stayed in Sacramento much longer, but he chose to focus again on the city that nurtured him. He ran for mayor in 2001, narrowly losing to Jim Hahn, and was then elected to the City Council. Four years later, he defeated Hahn to become the forty-first mayor of Los Angeles and the first Latino to run the city since 1872.

To the city's highest office, Villaraigosa brought grand ambitions for improving Los Angeles in the areas of education, transportation, crime, inner-city parks, and neighborhood revitalization. As a Latino, he also brought important symbolism to the job. "Los Angeles was founded in 1781 by forty-four Mexicans," he reminded me. "Then the Caucasians took over. Now Latinos have replaced Caucasians as the majority population. In a hundred years, it could be the Chinese or the Koreans. What matters is that we embrace our unique character." Throughout his City Council, state assembly and mayoral days, Villaraigosa has made it a priority to build consensus from the city's diverse population.

Friends praise him as a dynamo who devotes himself with boundless energy to his causes and to his convictions for improving the quality of our urban lives. Yet, at the same time, he seems to revel in the attendant perks and fame of his office. His ambitions will not end with being the mayor of Los Angeles, as he frequently travels outside the region, in part to stoke his visibility for statewide or national office. His political dreams though appear to be firmly interwoven with his ideals. "I'm still a progressive who wants to change the world," he says. "I still believe one person can make a difference."

■ Born Antonio Ramon Villar in 1953 in East Los Angeles, the oldest of four children raised by a single mother; attended Roosevelt High School and took community college classes before transferring to UCLA, where he received a history degree.

■ Received a law degree, then became a union organizer with the United Teachers Los Angeles; held positions as the local chapter president of the ACLU and the American Federation of Government Employees, putting him in regular contact with elected officials and shaping his ambitions to run for office.

■ Elected to the California State Assembly at age forty-one; worked on passage of legislation that helped modernize schools, offer healthcare for more than a half-million children, fund neighborhood parks and ban assault weapons.

ANTONIO VILLARAIGOSA,
Politician;
in front of the City Terrace
neighborhood where he
was raised, 2007

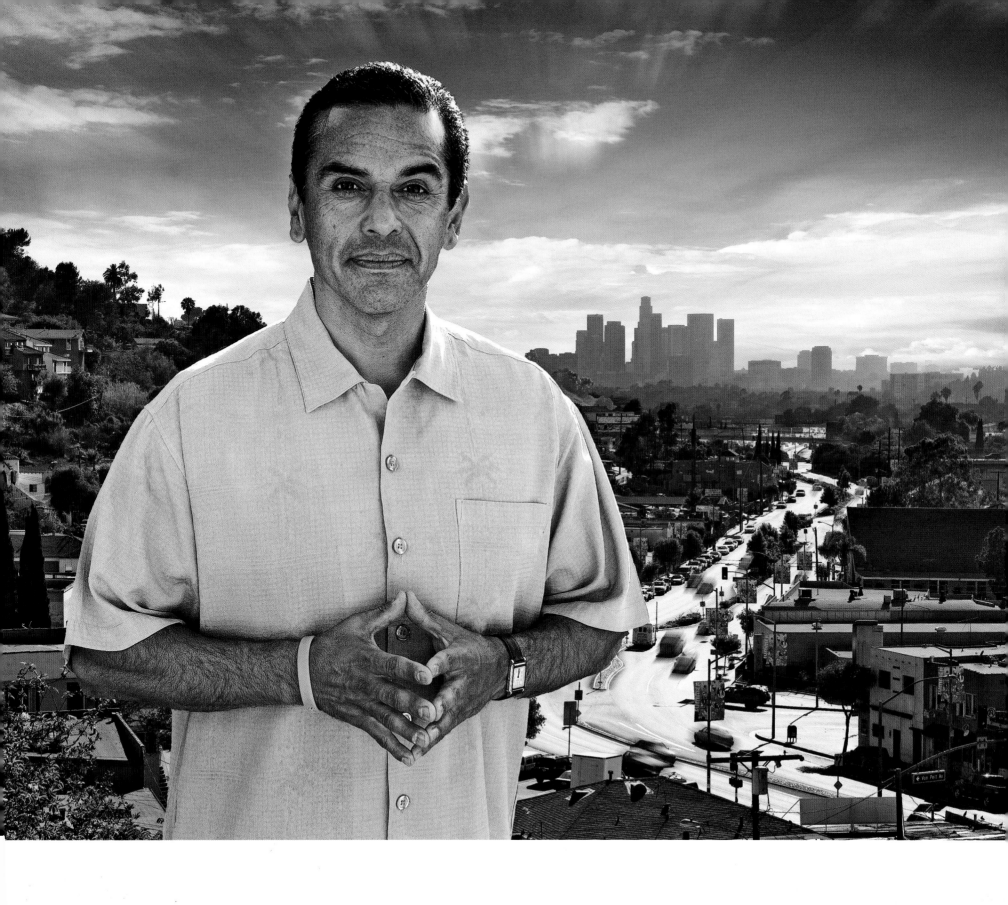

THE ENTERTAINERS

THE ENTERTAINERS

Jerry Bruckheimer—Film and Television Producer ■ Billy Wilder—Screenwriter, Director ■ Young Actors
Gordon Davidson—Theater Impresario ■ Cecil B. DeMille—Film Producer ■ Nat King Cole—Musician
Greg MacGillivray—Documentary Filmmaker ■ Ronald Reagan—Politician, Actor

Some people are driven to entertain others, to tell a story, sing a song, put on a show and raise the emotions and consciousness of their audiences. Ever since movies were first filmed in Los Angeles, Southern California has been the destination for the largest migration of entertainers in the world.

Although "The Business" employs only a fraction of the total workforce in Southern California—some 120,000 work in the local entertainment industry—the impact on the surrounding culture is much greater, casting a wide shadow with its klieg-light premieres, extravagant parties, celebrity sightings, location shoots and stretch limos.

Although I grew up here, it was not until I went to college in the early 1970s that I decided to pursue a career in the film and television world, and to turn my back on the legacy of four generations of newspaper publishers. I was attracted to storytelling, the mystique of the dream factories and the worldwide audiences. After I made movies at Stanford and UCLA, I was hooked.

My first visit to a real studio was memorable—and with an unexpected result. My excitement level rose as I entered the 20th Century Fox lot into a world of magic and possibilities. I drove through the *Hello Dolly* set, past the sound stages, and then walked into the Art Deco corporate offices, hallways filled with posters of the studio's past hits. Yet once I was seated in the palatial suite for an interview with the studio boss, who happened to be a family friend, I was confronted with a different reality. He counseled me that behind the glitz of the show business curtain was a much darker world, one that I should stay away from. His advice to me was to go to work for the *Los Angeles Times*. He cited a climate of irrationality, discrimination, and excesses. However, like most young idealists, I was immune to any warnings that ran counter to my dreams. So I nodded politely and asked him if I could have a job. In a few weeks, I was a production assistant on Brian DePalma's *The Fury* (1978). My wild ride had begun.

My aspiration to be on the creative side of Hollywood placed me in the belly of the beast. I soon learned that the joys of collaborations were rare, and just as my family friend had warned me, Hollywood produced heartbreaks, rejections, pettiness and deceit, crassness and outsized egos. Over the next nearly twenty years I worked in a variety of jobs, and produced a number of movies of my own, where the projects were at least satisfying and the petulant colleagues infrequent.

When I finally exited in 1994 to work in the Internet world, it was a bittersweet departure. The Fox studio boss had been right about some things: The Biz can be terribly difficult, insidious, and disappointing. Yet, it was also a real thrill when I was mapping out story beats with talented writers as a development executive, or running a well-oiled, hundred-person crew on some exotic location as a producer. These moments were magical.

It was a near impossible task to select only a few inspirational and pioneering entertainers in a town full of them. In the end, I chose eight (plus one group) who I simply admire. Those who I met in person left me with unforgettable memories.

From my own producing days, I know how hard it is to create a hit, let alone a succession of them. So in 2006, when I drove up to Palmdale to meet probably the most successful film and TV producer of all time, Jerry Bruckheimer, on the set of his biggest hit, *Pirates of the Caribbean*, I braced myself to encounter the kind of brash, take-no-prisoners type that often occupies the top perches in this town. In the massive hangar used to build the B-1 bomber, his crews had built three full-size pirate ships, raised up with hydraulic supports, to allow them to rock back and forth as if on waves. It was the largest set I had ever seen. Its interior walls were draped with thousands of yards of blue fabric, used to allow the matting-in of new backgrounds in the final film. Bruckheimer entered the cavernous building accompanied by his retinue of assistants. But he was not what I had expected. This Jerry Bruckheimer was soft-spoken and articulate. He was even patient as we tried one photo setup on the foredeck of Davy Jones' ship, then another against the blue-screen background. Could it be that this über-producer was just a regular guy?

On the sand in Laguna Beach, I met another seemingly unassuming entertainment legend, the outdoor documentary filmmaker Greg MacGillivray. Although he has worked on dozens of studio pictures, he has deliberately kept his distance from the Hollywood scene, so I suspected from the beginning that his laid-back demeanor is permanent. We met in his house just down from Main Beach in Laguna, where he has lived for thirty-five years. From his early days creating such surf-film classics as

Five Summer Stories (1972) to his stunning documentaries that play in gigantic-screen IMAX theaters, he has been an artistic pioneer content to stay connected to, but separate from, the mainstream movie business. The stack of well-used surfboards on the porch of his house gives further testament that in his fifties, MacGillivray's heart remains in the Pacific swells.

Another storied producer comes from the stage. Gordon Davidson has won more producing and directing awards than any other Southern California theatrical impresario. He ran the Music Center theaters beginning when the Mark Taper Forum

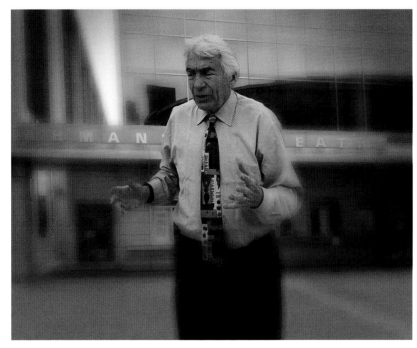

GORDON DAVIDSON, Theater Impresario; Music Center plaza, 2006

opened in 1967. I really got to know Gordon, though, when I joined the Taper's board of directors in the 1980s. He is such a dynamo of talent and energy, a passionate advocate of the theater, with an ever-expanding appetite for more. He ceaselessly lobbied the board for funding for more stages, more ambitious productions, more color-blind casting and more audience involvement—occasionally using his theatrical skills, gesturing expressively and using booming declarations or conspiratorial whispers, to eloquently draw us into his cause like an actor working his audience. During our photo session he recounted stories about my grandmother—"Mrs. C" as he calls her—and the early days of the Music Center; he gestured as if he were directing one of the thousands of scenes that he has guided. That's what I captured in my portrait of him.

The most prominent dreamer among the group is the one who obtained success as a movie actor before moving to the political stage: Ronald Reagan.

I first met Mr. Reagan when he was governor and my father was the publisher of the *Los Angeles Times*. The Reagans came to dinner to talk shop with Dad and some of his editors. Even though I was in high school, I was allowed to participate in the social part of the evening. Although I was never a fan of Mr. Reagan's politics, it was hard not to be charmed by his wit and oratory skills. At other times during his tenure as governor, and later, when he was president, I heard that Mrs. Reagan would occasionally call Dad to complain about something in the *Times*: a Conrad cartoon, an editorial or some coverage of her husband that had gotten their hackles up.

Cecil B. DeMille was a good friend of my great-grandfather Harry Chandler, and my grandfather Norman, but I never met him. While researching DeMille, I finally learned the origin of the phrase "Ready when you are, C.B.!" that's often used on film sets. It's an anecdote worth repeating. DeMille was filming a huge battle scene involving thousands of horses and warriors, a scene that could only be staged once, which meant using numerous cameras to capture the action from every angle. At the end of the huge action sequence, DeMille yelled, "Cut!" only to learn to his horror that all the main cameras had failed or missed getting their shots. Picking up his megaphone, he called to the remaining cameraman, placed up on a hill to a get a wide shot of the battle. "Did you get all that?" he yelled hopefully. The cameraman shouted back, "Ready when you are, C.B.!"

I was working in advertising when I got my first chance to come to Los Angeles to work on a movie. I remember walking onto the Fox studio lot for the first time. It was so amazing. A dream come true. Then later, when I was at the premiere of that movie, when the Fox logo and that dum-dum da-da-da music, started, I was hooked.

Jerry Bruckheimer is one of the most successful producers of movies and television shows of all time, a dynamo responsible for hits that include the *CSI* television series and the *Pirates of the Caribbean* movies. His larger-than-life escapist stories are carefully crafted with heart-stopping action sequences, extraordinary special effects, vivid cinematography and pounding music.

It was his passion as a storyteller and a dream to bring those stories to the big screen that catapulted him from the advertising world of Madison Avenue to the top ranks of Hollywood producers. Initially he partnered with ex-publicist and studio executive Don Simpson for thirteen years of hits, including *Flashdance* (1983), the *Beverly Hills Cop* films, *Top Gun* (1986), *Bad Boys* (1985, 2003), *Crimson Tide* (1995) and *The Rock* (1996). While Simpson, known to Bruckheimer as "Mr. Inside" because of his Hollywood contacts, worked the studios to sell these high-concept (simple to explain yet compelling) stories, Bruckheimer, "Mr. Outside," produced them. He mastered the selection of appealing casts, visually oriented directors, pulsating music and mass-market promotion. Together they developed a big budget + big action = big grosses formula and the Simpson/Bruckheimer brand that redefined the film business.

Persevering on his own after Simpson suffered through scandals and a 1996 drug overdose, Bruckheimer continued to produce a gravity-defying string of box-office hits, including *Con Air* (1997), *Armageddon* (1998), *Pearl Harbor* (2001), *Black Hawk Down* (2001) and the three *Pirates of the Caribbean* films (2003, 2006, 2007). He occasionally varies from his action extravaganzas with smaller dramas that have included *Dangerous Minds* (1995), *Remember the Titans* (2000) and *Veronica Guerin* (2003).

In 1997 he branched into television, building a team and getting personally involved with the casting, directing and editing of pilots for such successful series as the *CSI* shows, *Without a Trace*, *Cold Case*, and *Close to Home*, as well as the reality show *The Amazing Race*.

Bruckheimer's productions are undeniably popular. His films have earned worldwide revenues of more than $14.5 billion in box-office, video and recording receipts. In the 2005-06 season he had a record-breaking eight series on network television. His productions, while geared to the masses not the critics, have still received dozens of awards, including thirty-five Academy Award nominations.

He shows no signs of slowing down or looking back just yet. "Someday in the motion picture old-folks' home I'll be looking through a scrapbook and say, 'Oh, that was pretty good.' I've just got to keep looking ahead and worrying about what's coming up next."

■ Born in 1945 in Detroit, an only child to Jewish immigrants from Germany—his mother was an accountant and his father was a clothing salesman; had a hobby of still photography as a young boy and won awards for his images in high school.

■ Asthma and poor grades limited his college choices; enrolled first at Arizona State and then the University of Arizona; majored in psychology and became a film buff on the side; began a career at an advertising agency, first starting in the mailroom; moved to New York City to work at the BBDO agency and produce television commercials.

■ Moved to L.A. in his late twenties and started as an associate producer on *The Culpepper Cattle Company* (1972).

■ As his first marriage was collapsing, met his future business partner, Don Simpson, at a screening; attracted to his humor and chutzpah, moved into a room in his house.

JERRY BRUCKHEIMER,
Film and Television Producer;
on the soundstage of *Pirates of the Caribbean: At World's End,*
Palmdale, 2006

You have to have a dream so you can get up in the morning.

Billy Wilder was one of Hollywood's most eclectic and talented writer-directors, creating more than fifty movies, including classics in film noir, drama, comedy and war.

After fleeing Nazi Germany, Wilder tried unsuccessfully to enter the U.S. over the Mexican border, where immigration officials repeatedly denied him entry papers. Not giving up, he finally found a sympathetic border officer who asked him his profession. After Wilder, who spoke little English at the time, pantomimed that he was a moviemaker, the officer waved him through and said, "Make good ones, then."

Wilder got his first Hollywood break as a writer collaborating with the German director Ernst Lubitsch, on *Ninotchka* (1939), a hit comedy starring Greta Garbo. The film earned Wilder his first Academy Award nomination, which he shared with co-writer Charles Brackett, who would remain his writing partner on such classics as *Hold Back the Dawn* (1941), *The Lost Weekend* (1945), *A Foreign Affair* (1948) and *Sunset Boulevard* (1950).

Wilder made his directorial feature debut in 1942 with the highly successful risqué comedy, *The Major and the Minor*, which he wrote with Brackett and starred Ginger Rogers and Ray Milland. Its success allowed him to direct other screenplays he had written. He quickly learned to apply his deftness in story construction and dialogue to elicit great performances from his casts. He wrote and directed fourteen Oscar-nominated roles, played by actors including Jack Lemmon, Shirley MacLaine, Barbara Stanwyck, Audrey Hepburn, Gloria Swanson, Walter Matthau and William Holden.

Working with the chronically late and needy Marilyn Monroe was Wilder's greatest directing challenge, he often said. After working with her in *The Seven Year Itch* (1955), he vowed never to direct her again, quipping "I have discussed this with my doctor and my psychiatrist and they tell me I'm too old and too rich to go through this again." Yet he went on to cast her as the ditzy blonde in *Some Like it Hot* (1959). The results were delicious.

Dominant and diminutive, chain-smoking and argumentative, Wilder was not always an easy collaborator. Although he hated writing alone and never trusted his English enough to do so, many of his writing partners complained that he would abuse them if he didn't like their ideas, including mystery novelist Raymond Chandler, who co-wrote *Double Indemnity* (1944) with Wilder. In the 1950s, he teamed with a new writing partner, I.A.L. Diamond, and for nearly twenty years co-wrote a string of hits including *Witness for the Prosecution* (1957), *Love in the Afternoon* (1957), *The Apartment* (1960) and *The Fortune Cookie* (1966).

After winning three Academy Awards for *The Apartment*—for best picture, director and screenplay—Wilder's career slowed. Except for *The Fortune Cookie*, in 1966, most of his later films failed to excite critics or the public. He came out of retirement to do rewrites on the script for *Schindler's List* (1993) and was even considering directing it himself. Ultimately he felt he was too old and the Holocaust was too personal, so he helped convince Steven Spielberg to direct it.

With his six Oscars, twenty-one nominations and countless other tributes, including the National Medal of Honor, Wilder certainly lived up to his obligation to the border official who let him into America to make good movies.

- Born Samuel Wilder in 1906 in Austria-Hungary; nicknamed Billie by his mother who had spent several years in America in her youth and had become a fan of Buffalo Bill Cody.

- Dropped out of the University of Vienna after three months to become a journalist; moved to Berlin; co-wrote his first screenplay at age twenty-three; fled to Paris in 1933; learned later that both his mother and grandmother died at Auschwitz.

- Arrived in Hollywood late in 1933; shared an apartment with fellow émigré Peter Lorre; listened to the radio to memorize twenty new English words every day.

- Went back to Europe after World War II as a U.S. Army colonel, to oversee a program that evaluated hiring former Nazis in the theater or the movies; when the director of a passion play in a German town asked Wilder if an actor who was a former Nazi could be cast as Jesus, he said, "Permission granted, but the nails have to be real."

**BILLY WILDER,
Screenwriter, Director;
Los Angeles, 1966**

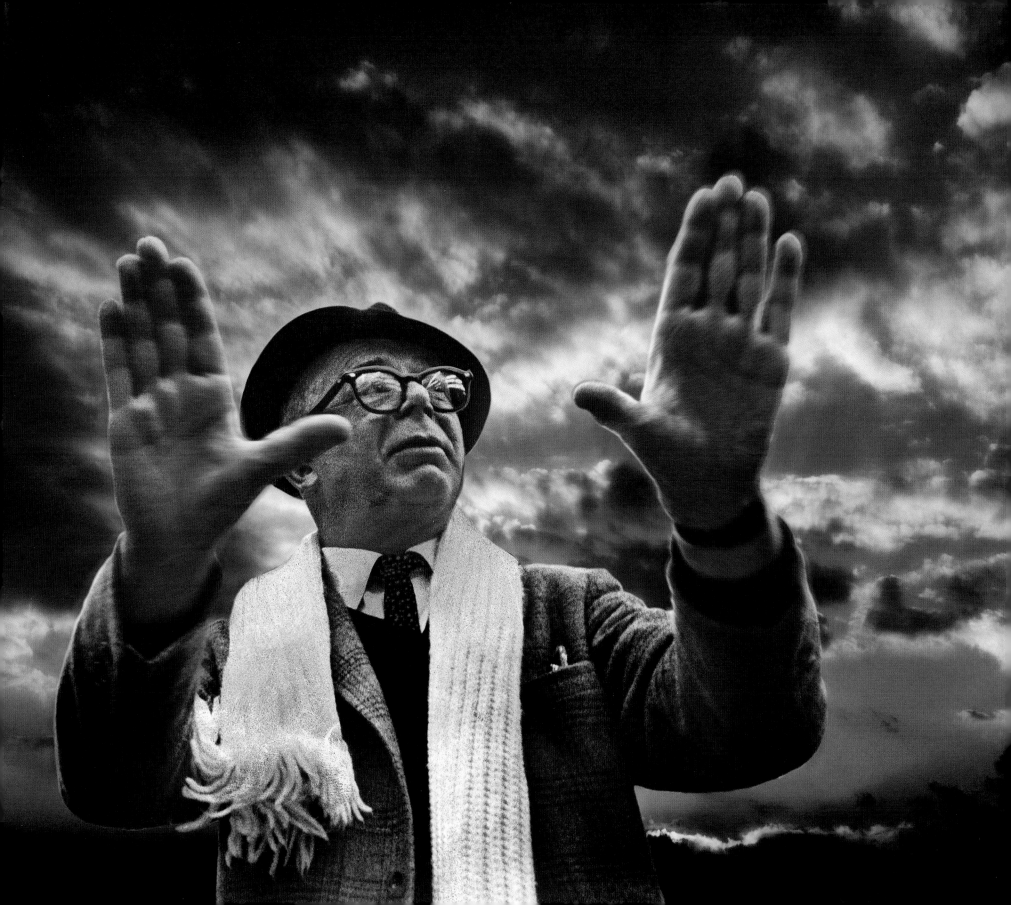

I grew up dirt poor in the Midwest. I was sort of the ugly duckling in grade school and so I dreamed about getting back at all the kids who made fun of me by making it in Hollywood. In the tenth grade, I convinced my mom and step-dad to move here so I could get into acting. Right now, I really dream about doing independent movies, not being some big star in the big-budget Hollywood films.
 —**Maitland McConnell,** age eighteen.
She has been cast in several *CSI* television episodes and played the third lead in the movie, *Ninja Cheerleaders* (2008).

As a kid, I moved all around the world—Singapore, Indonesia, Norway—before settling in Texas. I did some local theater there, which I loved. So a buddy and I headed to Hollywood to make it here. A month later, I had a manager, then an agent, and now I am pretty busy working.
 —**Jackson Rathbone,** age twenty-one.
He has appeared in television episodes of *The O.C., Beautiful People,* and *The War at Home* and in several low-budget horror films.

One morning at age ten, in the slow-paced town of Lincoln, Nebraska, I woke up and told my mom, "I want to act!" My mom said, "OK," and that led to a Nebraska talent-search contest, which led first to an agent in Kansas City, then to some work in New York and finally, when I was age twelve, to Los Angeles. I came hoping to just get better commercials, because that is all I knew. But I am very competitive and am now doing television series. I dream of going all the way with my acting.
 —**Lindsey Shaw,** age seventeen.
She has played the lead in the movie *Nic & Tristan* (2009), and is a regular on television, including *Aliens in America* and *Ned's Declassified School Survival Guide.*

Young actors exemplify the Hollywood dream of entertainers, chasing the rare and often fleeting quest for stardom.

Acting in the movies and television is one of life's most challenging career paths—one filled with heartaches and disappointments. When I was producing movies, I felt so bad during auditions, having to turn down one after another struggling actor. For them, this rejection happens day after day, audition after audition. Each time, they have to emote on command and open their hearts in a most vulnerable way in an attempt to land a role. And none but a few are ever invited to read for the starring roles. Yet this road to Hollywood stardom never empties.

For my portrait, it seemed arbitrary to select a single example—a Gish, Hepburn, Tracy, Nicholson or Hanks—among the many success stories. I decided instead to focus on some young dreamers who were just starting out on the path. I caught up with three young performers at Jeremiah Comey's Actors' Studio in Studio City, one of the many acting workshops in town. There, two students rehearse a scene while another works the video cameras that record their performances. Then they switch places. Scene after scene play out in the windowless room, followed by Comey's encouraging but honest suggestions. During a break, I snapped some photos and asked these young actors about their backgrounds and dreams.

Los Angeles defines the "art of the possible"—if you are courageous, you are able to succeed here. On the East Coast, they say "Show me." On the West Coast, we say "Why not?"

Gordon Davidson was the man most responsible for putting Los Angeles on the national theater map, as the founding artistic director of the Music Center's Center Theatre Group. Responsible for producing more than three hundred plays during his thirty-eight years at the Center, he brought serious drama and multiculturalism to the Southland's principal stages.

In 1967, what he calls the "big, magical thing" happened that changed his life forever. Dorothy Chandler, the Music Center founder, had seen his UCLA production of *Candide,* starring Carroll O'Connor, and invited Davidson to lunch at the Pavilion restaurant. Looking out the window at the round Mark Taper Forum, the theater in construction across the plaza, she asked him, "So how would you like to run it?" He gulped and said, "I would . . . very much!" For a thirty-three-year-old, to be steering this high-profile downtown stage, was the offer of a lifetime.

Davidson didn't play it safe at the new theater, but came out swinging. The opening play, *The Devils*, the tale of a libertine priest, a nun, and their sexual fantasies, had run without incident at the Royal Shakespeare Company in London. But in Los Angeles it created a maelstrom of controversy. The cardinal of L.A.'s Catholic diocese was outraged; civic boosters and prominent audience members, including Governor Ronald Reagan, stormed out of the play, calling for Davidson's scalp. Dorothy Chandler and Lew Wasserman, the MCA/Universal studio head, who led the theater's board, had to rush in to make a decision whether to close the show or support Gordon's artistic freedom. He pleaded his case with them and they allowed the play to continue.

Davidson went on to present and direct an amazing collection of dramas, farces and musicals, winning countless awards for himself and the theater, and always risking the occasional controversy rather than settling for plays that were too comfortable. He launched many hits that went on to successful tours and adaptations to films and television, including *Zoot Suit*, *Angels in America* and plays from Neil Simon, Lanford Wilson, Christopher Hampton, Michael Christofer and Mark Medoff. As a director, he also brought to life dozens of powerful dramas including *In the Matter of J. Robert Oppenheimer*, *The Trial of the Catonsville Nine*, *Children of a Lesser God*, *QED*, *Stuff Happens*, and *The Shadow Box*, for which he received a Tony award. His staging of Leonard Bernstein's *Mass* opened the Kennedy Center in Washington, D.C.

His dreams, though, were not just about mounting great plays on the Music Center's main stages. Davidson came to realize that he could accomplish something equally inspired by broadening theater's role in the Southland. Embracing the region's diversity, he launched theater programs that toured the schools; gave roles to African American, Asian and Hispanic actors in plays written for Caucasians; commissioned plays on regional topics; funded and nurtured young playwrights and directors and created experimental plays in smaller venues. Davidson became an innovator and a leader who attracted national attention. Both Washington's Kennedy Center and New York's Lincoln Center theaters made him offers to return east to run their stages. But he turned them down. The City of Angels had rewarded him with its soul and he was not giving that up.

At the height of his tenure at the Music Center, Davidson ran five stages, including the Taper, the Ahmanson and the Kirk Douglas Theatre in Culver City, wielding an unprecedented power in the cultural scene and reaching hundreds of thousands of Angelenos.

- Born in 1933; grew up in Brooklyn, the son of a professor of speech and drama who produced plays on the side; while enrolled at Cornell University as an electrical engineer, interned at General Electric's guided-missile systems division and earned extra cash at night ushering at the Tanglewood Music Festival; switched his major to drama.

- Landed his first theatrical job with John Houseman, the co-founder, with Orson Wells, of the Mercury Theater (*War of the Worlds*); brought his new wife, Judy, to Los Angeles and worked with Houseman, who established a professional theater company on the UCLA campus.

- Met Dorothy Chandler in 1967 and became artistic director of the Mark Taper Forum at the Music Center.

GORDON DAVIDSON,
Theater Impresario;
Music Center plaza, 2006

The person who makes a success of living is the one who sees his goal steadily and aims for it unswervingly. That is dedication.

Cecil B. DeMille reigned as the king of Hollywood in his nearly forty years as one of its most successful filmmakers. Known for his outsized personality, flamboyant showmanship, and his trademark leather boots and jodhpurs, he created the big-budget action blockbuster, often using historical and biblical stories and casts of thousands.

Pioneering the movie epics that we take for granted today with mammoth sets, multiple action sequences and ambitious special effects, DeMille lived for making entertainment on a grand scale. He was in his element perched on a raised platform with his megaphone, barking out directions to hordes of cast and crew in such spectacles as *The Ten Commandments* (1923), *The King of Kings* (1961); he remade his own silent version with the Charlton Heston classic in 1956, *Samson and Delilah* (1949) and *The Greatest Show on Earth* (1952).

DeMille also excelled at pushing the boundaries of on-screen lasciviousness. Although tame by today's standards, he loved to have his historical sets populated with thinly veiled slave girls and dancers, and loinclothed bodybuilders, at least until the Hayes Commission introduced censorship in the 1930s. He learned what the audiences liked and gave it to them in ever-more-extravagant dramas.

Although not known as particularly adept at working with actors, DeMille did have a great eye for casting up-and-coming performers, letting them exhibit their craft and making them into stars—which he did for Claudette Colbert, Gloria Swanson, Gary Cooper, Paulette Goddard, and Charlton Heston. He had little patience for actors who were not willing to carry out the physical work he required of them, as with Victor Mature, who refused to wrestle a lion in *Samson and Delilah*, even though the cat was tame and toothless.

As DeMille's fame grew, so did his ego and his reputation for being a tyrant on the set. "You are here to please me. Nothing else on earth matters," he once declared to a crew. He regularly lashed out at anyone who wouldn't heed his commands. Occasionally he got his comeuppance. In the 1935 movie *The Crusades*, his big-action sequences had already led to injuries of stuntmen and the death of horses. One day one of the stuntmen, an expert archer, tired of DeMille's screaming and abuse, let fly an arrow that pierced the megaphone the director was using to project his derision. A shocked DeMille stomped off the set—but for the rest of that production didn't shout at the stuntmen again.

For his own persona, C.B. created a character as imposing as any from his movies. He adopted a European-gentleman-inspired costume of jodhpurs, tall leather boots and a riding crop. He made sure he was seen about town escorting young starlets in one of his many chauffeur-driven luxury cars. He perfected his signature megaphone-wielding poses. DeMille was a master of promotion, both for his films and for himself, becoming in the process Hollywood's first celebrity director. Long before Alfred Hitchcock did it, DeMille put himself in front of the camera, in bit parts in his own movies and the newsreels of the day, even playing himself in other directors' pictures, including *Sunset Boulevard* (1950). He also hosted one of the most popular radio drama series of the day: *Cecil B. DeMille's Lux Radio Theater*. Paramount rewarded him for his fame not only with a generous salary and profits, but also by agreeing to place his name above the title of his films, an honor that today is given to only a handful of directors.

Over the span of his ninety movies, DeMille invented not just epic adventures of populist appeal, but something larger and equally enduring. He created the larger-than-life image of the Hollywood director.

- Born in 1881; raised in New Jersey by a father who was an actor, Columbia University professor and Episcopal lay minister, and a mother who was a playwright and theater manager; entered the Pennsylvania Military College at fifteen before transferring to New York's American Academy of Dramatic Arts.

- Debuted as a Broadway actor at the age of nineteen, then joined his mother's theater company, where he met actress Constance Adams; during his fifty-six-year marriage to her, was anything but faithful, having two well-known, long-term affairs.

- Joined fellow easterners Jesse Lasky and his brother-in-law Samuel Goldfish (later changed to Goldwyn) in creating motion-picture versions of theatrical plays; moved to Hollywood where, in 1916, they merged their company with two other production companies and assumed control of a newly formed distribution company, Paramount Pictures.

- Although politically conservative, was among those who refused to be intimidated by the McCarthy blacklist of Hollywood liberals in the 1950s; hired several blacklisted men, including actor Edward G. Robinson, who later credited DeMille with saving his career.

CECIL B. DeMILLE, Film Director; on the set of *Samson and Delilah* with bit actor Ezzrett "Sugarfoot" Anderson in costume, Mojave, 1948

Everybody who has a creative mind should sit down and try something new.

Nat King Cole sold more than fifty million records as he conquered the charts with such tunes as "Mona Lisa," "Get Your Kicks on Route 66" and "Unforgettable." Equally inspirational is how this velvet-voiced singer and accomplished pianist became an African American pioneer in the entertainment field, becoming the first black man to perform in many key venues and to host his own radio and television shows.

In the middle of World War II, Cole was a touring jazz pianist who happened to sing. His big break came when songwriter and singer Johnny Mercer heard one of his jazzy compositions with lyrics based on a traditional Negro folk tale that Cole remembered hearing in his father's church. Mercer invited Cole to record it for the fledgling Capitol Records. "Straighten Up and Fly Right" sold more than five hundred thousand copies and led to Cole's partnership with the label that would last for the rest of his career. Sales from his Capitol Records recordings helped to finance the company's round building in Hollywood; it became known as "the house that Nat built."

By promoting him as a singer and adding a string orchestra to some of his songs, Capitol Records helped Cole reach the top of the charts with such pop hits as "The Christmas Song," "Nature Boy," "Mona Lisa," "Too Young" and his signature tune "Unforgettable." His boyhood dream was finally realized with these successes; his name now lit up marquees at concert halls across the country, and his family's financial woes were finally behind him. Cole's engaging personality also brought him to the attention of the movie industry. He was cast in films including *The Nat King Cole Story* (1955), *China Gate* (1957), *St. Louis Blues* (1958) and *Cat Ballou* (1965).

But despite his talent and huge fan base, his career was plagued by racism. He fought back, regularly refusing to perform at venues that wouldn't admit black people, or demanding that racist rules change before he would play. In 1949, he and his wife moved into the upscale Los Angeles neighborhood of Hancock Park. When the all-white property owners' association there told Cole they did not want any undesirables moving in, Cole responded, "Neither do I. And if I see anybody undesirable coming in here, I'll be the first to complain." The association tried to keep the Coles out, but he overcame the pressure and remained in his home.

Things did not turn out as well for Cole when he performed in Birmingham, Alabama, in 1956. Members of the White Citizens Council rushed onstage during a song, injuring him while apparently attempting to kidnap him. After that, Cole never again agreed to perform in the South. The same year, NBC offered him his own television variety show. When *The Nat King Cole Show* debuted, it had everything going for it except sponsors. The ratings were good and guest stars, including Frank Sinatra, Ella Fitzgerald, Harry Belafonte, Mel Tormé, Sammy Davis and Eartha Kitt, worked for minimum fees. NBC chairman David Sarnoff ordered his sales staff to "find his show sponsors or heads will roll!" But Sarnoff's team was unable to convince risk-averse Madison Avenue advertisers to come aboard. The show lasted only one year.

Rationalizing that it kept his voice low, Cole had long been a three-pack-a-day smoker. At age forty-five, his cigarettes finally took their toll, leading to the lung cancer that ended his life. In 1991, his daughter, singer Natalie Cole, mixed her own voice with her father's 1961 rendition of "Unforgettable," delivering one last hit for this memorable and pioneering musician.

- Born Nathaniel Coles in Montgomery, Alabama, in 1919, then moved to Chicago as a young boy; learned to play the organ and piano from his mother who was the organist in his Baptist minister father's church; vowed that "One day my name will be up in lights and we won't be poor any more!;" began performing jazz in local clubs with his older brother Eddie while they were still teenagers.

- Joined a road company as the pianist in a Eubie Blake ragtime revue, which ran out of money in Long Beach; founded the "King Cole Swingers" with three other musicians, and got his first steady job on the Long Beach Pike amusement pier at ninety dollars a week.

- Fell in love with a pretty dancer, Nadine Robinson, married her and moved to Los Angeles; formed the Nat King Cole Trio jazz band, which soon attracted a buzz in the big city and led to tours throughout the country and a steady wage throughout his twenties.

- Released modest hits like "That Sunday, That Summer," "Ramblin' Rose," "Those Lazy, Hazy, Crazy Days of Summer" and "Dear Lonely Hearts," but lost many of his live bookings in the 1960s when rock and roll put a damper on most crooners' careers.

NAT KING COLE,
Musician;
Los Angeles, ca. 1950

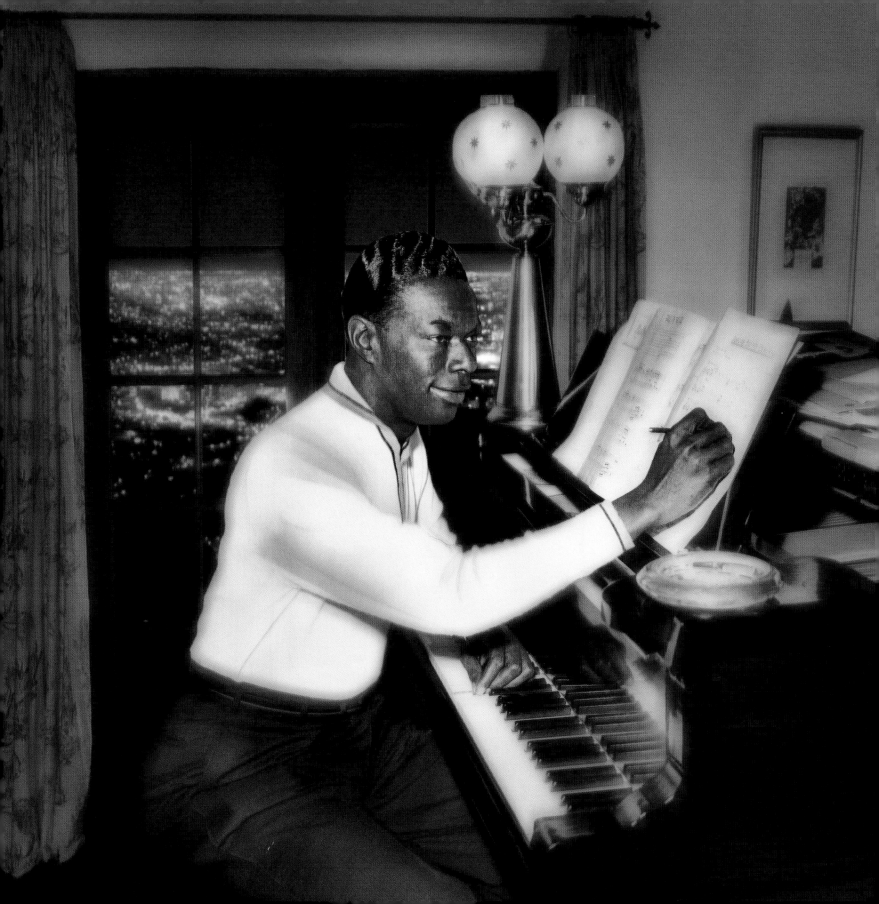

The uncertainty of success and failure is what drives people to climb Mount Everest and drives filmmakers like me to make movies against the advice of all the naysayers.

Greg MacGillivray has been making breathtaking adventure films for forty years, from artistic surf films to large-format IMAX movies shot on exotic locales including on the top of Mount Everest. Never content to repeat himself, he has pushed the boundaries of the medium.

After college, MacGillivray partnered with his best friend and fellow filmmaker Jim Freeman to make a documentary for fifteen thousand dollars about surfing in South America, called *Free and Easy* (1967). Its pioneering camera work brought the pair more projects, doing a variety of action, stunt and helicopter sequences in feature films including *Jonathan Livingston Seagull* (1973) and *The Towering Inferno* (1974). These gigs paid the bills, but after a few years, the partners pulled back from freelancing to do just one more surf film—putting all their talents and cash (and then some) into the project. They spent far more than any surf film had ever grossed, worrying not about getting their money back, but just about getting it right. *Five Summer Stories* (1972) was a huge artistic and financial success. It ran in theaters for seven years.

Raves for the movie eventually reached the Smithsonian Institution, which approached the filmmakers about shooting a film about flying for its National Air and Space Museum—in a new wide-screen format called IMAX. MacGillivray and Freeman saw the challenge: The cameras were heavy, bulky affairs, fine for sitting still on a tripod but not for the kind of movement that MacGillivray-Freeman Films was used to. But it was also an opportunity: IMAX films had ten times the resolution of 35mm movies. After agreeing to take on the commission, they had to invent more-mobile cameras, helicopter mounts and other gear to achieve their vision.

Their first IMAX film, *To Fly* (1976), was a giant hit; more than one and one-half million people paid to see its breathtaking aerials projected on the Smithsonian's hundred-foot-high IMAX screen. It set a new standard in cinematic experience. But MacGillivray could hardly celebrate. His partner, Jim Freeman, died in a helicopter crash just as the movie opened.

By the early 1980s, the success of the first handful of large-format theaters had prompted other museums and venues to follow suit. These experiential movie houses grew here and abroad to about two dozen. Most of them turned to MacGillivray to create more wide-screen magic to attract their growing audiences. A Hawaiian theater wanted a movie on the beauties of its islands; an Indonesian theater wanted four films on its country; the Smithsonian and other museums wanted more nature and adventure films. MacGillivray and his team were soon producing a new movie a year, though each took two to three years of work to create.

MacGillivray had found a niche well suited to his sensibilities. "Unlike working in Hollywood, I like dealing with the nice people who own these theaters, particularly the museums," he told me. "They have a mission in life other than making money. I respect that." This art-friendly business climate also allowed him to take more risks. "In commercial features, the adage is that you never use your own money to make movies, whereas occasionally we didn't wait for the theaters to commission these films. For *The Living Sea* (1995), we invested seventy-five percent of the funds ourselves and took a big risk. Fortunately, it grossed a hundred million dollars." It was also nominated for an Academy Award. In 1998, his film *Everest* was the first large-format film ever to reach *Variety's* top-ten box-office chart.

Thirty-five gorgeous, captivating, big-screen films later, MacGillivray has produced five of the top ten, and ten of the top twenty moneymakers ever made in this category. Yet, his casual demeanor still recalls the high-school guy who traveled the state, happily shooting 16mm films of surfers and waves.

■ Born in the San Diego Naval Hospital in 1945, when his dad was stationed in the South Pacific; grew up in Corona del Mar, a bright student who excelled in high-school physics and thought of becoming a science teacher.

■ At age thirteen, took his parents' gift of an 8mm movie camera and started shooting and editing small films, soon graduating to 16mm; mowed lawns and delivered newspapers to save up money for film and processing.

■ In high school, spent his entire savings of three thousand dollars on a four-year odyssey, making a surf film; as a freshman at the University of California at Santa Barbara, found a distributor and opened *A Cool Wave of Color* to enthusiastic audiences.

GREG MacGILLIVRAY,
Documentary Filmmaker;
with a 70mm IMAX camera in
front of his Laguna Beach house,
2007

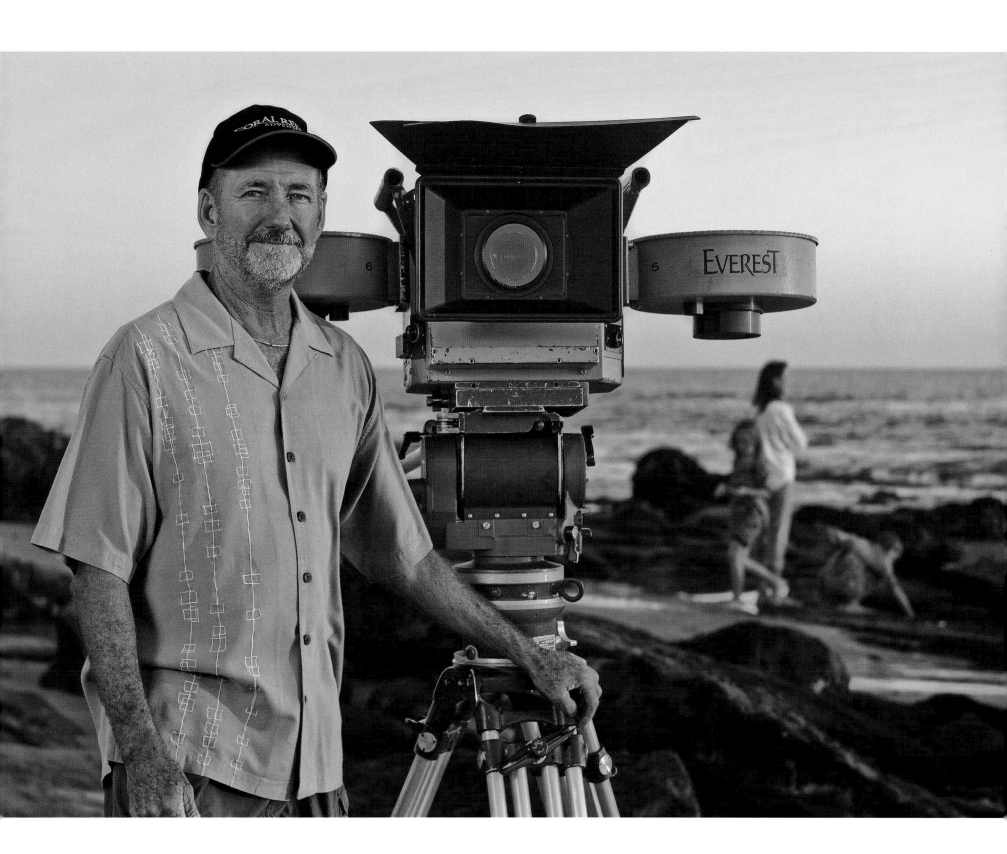

My philosophy of life is that if we make up our mind what we are going to make of our lives, then work hard toward that goal, we never lose— somehow we win out.

Ronald Reagan was the embodiment of the high achiever, turning an average intelligence and an acting career into leadership positions as a union boss, television host, governor and finally, two-term President of the United States. He played all these parts with aplomb, using his personal charm to make a lasting impact on Southern California and the world.

Throughout his multiple careers, Reagan spoke little about his ambitions, yet from the time he first moved to Los Angeles as a twenty-six-year-old sports announcer, he continually pursued one lofty dream after another in the public spotlight.

After years in front of a camera as an actor and television host, he leaped into the even brighter spotlight of politics, motivated in part by the realization that he could make a lasting impact speaking for himself as a public official rather than reciting scripted lines.

While serving as the head of the Screen Actors Guild after John Kennedy's 1960 election, Reagan formally shifted his alliances to conservative Republicanism. He soon found a candidate to match his newfound philosophy: Barry Goldwater. In a nominating address for Goldwater's 1964 presidential bid, Reagan gave a speech that launched his own political career: "The founding fathers knew a government can't control the economy without controlling people. And they knew when a government sets out to do that, it must use force and coercion to achieve its purpose. So we have come to a time for choosing."

The accolades he received from this address propelled him to seek the California governorship, which he won in 1966 and again in 1970. His good looks, on-camera ease and sense of humor garnered him more supporters than many of his policies did. Gradually, during his gubernatorial years, he came into a more cohesive and popular vision (later dubbed "Reaganomics") to shrink taxes, the size and cost of government and citizens' dependence on it, believing that such moves would lead "toward renewed respect for—and greater reliance on—the collective genius and common sense of the people." Under his watch, he also completed the Central Water Project, added many new highways, increased funding for higher education and reformed welfare.

Reagan's political ambitions didn't stop with California; he tried unsuccessfully to win his party's presidential nomination in 1968 and again in 1976, finally winning the nomination and general election in 1980, when he defeated incumbent Jimmy Carter, and again four years later, running against Walter Mondale. Surrounding himself with a top notch team, Reagan proved he could be an effective world leader with a vision for change. With his concept of supply-side economics, he was able to cut taxes, spur an economic recovery and increase defense capability. His strong-willed foreign policy was credited with increasing America's influence through the world and helping to precipitate the collapse of the Soviet Union. A victim of Alzheimer's disease while still in office, he died in 2004.

Ronald Reagan once remarked, "America is too great to dream small dreams." He certainly never did.

- Born in 1911 and raised in Tampico, Illinois, in a middle-class family; excelled at sports in high school and at Eureka College; became a major league baseball radio announcer, and while traveling with the Cubs to Los Angeles in 1937, got a screen test with Warner Bros. that led to a seven-year acting contract; starred in some modest hits: *Dark Victory* (1939), *Hell's Kitchen* (1939), *Knute Rockne—All American* (1940) and *Kings Row* (1942).

- When his film career sagged, his agent, the legendary Lew Wasserman, got him a lucrative eight-year deal to host and own a piece of *General Electric Theater*, a half-hour CBS anthology series.

- Originally a Democrat, he shifted his sympathies far to the right after touring the country as a pro-business spokesman for General Electric.

- Met his first wife, actress Jane Wyman, on the set of *Brother Rat* (1938); elected Screen Actors Guild president in 1947 and became embroiled in the union's anti-Communist purges during the cold war; his political stances and ambitions caused a rift in his marriage and led to a divorce; married actress Nancy Davis four years later in 1952; she became his staunchest supporter.

RONALD REAGAN,
Politician, Actor;
with wife Nancy at the
Music Center, Los Angeles, 1972

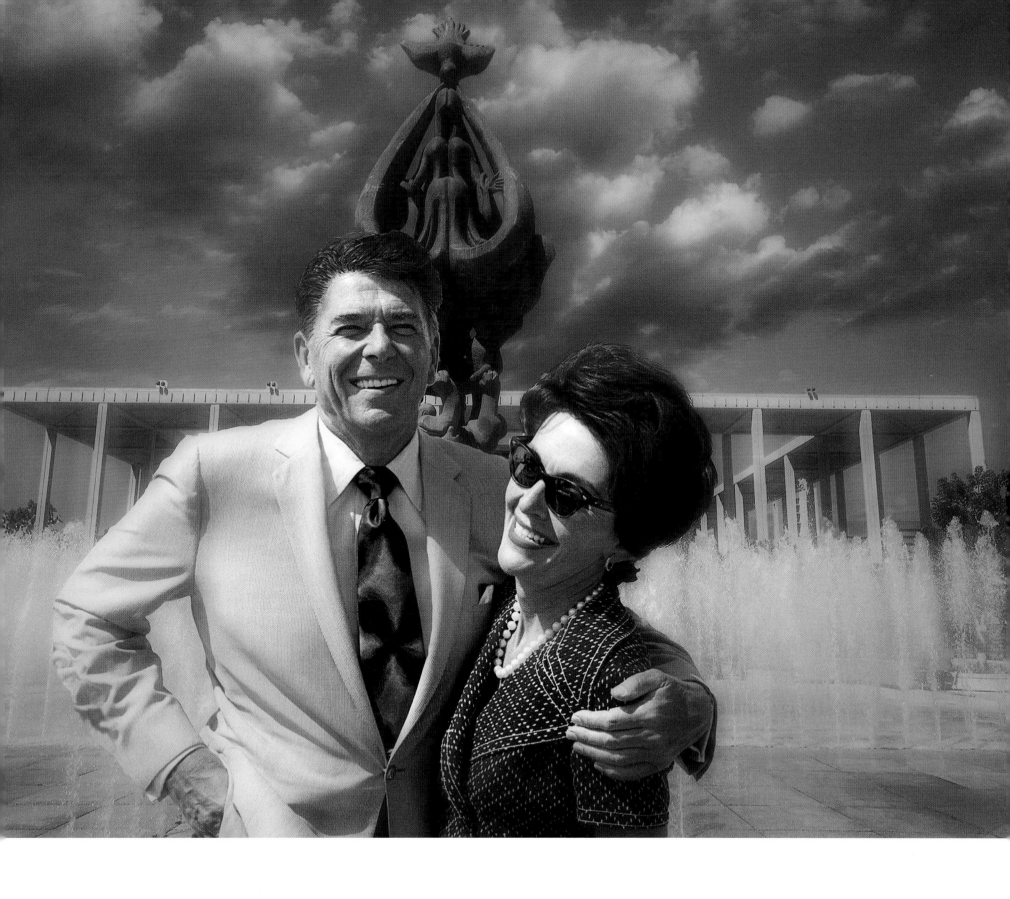

THE ENTREPRENEURS

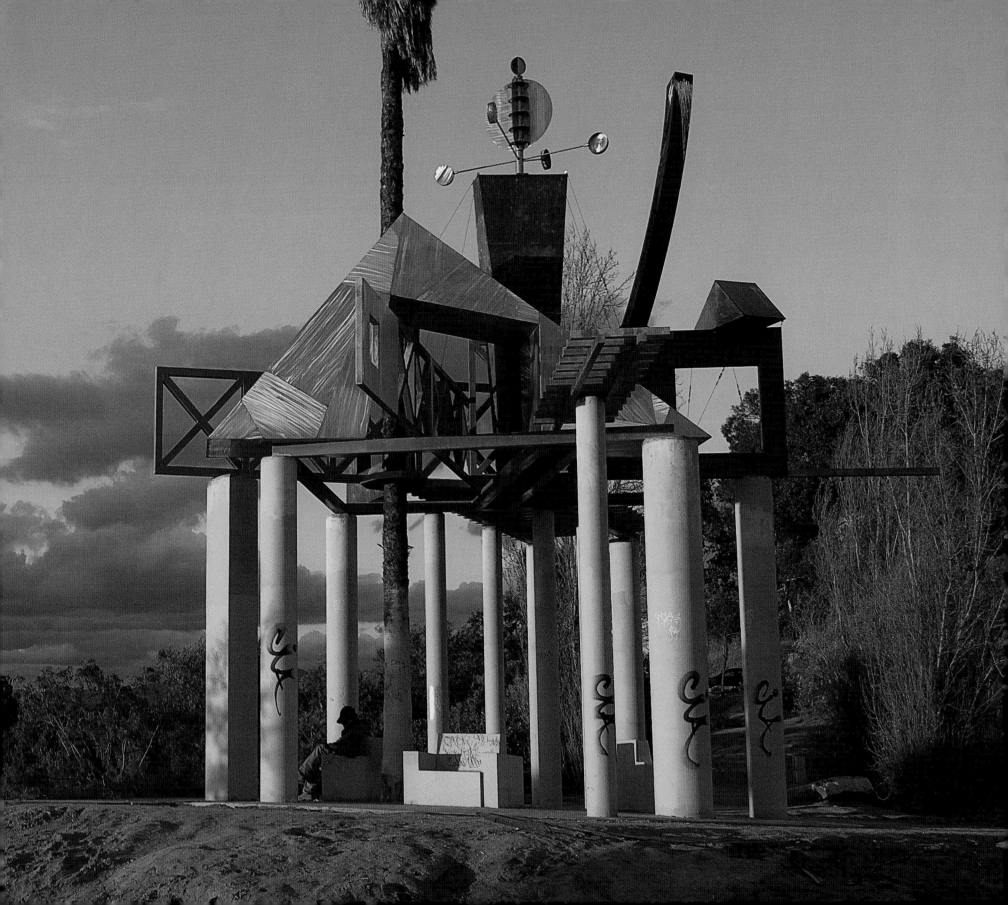

THE ENTREPRENEURS

HARRY CHANDLER—Newspaper Publisher, Real-Estate Developer ■ ELI BROAD—Businessman, Philanthropist
HOWARD HUGHES—Film Producer, Aviator, Businessman ■ EDGAR ACOSTA—Restaurateur ■ BILL GROSS—Entrepreneur
CREATIVE ARTISTS AGENCY TRAINEES ■ GENE AUTRY—Singer, Actor, Businessman

Southern California has long proved to be fertile ground for new ideas, new companies and high-achieving individuals. Businessmen and women have built cities and industries here, companies and products, legacies and fortunes. Aided by the Southland's unlimited supply of workers and trading partners, abundant natural resources and a business climate that encourages start-ups, these entrepreneurs have pushed the economic engine of the L.A. region into overdrive. Although a much younger area than its eastern and northern California counterparts, Southern California now surpasses all other U.S. urban centers in its gross domestic product. As a stand-alone U.S. state, the five Southland counties would rank third in the economic rankings—and sixteenth as an independent nation, just behind Mexico and ahead of the Netherlands. In this chapter is an exceptional group of entrepreneurs, boosters, and industrialists—plus a bootstrap immigrant and some aspiring film honchos—who are leaders in L.A.'s march to the top of the world's economic hierarchy.

I first shook hands with Eli Broad at a downtown civic event. But until I visited his Brentwood house for the photo shoot, we were essentially strangers. As one of the city's richest men, one of its largest benefactors and the founder of two Fortune 500 companies (KB Homes and SunAmerica), Broad was someone I really looked forward to talking to. Before our meeting, I had suggested to his assistant that he dress more casually than the suits I had always seen him photographed in, but she said that he was not comfortable being in casual clothes. He welcomed me to his home wearing a dark suit, white shirt, conservative tie and pocket square. On the tour of his remarkable hillside house, he was understandably proud of its dramatic architecture, but he showed even more pleasure introducing the famous contemporary American art pieces displayed inside. Yet as we talked, I found Eli to be like his attire: immaculately courteous but formal to the point of distraction. As he sat stiffly in his living room for the portrait, he reminded me of a tycoon from another era—a DuPont or a Morgan. All that was missing was the top hat.

Much more casual and approachable is Pasadena's legendary serial entrepreneur Bill Gross—with whom I was fortunate to work. In the late 1990s, Bill conceived and launched dozens of technology companies, among them a small search engine called Goto.com, which turned out to be Bill's biggest hit, as it invented the multibillion-dollar industry of paid search results. When I joined in 1998 to head new business development, the company had two million dollars in annual revenues. Four years later when I left, that number had already grown to a billion dollars. Gross was our founding board member and sometime-mentor, a man whose leadership helped achieve those heady growth figures. I found him to be incredibly bright and energetic; always full of new ideas—not all good, mind you—but his rapid assessment skills and big-picture thinking were truly inspiring.

Another notable businessman with an unquenchable thirst for starting or investing in new ventures was my own great-grandfather, Harry Chandler, the second publisher of the *Los Angeles Times*. Although he died nine years before I was born, I

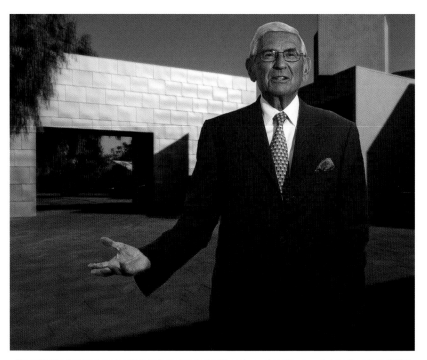

ELI BROAD, Businessman, Philanthropist; in his Brentwood motor court, Los Angeles, 2007

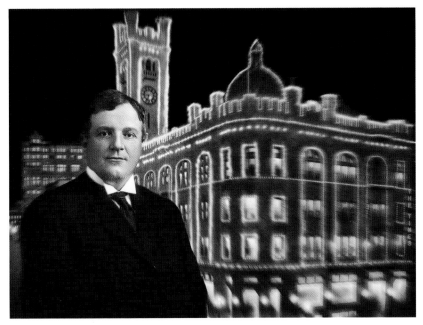

HARRY CHANDLER, Newspaper Publisher, Real-Estate Developer;
in front of the *Los Angeles Times* building, Los Angeles, ca. 1915

their cousins, friends and visiting dignitaries. His daughter Ruth told me that she remembers her father asking her mother about one of the houseguests he noticed at the breakfast table. He was shocked when she calmly informed him, "She has been living with us over two months, dear!"

One of my favorite stories about my great-grandfather I uncovered while digging through his business files at the Huntington Library in San Marino. Harry was on the board of one of the prominent downtown banks when his greatest newspaper rival, William Randolph Hearst, having fallen into tough times after the stock market crash of 1929 and overspending on his multiple residences, approached the bank for a loan to allow him to make payroll for his newspapers. He was willing to pledge his lavish San Simeon castle and its surrounding ranchland as collateral, but the bank managers were wary. So, mischievously, Harry secretly made the six-hundred-thousand-dollar loan himself. Hearst was relieved to keep his company afloat—but must have been aghast when later he found out who held his loan. A few years went by and Hearst was behind on payments, so Harry and an associate of his decided to visit the castle to decide whether to take over some of the surrounding land to satisfy the debt. Unexpectedly, Hearst and his live-in mistress, Marion Davies, were waiting for them as they came up to the hilltop of their grand estate. As he was taken on a tour of the extravagant grounds, Harry took much pleasure in making Hearst squirm about the future of his property. Finally Hearst asked him straight out why Harry had made the loan. And Harry responded, "Because if I ever saw you teetering on the brink of disaster, it would give me great pleasure being the one to give you the final push over." Hearst was taken aback, but Harry's smile let him know he was kidding. Chandler decided not to foreclose on the castle land, allowing Hearst to make payments to his rival until almost ten years later, when the State of California bought enough of the San Simeon ranchland to enable Hearst to finally pay off Harry's loan.

have long felt his presence loom large over my own life. He loved to work, took few vacations and although he was one of the city's wealthiest men, wore a suit until it was threadbare. He kept lengthy and unique office hours. He would be at his desk all day, go home for dinner and then return to the *Times* until past midnight, when the paper's columns were finalized and the printing began. He had so many engagements that meetings would be often scheduled as late as 2:00 A.M., yet his door was always open to others with ideas for the city, from someone needing cash to start a little corner store, to a businessman ready to start a new industry. When he wasn't working, my great-grandfather spent most of his time at home, which couldn't have been restful, since his Los Feliz house had a dozen bedrooms that were always filled with his eight children,

And the Times *is a professional spectator at this greatest drama on earth—
the building of a great city, the like of which has never been seen
in the world before—a city which stands unique and alone.*

Harry Chandler

Harry Chandler was Los Angeles' greatest booster, builder and kingmaker in the era of its greatest growth. A rags-to-riches success who, as the second publisher of the *Los Angeles Times,* tirelessly dedicated himself to the dream of making a great city. He was also my great-grandfather and namesake.

In the 1880s, when a twenty-year-old Harry arrived in Los Angeles, the small pueblo was a land of sunshine and opportunity that perfectly suited this young, penniless entrepreneur. He wandered into the San Fernando Valley and found work breaking colts and picking fruit. As partial payment he got permission to sell some of the fruit to nearby farm laborers. He saved and bought a horse and buggy to help transport the fruit. Within a year, Harry was hauling fruit in the daytime and delivering most of the city's half-dozen newspapers in the morning. That put him in contact with the *Los Angeles Times*' founder Harrison Gray Otis. Otis liked the enterprising young man and soon hired him as the general manager of the four-page broadsheet with its paltry daily circulation of 1,400.

Soon married to Otis's daughter, Harry took over as publisher upon her father's death in 1917. In a few years, he pushed the paper to surpass all other American newspapers in the number of ad pages. The paper was influential and profitable, which allowed Harry, with his unlimited energy, to pursue his other ambitious agenda: transforming Southern California.

Using the clout of the *Times*, he embarked on a lifelong quest to expand and improve the city—becoming, in the process, a very wealthy man. He stimulated tourism and immigration with publications like special mid-winter editions of the newspaper that were distributed across the country, promoting the region's idealized lifestyle. He fought for constructing the key foundations of a great city: its harbors, water supply, transportation and industries. Yet his involvement went far beyond the realm of a newspaper advocate. He personally wrote checks and joined the boards to co-found a breathtaking number of Southern California institutions and landmarks.

As a real-estate investor, he was the lead partner in syndicates that owned and developed much of the San Fernando Valley (and no, the movie *Chinatown* (1974) was *not* the real story of Harry and his developer partners), much of Hollywood and the Hollywood Hills (where he erected the Hollywoodland sign with four thousand light bulbs illuminating it for the first sixteen years, to promote the development), Mulholland Drive, much of Dana Point, the Tejon Ranch, the Vermejo Park Ranch and the C & M Ranch. At one point these holdings made him one of the largest private landowners in the United States. At the same time, he was an officer or director in thirty-five California corporations, working in sectors that included oil, shipping and banking.

Rival newspapers, including Hearst's *Los Angeles Examiner*, unions, left-leaning writers and elected officials regularly denounced Harry's actions and the paper's policies, yet by all accounts he was a kindhearted man responsible for a staggering number of transformational accomplishments. When Harry died in 1944, his *Newsweek* obituary, titled "Midas of California," began: "He had been called the most hated man in California. Yet, paradoxically, more than any other man, Harry Chandler was given the credit for building the great city of Los Angeles from a pueblo of twelve thousand inhabitants to a metropolis of close to two million."

- Born in Landaff, New Hampshire in 1864 to a modest family that had been farming for generations since the first Chandlers arrived from England in the late 1600s.

- Exhibited his risk-taking first as a student at Dartmouth College when one winter day, acting on a dare, he jumped into a vat of ice water, contracting pneumonia as a result and forcing him to withdraw from classes and head to L.A. to recover.

- His first wife, Magdalena, died while delivering their second daughter; quickly courted and married his boss's daughter, Marian Otis, with whom he would have six children.

- Nearly was killed for his pro-business and anti-union advocacy in 1910, having left his office minutes before a bomb planted by two Chicago union terrorists ripped apart the *Times* building, killing twenty employees and injuring dozens more.

**HARRY CHANDLER,
Newspaper Publisher,
Real-Estate Developer;
Los Angeles, ca. 1930**

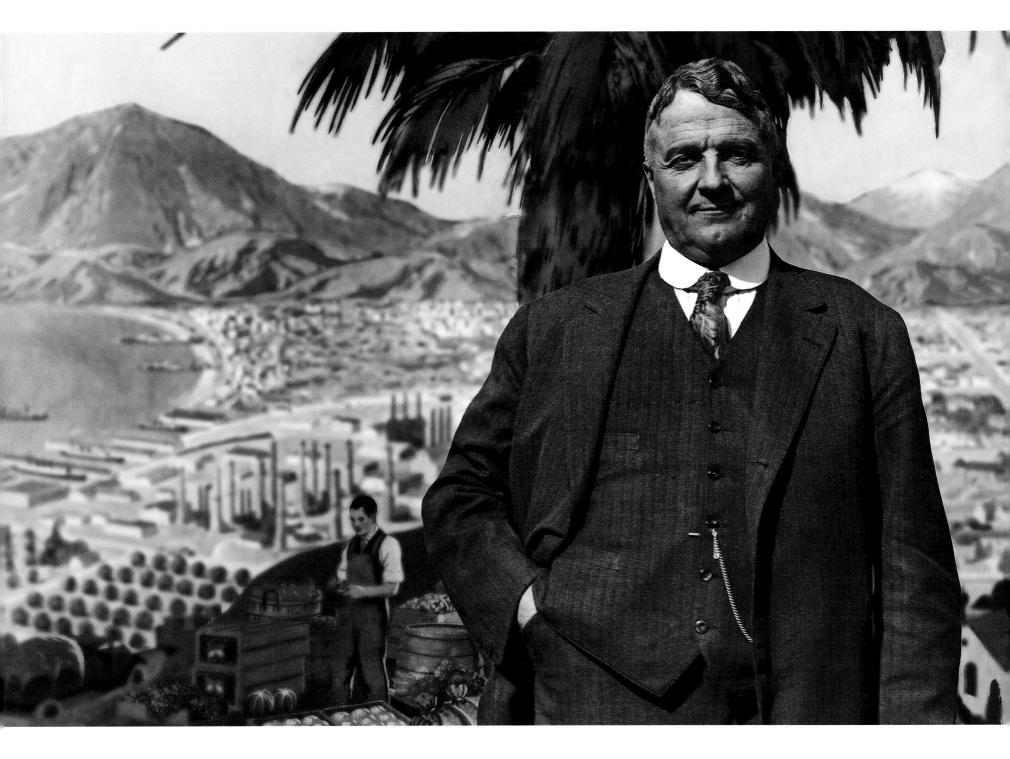

L.A. is a meritocracy where if you work hard, you're accepted.
The city's been good to me. And I want to give back.

Eli Broad didn't retire with his riches from founding two multi-billion dollar businesses; instead he devoted himself to his passions for the arts, civic initiatives, medicine and education, transforming himself into Los Angeles' greatest culture supporter and philanthropist.

With a net worth in the billions of dollars, Broad's spectacular story took a turn into philanthropy when he was first introduced to the art world by his wife. Broad found it "a relief from spending all my time with bankers and other businesspeople." He started his art collection with a van Gogh drawing acquired for ninety-five thousand dollars. Since then, the Broads have created one of the world's finest contemporary art collections. One of his many purchases made headlines when he bought Roy Lichtenstein's *I . . . I'm Sorry* for $2.5 million at a Sotheby's auction and paid for it with his American Express card—earning 2.5 million frequent flier miles, which he subsequently donated to an art school so students could travel abroad.

In the 1990s, the Frank Gehry-designed Walt Disney Concert Hall was stalled due to a lack of sufficient funds, so Broad and Los Angeles Mayor Richard Riordan took on the task of completing the fund-raising. The team reached out to another level of Southern California donors and solved the shortfall. Then once Disney Hall opened, Broad helped lead the effort to raise more funds to turn Grand Avenue—where the Music Center, Disney Hall and the Museum of Contemporary Art stand—into a cultural and retail destination.

"I am a civic and social entrepreneur," Broad explained to a reporter. "Everything we do is aimed at creating things that did not exist before." His efforts have resulted in the new Broad Contemporary Art Museum at LACMA, the Eli and Edythe Broad Art Center at UCLA, the Broad Center for the Biological Sciences at Caltech, the Eli and Edythe Broad Graduate Art Studios at CalArts and the Broad Center for Superintendents, a training program for future school district leaders. Obviously he is not shy about demanding that the buildings he funds are named for him and his wife. "You want to do good. You want people to think well of what you're doing," Broad says. "I don't think we remember the lawyers or the accountants. But we sure remember the architects and the artists." And the people the buildings are named for.

Broad, at seventy-four, showed no signs of slowing down when I met him. His longtime friend, former Mayor Riordan, goes hiking with him on the weekends and once told a reporter: "People ask me, 'Does he ever stop and smell the flowers?' He does, for ten seconds. And the next day he can tell what flower it was, the fragrance it had, and what artists have painted it."

While Broad is more comfortable speaking about specific projects than grand visions, the impressive results that he has achieved in transforming contemporary Los Angeles suggest that Eli is indeed a true dreamer.

- Born in 1933 in the Bronx to Lithuanian-immigrant parents; moved to Detroit at age seven, where his parents opened a five-and-dime; resisted the pressure to work in the store and instead set off to college at Michigan State University with dreams of doing something bigger.

- Married his hometown sweetheart, Edythe, and became the youngest certified public accountant in Michigan history.

- Co-founded Kaufman Broad (KB) Homes to pioneer the mass-production of the affordable tract home; became a millionaire by the time he was twenty-six, when KB Homes filled suburbs throughout the West (and even France) with cookie-cutter houses.

- Moved to Los Angeles to be at the center of the tract-home market.

- During a building recession in the 1980s, saw the need for a business to counter-balance the volatility of the housing sector and launched an insurance division, whose success soon developed into SunAmerica, a second Fortune 500 success.

ELI BROAD,
Businessman, Philanthropist;
in his Brentwood home,
beneath Jasper Johns' *Flag***, 2007.**

I am by nature a perfectionist, and I seem to have trouble allowing anything to go through in a half-perfect condition. So if I made any mistake it was in working too hard and in doing too much of it with my own hands.

Howard Hughes was a larger-than-life character—defined by moxie and enigma—who excelled in Southern California's three main industries—film, aviation and real estate.

Using his father's Hughes Tool Company fortune, Howard Hughes combined his passions for aviation and filmmaking into producing an action movie about World War I fighter pilots called *Hell's Angels* (1930) with Jean Harlow, for which he acquired the largest private air force in the world and personally directed the aerial combat scenes. The movie set records for the biggest budget and box-office receipts of its day. Hughes also financed the original *Scarface* (1932) and *The Outlaw* (1943), which starred Jane Russell.

Simultaneously, Hughes formed the Hughes Aircraft Company to manufacture a series of innovative airplanes. Preferring to be a working designer and test pilot rather then a manager sitting behind a desk, he set speed records of 352 miles per hour in 1935, a coast-to-coast record of seven hours and twenty-eight minutes in 1937, and an around-the-world record of three days, nineteen hours and seventeen minutes in 1938—the latter earned him his own ticker-tape parade on New York's Broadway.

During World War II, Hughes focused on designing experimental planes for the military. His most notable invention was a wooden troop carrier designed to carry 750 passengers, the Hughes Flying Boat, nicknamed the *Spruce Goose*. With its eight engines and 320-foot wingspan, it remains the largest plane ever made. In 1947, Hughes piloted it for its sole, brief voyage: a one-mile trip across the Long Beach Harbor.

His daredevil reputation, large fortune and handsome looks naturally attracted female admirers. After his first marriage dissolved, Hughes romanced numerous leading ladies including Katharine Hepburn, Ava Gardner, Ginger Rogers and Lana Turner—as well as a long list of starlets, including a twenty-five-year-old named Jean Peters, whom he married in 1957 and divorced in 1971.

By 1950, Hughes began acting strangely, compulsively fixating over trivial tasks and becoming at times indecisive and confused. "I'm not a paranoid, deranged millionaire," he quipped, "Goddammit, I'm a billionaire." His doctors could neither diagnose nor treat his symptoms. Current theories range from brain damage, to obsessive-compulsive disorder, to advanced syphilis. His behavior became so erratic that he eventually retreated into paranoid solitude. Because he failed to appear in court in 1963 for an antitrust case against TWA, he ultimately lost ownership of the airline. In 1972, he was forced to sell Hughes Tool Company, the basis for his fortune.

For many of his later years, Hughes holed up in the penthouse of the Desert Inn in Las Vegas. When the management tried to evict the high-maintenance recluse, he bought the hotel instead of moving again. The billionaire fed his cinema habit, in the days before VCRs and DVDs, by purchasing a local television station so he could program the movies he wanted to watch late into the night. If he fell asleep during a film, he would call to order a replay of the scenes he missed.

When he passed away in 1976, weighing only ninety pounds, he left behind an estate valued at two billion dollars, without a will—and four hundred willing heirs. Had illness not crippled him, this risk-taking, record-setting entrepreneur and aviator would have soared to even greater heights.

- Born in 1905 in Houston, Texas, the son of a successful oil wildcatter and inventor of drill bits for drilling rigs, and a mother who obsessively protected him from germs and diseases.

- As a teenager, inherited almost nine hundred thousand dollars upon his parents' early deaths.

- Dropped out of Rice University, married Ella Rice and moved from Houston to Los Angeles in 1925 to pursue his two interests: moviemaking and aviation.

- Crashed one of his experimental planes, the XF-11, into the roof of a Beverly Hills house, severely injuring himself; was rescued by a Marine Corps sergeant and rushed to the hospital where he barely survived; sent a check to cover the house's damages and a weekly reward to the marine for the rest of his life.

- To avoid paying income tax, changed his legal residency every 180 days, moving from hotel suite to hotel suite in different states and abroad in the Bahamas, Nicaragua, Canada, Mexico and England.

- In Las Vegas, purchased the Desert Inn, the Sands, the Landmark, the Castaways and the Silver Slipper, plus the airport and substantial land, in an attempt to save the city from its Mafia-controlled gambling roots.

**HOWARD HUGHES,
Film Producer, Aviator,
Businessman;
at the controls of the
Spruce Goose,
Long Beach Harbor, 1947**

*My dream was to come to the U.S. and get a piece of the pie,
the American pie—to own my own house and land,
then to have my own business.*

Edgar Acosta is a Philippine-born restaurateur whose career embodies the success stories of thousands of small-business owners in Southern California pursuing the American dream. Through hard work and talent, he is triumphing in his own life, while enriching the lives of others.

"When I was a young boy in the Philippines," Acosta told me, "I remember hearing about Universal Studios and seeing all the images of Los Angeles in the movies and thinking that I want to get there." It took a U.S. military invasion and an American general to make that happen.

While working in a Manila hotel in 1981, Acosta happened to impress a Saudi Arabian sheik, who offered him a job working in a luxury hotel restaurant in the Saudi city of Dhahran—at five times his pay. Acosta was torn. Although ready to leave the Philippines and desperate to make a living wage, he would have to leave his wife and young children behind. When the sheik agreed to fly him home once a year to see his family, Acosta agreed.

After nine years of unrelenting work supervising three meals a day, seven days a week in the Saudi restaurant, Acosta was lonely and still no closer to his dream of owning his own establishment. Then, in 1990, Iraqi president Saddam Hussein's invasion of neighboring Kuwait suddenly filled the hotel with the exiled Kuwaiti royal family and other notables, stretching his workload to the limit.

Into this surreal world marched U.S. General Norman Schwarzkopf and staff. The hotel became a command center for Operation Desert Storm, to drive the Iraqis from Kuwait. Acosta was assigned to serve Schwarzkopf personally. As the distant negotiations between Hussein and the United Nations stalemated, Acosta remembers the general and his team suddenly moving into full alert. Then while the rest of the world watched CNN reports of the half-million U.S. and coalition troops pushing toward Baghdad, Acosta continued to cook meals for the commander of that invasion. When the war ended as fast as it had begun, Acosta was offered free passage to America aboard one of the departing troop planes to the States—Schwarzkopf himself wrote a personal recommendation. Uncertain where in the U.S. to go, Acosta remembered the idyllic images he had seen in films and television and announced that he wanted to go to Hollywood.

His first months in Southern California were anything but idyllic. "It was back to zero," he recalled. With no connections, his years of hard work and advancements abroad meant nothing. He finally got a job at a French crêperie in the famed Farmer's Market, but the tiny food stand hardly compared to the big restaurant he had been running in Dhahran. He soon impressed the French owner and was promoted to manager, upgraded the staff with other Filipino-Americans and increased sales dramatically. Most important, he was at last able to send for his family and permanently reunite with them in Los Angeles.

In 2002, just as The Grove shopping mall was opening nearby, his boss informed Acosta that he needed to sell the crêperie. Acosta saw an opening. He worked around the clock and borrowed enough money from friends and family to buy it. His dream of becoming an owner had come true at last. Two years later, his business was so good that he opened a second crêperie, in Hollywood, of course. "If you really want to change your life, this is where to come," he says.

■ Born in the 1950s in the Philippines.

■ Began his career in Manila as a cook's helper, then waiter, then headwaiter, then assistant manager of a hotel's restaurant.

EDGAR ACOSTA,
Restaurateur;
at his cafe at Los Angeles'
Farmers Market, 2007

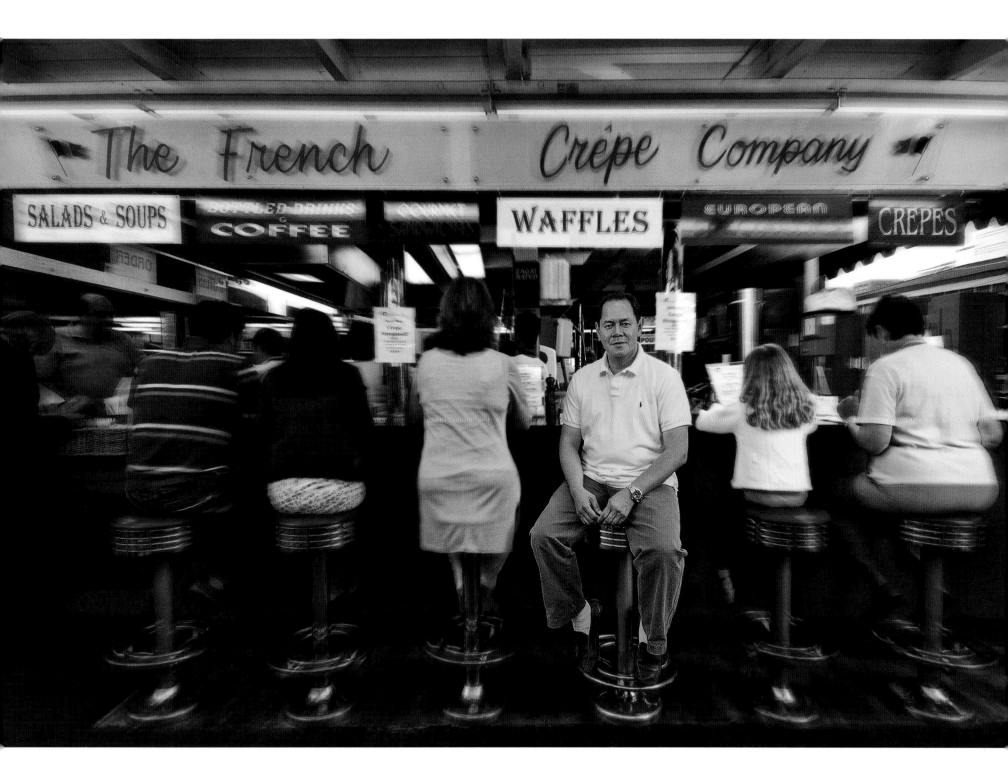

Being a dreamer in Southern California, you aren't an outcast like you are in other places. Here you fit in.

Bill Gross is the ultimate technology dreamer and serial entrepreneur. He built several high-tech companies of his own before founding the world's most storied business incubator, Idealab, which has birthed a hundred companies in less than a decade.

After seeing firsthand how difficult and risky it was to launch his own businesses, Gross conceived an organization that could support the launch and nurturing of many start-up companies. In 1996, he founded Idealab, in Pasadena, with the infrastructure to offer legal, technology and human resources support to several nascent companies simultaneously. He also raised enough cash to fund the first few months of their costs, before they had to secure subsequent venture capital financing. His timing couldn't have been more perfect; the Internet boom of the late 1990s accelerated, and Idealab proved itself to be a major player.

Bill, with his hyperactive, smartest-guy-in-the-room personality, invented business plans that became the bases for new companies. At his peak, Gross was launching about one new company every month. His biggest hits were Citysearch, now a part of IAC/InterActive Corp., which created local online community directories; eToys (now part of The Parent Company), an early leader of consumer e-commerce; and Goto.com (renamed Overture Services), which is now the driver of Yahoo's multi-billion-dollar advertising business.

The crash of the Internet bubble in 2001 severely tested Gross and Idealab. Many of his start-ups had to be shut down for lack of funding or customers. He personally lost tens of millions of dollars and narrowly skirted bankruptcy. Some later-stage investors sued him, trying to recover their own losses. His faith was shaken, but never broken.

When I revisited the Old Town Pasadena-based Idealab for the photo shoot, the mood was once again positive. Gross reported that about a third of his companies have been successful, a third have failed, and another third are still running but haven't yet become profitable. Gross boasted like a proud father about his next group of "children," pioneering new approaches to renewable energy, the next generations of robots, improving the Internet search experience and inventing new technologies like three-dimensional printing. Around his warehouse-style office, he supervises new groups of eager faces—perched over computer monitors and huddled around whiteboards in the conference rooms—searching for their own path to financial success.

Appropriately, Gross has grown more cautious since the Internet bubble popped. The bar on his screening process for starting new companies has been raised to now allow only one or two new companies a year. But this eternal optimist remains keenly on the hunt for his next winner.

"We are still looking for big problems to solve," Gross assured me, "particularly those that can have a positive impact. Often this means the more unorthodox the better. In particular, we are looking for good, disruptive ideas." Something that can upset current conventions, withstand the occasional attack—and make a big impact. It sounds like a description of Bill Gross himself.

- Born in 1958 in New Jersey; moved to Los Angeles with this family.

- At age fifteen, invented a parabolic dish that generated electricity from the sun; purchased ads in the classified section of *Popular Science* magazine and made a few thousand dollars selling plans and kits for the solar product.

- After being accepted to Caltech at seventeen, created a company to sell a new loudspeaker design; failed at this business, but gained the confidence to try again.

- After college, started a software company with his brother, which made a natural-language product called HAL for Lotus 1-2-3, the leading spreadsheet software of the day.

- On his third try, finally hit gold: founded Knowledge Adventure, which grew to be the third-largest educational software publisher.

BILL GROSS,
Entrepreneur;
in his Idealab office,
Pasadena, 2007

All truth passes through three stages.
First, it is ridiculed.
Second, it is violently opposed.
Third, it is accepted as being self evident.

ARTHUR SCHOPENHAUER

CAA Trainees stand tall in the ranks of entry-level entertainment executives. Hoping to make it on the business side of the music, film and television industries, these hardworking, over-qualified, underpaid twenty-somethings endure a long period of menial work to be in The Biz.

Hollywood is filled with entrepreneurs: the Mayers, Murdocks and Wassermans who have built the studios and networks. And behind them are hundreds of lesser-known but sometimes equally impressive individuals who produce movies or albums, run production companies or special-effects shops or develop scripts. Rather than select a single individual among the many success stories, well-known or otherwise, of Hollywood entrepreneurs, I chose a group of young dreamers who are just starting out on the path to fame and fortune: these young trainees at the famous Creative Artists Agency.

Long acknowledged as a Hollywood power center, CAA was made famous during the Michael Ovitz years as he and his agents wielded unprecedented deal-making power across a huge number of entertainment projects, representing stars such as Madonna, Bruce Springsteen, Dustin Hoffman, Tom Cruise, Barbra Streisand, Sylvester Stallone and Kevin Costner; and directors who included Steven Spielberg and Sidney Pollack. Today the talent agency occupies a stunning new Century City office where its clean architectural lines and immaculate white public spaces mask the energy of its tenacious negotiators working their phones and BlackBerries on behalf of clients like Wil Ferrell and Angelina Jolie, matching projects and talent, and brokering contract terms that include backend profits, creative approval rights and lavish perks.

The trainee programs at this and the other top talent agencies have launched the careers of numerous Hollywood heavyweights, including Barry Diller, Michael Eisner, Jeffrey Katzenberg, Michael Ovitz and David Geffen, who all came out of the legendary William Morris mailroom and went on to run studios, networks, record labels, and talent agencies. These boot camps for hustlers now attract some of the sharpest young Turks around, from top universities, some with MBAs or law degrees. They start out working fourteen-hour days in the mailroom, delivering scripts and running menial errands. After a few months, they "get on a desk," to assist an agent, including listening-in on an agent's phone calls—all in the hopes of becoming an agent themselves, getting hired away as a production executive or starting their own entertainment projects and companies.

During the morning of my photo shoot in the CAA lobby, the trade newspapers arrived and suddenly all the trainees grouped around them. One of their own, Ben Dey, was on the front page of the *Hollywood Reporter,* in a story about how a top movie producer, Brian Grazer, had just bought one of his pitches, *Coma Boy,* to develop into a comedic film. Grazer, of Imagine Entertainment, visits CAA once a year for a lunchtime meeting to hear pitches for movies and TV shows from the trainees. Dey's colleagues were enthusiastic and envious as they read about one of their own reaching the next rung of the ladder to success. It was a sign that their own dreams could also come true.

CREATIVE ARTISTS AGENCY TRAINEES, Century City, 2007
Left Grouping (left to right):
Back row: Craig Brody, Adriana Ambriz, Ben Kramer, Matt Mazzeo, Noah Edelman, Sara Malek, Ben Stone, Rudy Lopez-Negrete;
Front row: Arleta Fowler, Mike Elling, Larry Galper, Anthony Kaan.
Right Grouping (left to right):
Back row: Tim Little, Ben Dey, Alex Lerner;
Fourth row: Vikram Dhawer, Michelle McQuaid, Benjamin Blake, Josh Krauss;
Third row: Shawna Kornberg, Matt Rosen, Justin Castillo, Ryan Ly;
Second row: Andrew Saunders, Rosanna Bilow;
Front Row: Ryan Heck, Elika Tavana, Sean Carey.

There is a satisfaction that comes from success in business that is less personal, but also less selfish, than success in show business or sports.

Gene Autry was the ultimate Hollywood hyphenate, famous as a singer-actor-rodeo rider in film-radio-television-live performances. In his later years, he became a television producer-broadcaster-baseball team owner-museum founder.

In his youth, this multi-talented workaholic gave few indications that he one day would be successful. After graduating from high school, he was going nowhere fast as a railroad laborer in Oklahoma, when the famous humorist Will Rogers happened to hear Autry singing for his own pleasure in a telegraph office. Rogers encouraged Autry to go to Hollywood to get work singing in the movies.

At age twenty-seven, Autry arrived in Los Angeles with his wife, and within a year, signed a contract with Republic Pictures, an agreement that catapulted him into a prolific movie career. He appeared in ninety-three films over the next twenty years, mostly B-westerns in which he became renowned as "The Singing Cowboy." His affable screen personality and smooth singing voice made him one of the greatest western stars of all time. Gene and Ina Mae settled into a sprawling house with stables where he became an accomplished horseman, performing in rodeos, parades and stadiums. When he ran into Rogers again, the humorist said, "I see you made it, kid."

Autry released 640 recordings, including more than three hundred songs that he wrote or co-wrote. His record sales topped a hundred million. His recording of "Rudolph the Red-Nosed Reindeer" sold more than thirty million copies.

In 1950, Autry became one of the first major movie stars to work in television, where he created ninety-one episodes of *The Gene Autry Show* and produced other series, including *Annie Oakley*, *The Adventures of Champion*, and *Death Valley Days*. Autry is the only person to have all five of the possible stars on the Hollywood Walk of Fame: one each for films, TV, radio, recording, and live theater performance.

Though his performing trailed off in the late 1950s, Autry still dreamed of continued success and fame. Having invested wisely, he used his wealth, connections, and shrewd business sense to reinvent himself as a media tycoon.

He started by buying Challenge Records, a label that spawned a hit in 1958: the song "Tequila" by The Champs. Then, under the Golden West Broadcasters banner, he bought radio and television stations, including KOGO in San Diego, KMPC radio and KTLA television in Los Angeles. Autry proved himself an astute broadcast manager, increasing the ratings and success of these properties, and he made a fortune when he eventually sold them. KTLA, for example, was bought by Tribune for $245 million in 1982.

In 1960, when Major League Baseball announced plans to add another team in Los Angeles, Autry pursued the radio broadcast rights, but wound up becoming owner of the Los Angeles Angels. He was a passionate owner and fan, even after the team moved to Anaheim in 1966 and became known as the California Angels. He didn't live to see his beloved Angels win the World Series.

Autry's final dream was to create a museum celebrating the Old West. In 1988, the Gene Autry Western Heritage Museum opened in Griffith Park, featuring much of his collection of Western art and memorabilia. Now known as the Autry National Center of the American West, it incorporates three institutions dedicated to the study of the West and has become one of the finest museums of its kind. The Center presents exhibits that illuminate a wide range of Western characters and legends, but the most inspiring—and accomplished—of them all is Gene Autry himself.

- Born in 1907 near Tioga, Texas; raised in modest homes in Texas and Oklahoma.

- In 1934, packed up his Buick, guitars and accordion, and his wife Ina Mae, headed for Hollywood; wrote "Ridin' Down the Canyon," one of his first hit songs, along the drive, and claimed it took him only three miles to finish it.

- Made his debut on screen playing a caller at a barn dance in the movie *In Old Santa Fe* (1934), for which he earned five hundred dollars.

- From 1940 to 1956, hosted a live weekly CBS radio show, *Gene Autry's Melody Ranch*, featuring his theme song "Back In The Saddle Again;" continued to travel the country playing concerts and rodeos, often doing two shows a day, seven days a week, for months at a time.

- Having passed up a chance to play minor league baseball in his youth, bought part ownership in the Hollywood Stars, a minor league team that played at Gilmore Field.

- Allowed his name to be used by oil prospectors and ended up co-owning several successful oil operations in Oklahoma and Texas.

GENE AUTRY,
Singer, Actor, Businessman;
beside a publicity photo of
himself as "King of the Singing
Cowboys," Los Angeles, 1980

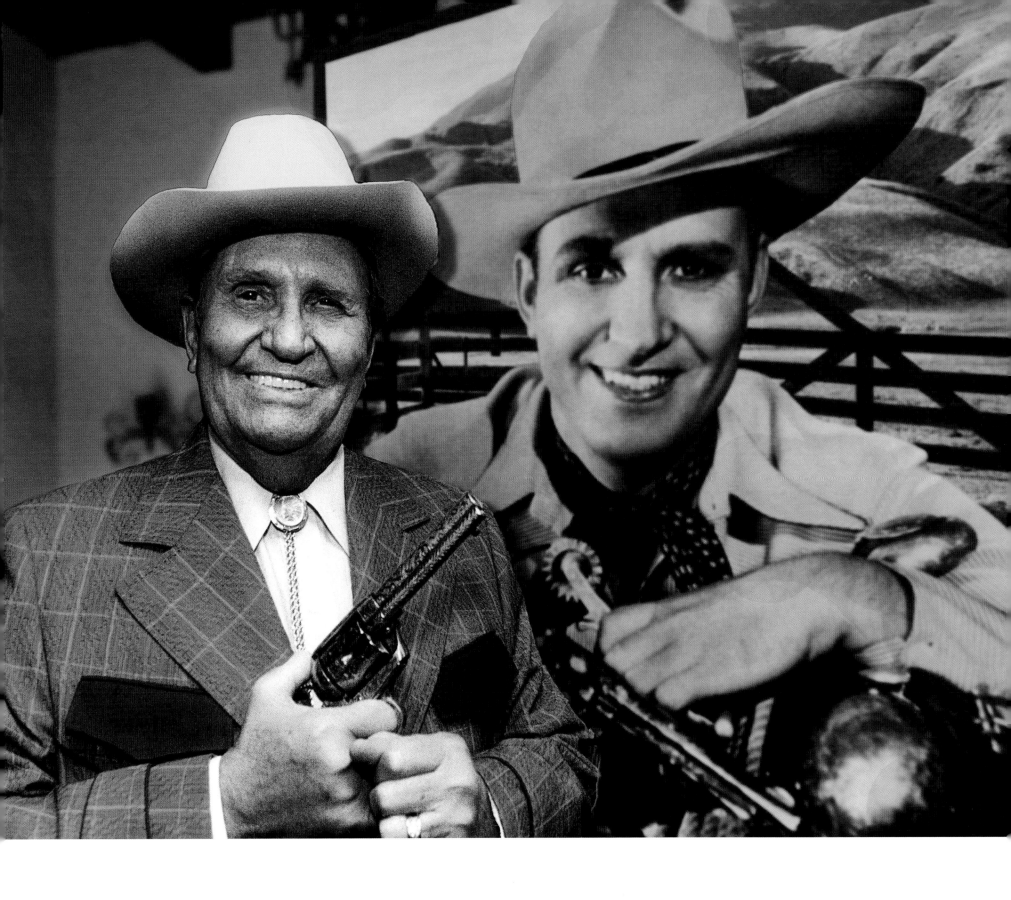

THE DISCOVERERS

THE DISCOVERERS

GEORGE ELLERY HALE—Astronomer ■ RAY BRADBURY—Writer
WALT DISNEY—Film Producer, Amusement Park Creator ■ BOB ROGERS—Exhibition Designer
ALDOUS HUXLEY—Author ■ BOB MITCHELL—Space Engineer ■ AMELIA EARHART—Aviator

Some people are not content to wrestle with the concerns of the here and now, but are driven to grapple with the unknown, pushing to the outer limits of human progress. These are the discoverers.

Southern California was founded by a succession of these individuals: the Spanish explorers who first touched our coastlines; the Franciscan missionaries and pioneers who started our communities, and the Yankee settlers who led the westward expansion to further colonize our cities.

From this heritage has come a steady stream of Angeleno explorers pushing the boundaries of knowledge and endeavor. The six men and one woman profiled here have been prodigious in their accomplishments and varied in their pursuits. They have made Southern California the center for celestial observation, record-setting aviation, and deep-space exploration. They have created Tomorrowland and the Kennedy Space Center, and have produced fly-bys of Mars and *The Martian Chronicles.* They have opened windows into the future and the doors of perception into our subconscious.

To research these pioneers, I went on modest journeys of discovery of my own. The first began in the hills of West Los Angeles. There Walt Disney constructed a half-mile, one-eighth-scale train layout, the Carolwood Pacific Railroad, in his Holmby Hills backyard, a train that he, his two daughters and guests could ride. My maternal grandmother, Jane Brant, who was a friend of the Disney family, told me of seeing Walt piloting his train around his yard, through a ninety-foot tunnel, past the switching yard and over the trestle. This hobby was the catalyst that propelled him beyond his film business to create a family-oriented amusement park with a full-scale train—Disneyland.

And it was at Disneyland, in 1959, when I was a boy of six, that I first got to see Walt Disney in action. I was fortunate to be one of the first to ride the bobsleds on the Matterhorn and to take the plunge on the Submarine Voyage. The occasion was a private affair for press and their families marking the park's expansion. Disney personally greeted my family on Main Street, and later I saw Walt enjoying a turn driving the train that ran around the park, just as he had done on his own backyard railway.

George Ellery Hale built an observatory on the summit of Mount Wilson that became home to a series of the world's largest telescopes and most powerful solar instruments, which revolutionized astronomy in the first four decades of the twentieth century. Walking among the telescope domes, towers and support buildings, I found it remarkable that most of their parts were hauled to the summit on foot or by mules. Ironically, my research also revealed that in 1904, when he first started building, Mount Wilson had the purest air in the country.

Another journey took me to Mulholland Drive, above Hollywood, to see a four-thousand-square-foot Mission-style home, complete with meditation paths, where the renowned author Aldous Huxley lived—and died—in 1963. His second wife, Laura, passed away there at age ninety-six in 2007. When I visited, the books, photos and artwork that belonged to Huxley and his wife were still there. Seeing these artifacts of Huxley's explorations into the subconscious through psychedelic drugs, religion and spiritualism brought back nostalgic memories of the late 1960s when my generation was so preoccupied with following the path that he had pioneered.

I also visited an undistinguished office complex in Burbank, the headquarters of a Disneyesque inventor named Bob Rogers. He is a magician—literally—who has developed a thriving business creating interactive and educational visitor centers and attractions around the world. Exploring his building—a mash-up of Thomas Edison's studio, Houdini's workshop, backstage at Disneyland and a Hollywood prop house—was great fun, as was hanging out with Rogers, the funniest and most sarcastic of all the dreamers I met.

I drove to La Cañada Flintridge, to the Jet Propulsion Laboratory, to meet a no-nonsense guy named Bob Mitchell. He is a real rocket scientist, who leads NASA's most challenging space flight by guiding the Cassini spacecraft by the moons of Saturn. After our photo session on the site of JPL's large Mars-lander test field, he described some of the high-level particulars of Saturn. This smartest-guy-in-the-room quickly lost me with technospeak and concepts beyond my high-school physics. Yet I could see in his eyes a wonderment and enthusiasm for these space explorations that was captivating.

And I went to Westwood to meet the octogenarian, futurist and author, Ray Bradbury. Planted in his writing chair while his black cat prowled between his legs, surrounded by strange sci-fi objects, wearing tall white knee socks, dark shorts and a windbreaker, Bradbury was the idiosyncratic dreamer. The master storyteller's intellect was as sharp as ever, as he carried on simultaneous conversations with a family

friend, his daughter and me. He pontificated on all manner of things, including the upcoming premiere of his new play, another book in the works and, of course, on Los Angeles. He pronounced his city a nurturing place that is the center of the universe for the creative world, which coming from someone who has thought a lot more about the universe than most, carries considerable weight.

Each stop on my photo and research voyage to better understand these remarkable pioneers provoked thought, not only about the success they achieved, but also about the worlds they envisioned. Now it is your turn to visit these discoverers.

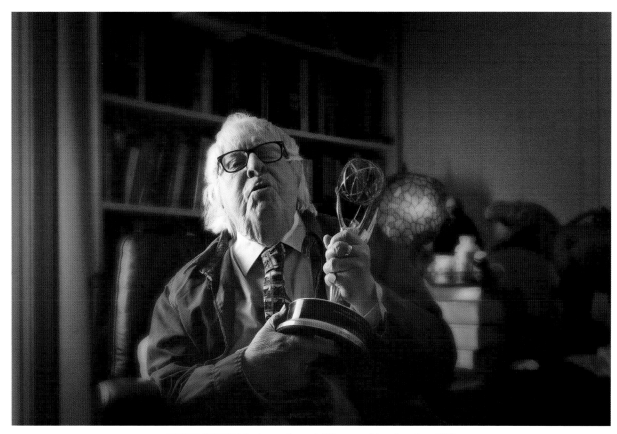

RAY BRADBURY, Author; at home in Westwood, Los Angeles, 2007

Like buried treasures, the outposts of the universe have beckoned to the adventurous from immemorial times . . .

George Ellery Hale pushed the frontiers of space observation further than any other twentieth-century scientist, making breakthrough astronomical discoveries of his own and constructing a succession of the most powerful telescopes ever built.

Hale came to fame when he was a professor at the University of Chicago and revolutionized solar observations with the invention of the spectroheliograph, an instrument that made it possible to photograph the sun's features. Next he built the first modern observatory, the Yerkes Observatory in Wisconsin, which housed the world's largest telescope—complete with a forty-inch lens.

But Hale soon saw the need for an even larger telescope. He headed to Pasadena, where he found a location that had unmatched calm air: Mount Wilson, where he established the world's ultimate center of observation for its day and for decades that followed. There, Hale seeded the preliminary construction of a sixty-inch telescope using twenty-seven thousand dollars of his own money. Never one to set his sights at anything but the top, he convinced steel magnate Andrew Carnegie to fund the $150,000 balance. After three years of work, the Hale telescope and observatory were finally operational. In December 1908, Hale took the first look into the reaches of space with never-before-seen clarity and magnification. Hale and the other astronomers who used it were able to calculate the first accurate measurement of the size of our galaxy and the solar system's position in it.

Months later Hale built a sixty-foot solar tower to observe the sun, which led to his discovery of the existence of magnetic fields in sunspots. To further study these sunspots, he then constructed a 150-foot solar tower, also funded by Carnegie's institute.

Never satisfied for long, by 1914, Hale began a project to build a hundred-inch telescope. Financed primarily by Los Angeles businessman John Hooker, the huge, nine-thousand-pound glass disk from which the lens was ground had to be shipped from France.

When the Hooker hundred-inch telescope was completed in 1917, and for thirty years afterwards, it was the world's largest. It revolutionized astronomy. The man who best exploited the power of the instrument was Hale's colleague, Edwin Hubble, whose first great discovery was faint lights in remote galaxies. By measuring the distances to these galaxies, Hubble estimated the size of the cosmos. Then in 1929, Hubble made an even greater discovery: he found that other galaxies were moving away from our own Milky Way—and, therefore, that the universe is expanding, which helped establish the Big Bang theory of the origin of the cosmos.

By the late 1920s, Hale was driven to unlock more mysteries of the heavens by constructing a two-hundred-inch telescope. He convinced the Rockefeller Foundation to donate six million dollars to Caltech for its construction on the 160 acres that Hale had secured on Palomar Mountain, a hundred miles southwest of Mount Wilson. To make the glass for the mirror, Corning Glass Works of New York turned sixty-five molten tons of Pyrex, carefully cooled over ten months, into a two-hundred-inch disk, which was shipped to Pasadena in a special train car, at a maximum speed of twenty-five miles per hour while thousands of people lined the train tracks to watch this special cargo pass by. Sadly, Hale was never to see his final masterpiece completed; his health failed and he died in 1938, before the telescope named for him was finally operational. In 2007, using adaptive optics to remove distortions, the clearest images of outer space ever taken came from the same two-hundred-inch giant that the prescient pioneer Hale had begun nearly eighty years earlier.

- Born in Chicago in 1868 to doting, wealthy parents who bought him professional-quality astronomical instruments throughout his teenage years; received his own solar observatory in his twenties.

- Earned a degree in physics from MIT in 1890; joined the faculty of the University of Chicago.

- Suffered several nervous breakdowns throughout his Southern California career, brought on by his perfectionist personality and the stress of managing his complicated building projects, forcing him more than once to abandon the efforts and to retreat into various sanatoriums.

GEORGE ELLERY HALE, Astronomer; with his patron, Andrew Carnegie (left), Mount Wilson Observatory, ca. 1920

If you dream the proper dreams, and share the myths with people, they will want to grow up to be like you.

Ray Bradbury is one of the legends of American fiction writers for his numerous works of fantasy, horror, science fiction and mystery—including *The Martian Chronicles* and *Fahrenheit 451.*

Bradbury was always mesmerized by the future. He grew up captivated by movies and stories set in space and in the worlds of tomorrow. By thirteen, he was building play spaceships in his backyard. Bradbury's first major success as a writer came at age thirty, when his novel about the first attempts to conquer and colonize Mars, *The Martian Chronicles*, was released. Its sophisticated prose and allegorical themes of racism, censorship and atomic war won many fans. Using realistic characters with conventional values allowed his readers to relate to them, even as fantastic things happened to them. Yet his writing didn't earn the professional respect Bradbury wanted. He remembered "being beat up by the New York intellectuals. The critics there ridiculed me for doing science fiction." At the time, sci-fi was still thought to be something suitable for pulp paperbacks, not hardcover literature.

Bradbury was not deterred; the critics' arrows only accelerated his exploration of the frontiers of fantasy and erudition. Next came *The Illustrated Man*, and then in 1953, his bestseller, *Fahrenheit 451*, a scathing indictment of censorship set in a future society where books are outlawed and freedom of thought is forbidden. The inspiration for the book, he has explained, was from an incident in 1949, during the anticommunist phobias of the McCarthy era, when he and a friend were walking the streets of Los Angeles and were stopped by a police officer, who proceeded to interrogate them without cause. Among Bradbury's other works are *Dandelion Wine, Something Wicked This Way Comes, I Sing the Body Electric!, Driving Blind* and *Quicker Than the Eye*.

For a man so preoccupied with the future and the cosmos, a lot about Bradbury is down-to-earth. He does not drive and never has. He fears flying in airplanes and didn't take his first flight until 1982. He is a pack rat of sorts, and has long collected memorabilia, toys, gifts from fans, souvenirs and papers relating to his works. His Westwood home office looks like a prop house for *Aliens*. Amid the clutter, even at age eighty-seven, this literary legend was still going strong, working on a new play, conducting interviews and planning his personal-appearance schedules.

On the occasion of his eightieth birthday, Bradbury wrote, "The great fun in my life has been getting up every morning and rushing to the typewriter because some new idea has hit me. The feeling I have every day is very much the same as it was when I was twelve. In any event, here I am, eighty years old, feeling no different, full of a great sense of joy, and glad for the long life that has been allowed me. I have good plans for the next ten or twenty years, and I hope you'll come along."

- Born in Waukegan, Illinois, in 1920; moved to Los Angeles as a teenager when his father was laid off as a telephone lineman and came west in search of work; after graduating from Los Angeles High School, opted not to go to college but to continue his education at night in the library.

- Wrote his first stories on rented typewriters while supporting himself selling newspapers; published several stories in magazines by the time he was twenty; his first book, *Dark Carnival,* was a collection of his short stories.

- Married a local girl, Marguerite McClure, and fathered four daughters.

- Published more than thirty books, hundreds of short stories, poems, essays, and plays; hosted his own television series, *The Ray Bradbury Theater,* an anthology drama that aired from 1985 to 1992; earned a star on the Hollywood Walk of Fame; an asteroid and a crater on the moon were named in his honor.

RAY BRADBURY,
Author;
Los Angeles, 2007

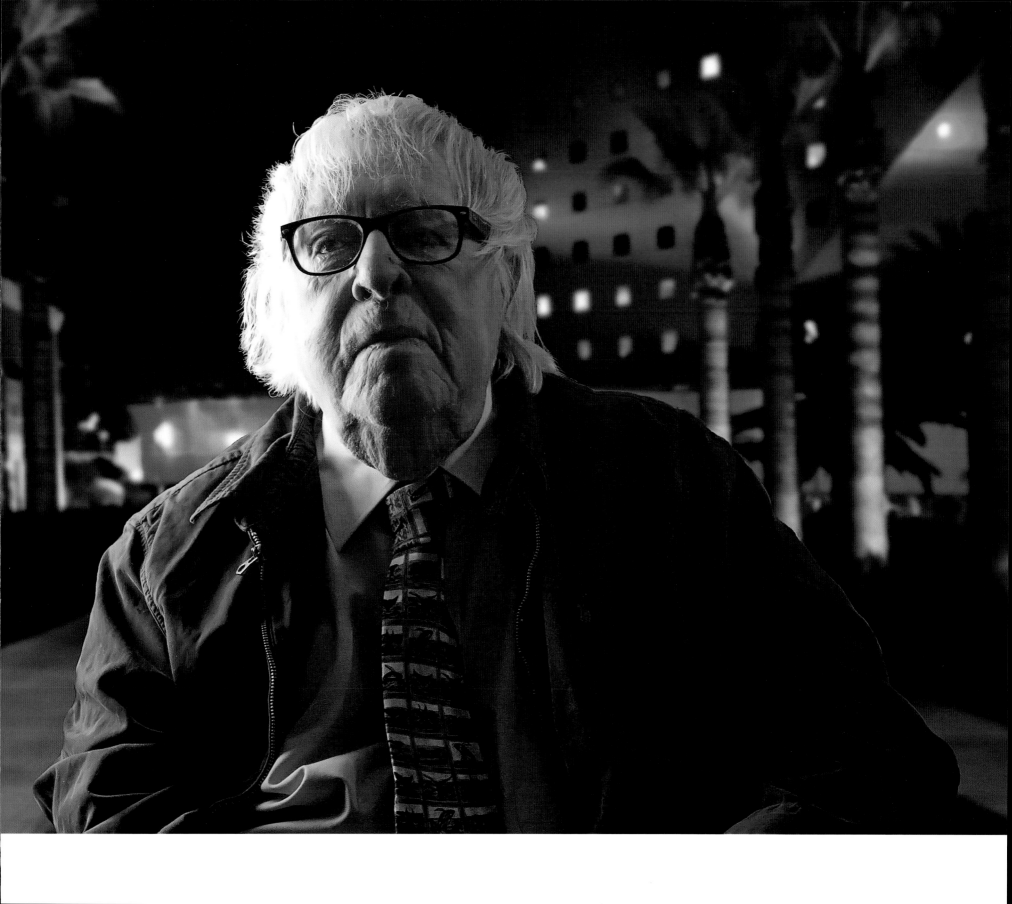

Somehow I can't believe there are any heights that can't be scaled by a man who knows the secret of making dreams come true. This special secret, it seems to me, can be summarized in four C's. They are Curiosity, Confidence, Courage, and Constancy—and the greatest of these is Confidence. When you believe a thing, believe it all the way, implicitly and unquestionably.

Walt Disney was the ultimate Angeleno dreamer. Starting as a cartoonist, he transformed family entertainment and created one of the most recognizable brands in the world. A lifelong pioneer and innovator, he arguably did more to touch the hearts, minds and emotions of audiences around the world than any other person in the twentieth century.

He was only twenty-one when he hopped on a train to Los Angeles, carrying an unfinished print of an animated short film—and a dream. Using money borrowed from his family, Disney set up shop in his uncle's garage, persuaded his older brother, Roy, to join him, and the two founded the Walt Disney Company.

Six years of struggle followed before their first real hit emerged. "Mickey Mouse popped out of my mind onto a drawing pad . . . on a train ride from Manhattan to Hollywood at a time when the business fortunes of my brother Roy and myself were at their lowest ebb and disaster seemed right around the corner," Disney later recalled. He introduced the character using his own voice as Mickey in a short cartoon, *Steamboat Willie*. Donald Duck, Goofy and other characters soon followed.

By the time Disney was in his early thirties, the Walt Disney Company had seventy-five employees. But he was miserable. Running the company more like a cult than a corporation, Disney pushed himself and his staff to produce more and better films. Working around the clock, he drove himself to the point of exhaustion and a near-breakdown. But his passion as a storyteller and talents as an animator kept him and the company going. In 1932, he created the first color cartoon, *Flowers and Trees*, which scored the first of his twenty-six (a record that still stands) Academy Awards.

In 1937, Disney and his animators adapted a classic German fairy tale and created the first feature-length animated movie, *Snow White and the Seven Dwarfs*. Its emotional impact on adults as well as the young resulted in a monster hit, enabling the studio to begin a series of legendary animated features that included: *Pinocchio* (1940), *Fantasia* (1940), *Dumbo* (1941) and *Bambi* (1942). After World War II, however, the studio's output seemed to go stale. Roy Disney struggled to placate the bankers and anxious stockholders, as profits sank and debts mounted. So Walt Disney rolled up his sleeves and led his team back, this time with hits such as *Cinderella* (1950), *Alice in Wonderland* (1951), *Peter Pan* (1953) and the live-action films *Treasure Island* (1950) and *20,000 Leagues Under the Sea* (1954).

In the early 1950s, Walt Disney dreamed of a way to entertain families beyond the movie theater: Disneyland, an amusement park completely different from the Ferris wheel and carny rides of the day. Raising enough money to build his village was a challenge. "I could never convince the financiers that Disneyland was feasible, because dreams offer too little collateral," Disney said later. "It takes a lot of money to make these dreams come true." Disneyland opened in Anaheim in 1955 and transformed family entertainment.

As Walt Disney entered his sixties, his studio was churning out successes, including *Sleeping Beauty* (1959), *101 Dalmatians* (1961), *Mary Poppins* (1964) and *The Jungle Book* (1967). His focus, though, was elsewhere. He started a design firm, WED (Walt's initials), to engineer new attractions at Disneyland, and a new theme park, Disney World, and a planned urban community, EPCOT Center, in Orlando, Florida. His death at sixty-five from lung cancer prevented him from seeing these additions to his Magic Kingdom. But his empire continued to flourish with new dreamers extending the legacy of the Disney imagination.

- Born in 1901; raised in Missouri by a mother who loved fun and a hardworking father whose many careers taught him self-confidence; developed a love of cartoon drawing in grade school.

- During high school, sold food on steam trains where his uncle, Michael, was a locomotive engineer.

- Dropped out of school at sixteen to enlist in the Red Cross Ambulance Corps and was sent to France at the conclusion of World War I; after the war, made short, animated films for a Kansas City advertising company; founded a little cartoon studio, Laugh-O-Grams.

- In Los Angeles, married one of his employees, Lillian Bounds, who became his lifelong partner and supporter.

- Never fit the image of the typical Hollywood mogul; a midwesterner at heart, who shunned the party scene, preferring to tinker with his backyard railroad or ride horses.

- Established the California Institute of the Arts in 1961, a college-level school of the creative and performing arts. "It's the principal thing I hope to leave when I move on to greener pastures. If I can help provide a place to develop the talent of the future, I think I will have accomplished something."

WALT DISNEY,
Film Producer,
Amusement Park Creator;
in the Viewliner train,
Disneyland, 1957

What I have tried to do in the things we have created is not to merely do magic, not just optical puzzles, but to give a warm feeling about the world. We try to connect with people, with emotions, with meaning—and to be enriching. We want to leave the world a better place than we found it. That is real magic!

Bob Rogers is a kid who never really grew up. One part jokester, one part storyteller, one part magician, he has created a world-renowned company that builds innovative educational visitor centers and attractions.

During his first job working at the Magic Store in Disneyland, a fellow magician gave Rogers an important lecture: "He said my job was not to show the guests how good I was, but to make them feel magical, feel smart and good about themselves." That lesson has helped guide his endeavors ever since.

After getting fired three times from various jobs at the Disney Company, Rogers started his Burbank-based company, BRC Imagination Arts, to offer his Hollywood entertainment skills to museums and visitor centers. He perfected his vision by studying mythology and fairytales to learn the secrets of storytelling, story structure and archetypes; researching new technologies; and taking advantage of L.A.'s depth in creative talent by hiring a team of exceptional artists, filmmakers and technicians. Motivated by his dream to entertain others in unique ways, he set out to create immersive and emotional experiences that educate, entertain and inspire visitors.

Rogers and his team have been on a tear ever since, creating projects that fuse showmanship with scholarship, including: the Abraham Lincoln Presidential Library and Museum in Springfield, Illinois, where the ghost of Lincoln (in the photo), and other historical figures, share the stage with a live actor; the U.S. Pavilion at the 2005 World's Fair in Japan, where two million visitors enjoyed a 3-D movie of Ben Franklin experiencing the technological advances of the three hundred years since he was born; and the Kennedy Space Center Visitor Complex, where audiences find themselves seemingly blasting into space on a sixty-million-dollar shuttle-launch simulator. He has also built exhibits for Chicago's Adler Planetarium, General Motors, Ford Motor Company, the Texas State History Museum, Universal Studios and Warner Brothers. His upcoming works include exhibits at the Great Wall of China, Hadrian's Wall in England and the Henry Ford Museum; and experience centers for Niagara Falls, NASA's Houston space complex and the kingdom of Saudi Arabia. He has even been invited back to work for Disney, creating movies for Disney World.

Although he now runs a complex company with offices in the Netherlands and the United Kingdom, in person, Rogers doesn't come across as a CEO type. His speech is riddled with sarcasm and wit, his behavior with pranks. Yet, behind his casual disposition is a visionary. *Newsweek* called him the "industry's resident futurist." Among 250 international awards for creative excellence, he received a Lifetime Achievement Award from TEA, the Themed Entertainment Association industry group. In the mix were two Academy Award nominations.

His lobby walls greet visitors with large, inspirational quotes. One of them reads: "Discovery consists of seeing what everybody has seen and what nobody has thought." Bob Rogers certainly has conjured more than his share of discoveries.

■ Born in 1950; moved to Orange County in 1955, the same summer that Disneyland opened.

■ First job was as a magician at the Magic Store in Disneyland; filled-in for absentees in other departments so he could learn how things worked; fired because of his curiosity; "No rehire" written on his personnel file during his exit interview.

■ Studied filmmaking at Stanford University, then at CalArts; rehired at Disney as a writer; eventually was fired at age twenty-three—and escorted out by the head of the entire story department, who told him, "People like you are why we have guards at the gate."

■ Directed commercials and educational films for seven years, then rehired at Disney for a third time, joining the Imagineering team to produce the *Impressions of France* film for Epcot, which ended up playing for twenty-five years; after the project was done, they showed him to the door once again.

**BOB ROGERS,
Exhibition Designer;
beside two of his characters,
Leonardo da Vinci and
Abraham Lincoln,
Burbank, 2007**

The vast majority of human beings dislike and even dread all notions with which they are not familiar. Hence, it comes about that at their first appearance, innovators have always been divined as fools and madmen.

Aldous Huxley was a trailblazing writer whose life was preoccupied with journeys, real and metaphysical, as he and the characters from his novels merged, both exploring new worlds and new ages.

After visiting America, where he witnessed rampant commercialism and technology gone amok, Huxley returned to Europe filled with pessimism for future societies. He shaped his concern into his most famous book, *Brave New World*, a biting view of a twisted, dark dystopian world, fraught with cynicism. When the book was published in 1932, it became an instant classic.

Suffering with poor eyesight, Huxley took a chance that moving to the dry, sunny Southern California climate would improve his vision—and that the cults that flourished there would stimulate his philosophical curiosities. So, in 1937, the forty-three-year-old novelist gathered his books, wife and son, and set sail. Coming to Los Angeles proved a turning point in his life. His fortunes increased, his eyesight improved and his writing and lifestyle headed into brave new worlds of his own making.

His first novel written in L.A. was *After Many a Summer Dies the Swan*, the story of a William Randolph Hearst-like millionaire fearing his own death. Hollywood studios soon learned he had moved here and hired him to write screenplays for more money than his novels had ever earned. Huxley scripted adaptations including *Pride and Prejudice* (1940), and *Jane Eyre* (1944). But he was disappointed in his experience with moviemakers. Walt Disney rejected his screenplay of *Alice in Wonderland* with the comment that he could only understand every third word. Huxley's obtuse dialogue and meandering plotting were at odds with the storytelling demands of the movies.

After three years of living in the big city, Huxley made a short but profound journey. He fled L.A. to a peaceful forty-acre ranch in the high-desert hamlet of Llano, in northern Los Angeles county. His first priority was to try to improve his eyesight. Using the bright lighting of the desert and a technique called the Bates Method, he was able for the first time in more than twenty-five years to read and even drive a car without eyeglasses. He wrote a book about his success, *The Art of Seeing*.

His second goal was to find enlightenment, which he pursued by embracing a new set of philosophies and experiences. He started meditating, went on vegetarian diets, practiced Indian mysticism and experimented with psychedelic drugs: peyote, mescaline and finally LSD. He wrote two nonfiction books about his experiences with these altered states of mind, *The Doors of Perception* (1954) and *Heaven and Hell* (1956), which were landmark accounts, fully a decade before the youth movement of the late 1960s rediscovered them.

Despite his increasing drug use, Huxley stayed productive. He wrote *Ape and Essence*, a novel set in a dystopian civilization (after a nuclear holocaust is started by intelligent baboons); *The Devils of Loudon*, depicting mass hysteria and exorcism in seventeenth-century France; *Brave New World Revisited*, and his final novel, *Island*, in 1962, a more upbeat, New Age story set on a fabled island paradise, with psychedelic mushrooms and a cynical journalist who shipwrecks there.

On his deathbed in 1963, riddled with cancer and unable to speak, Huxley made a written request to his wife for a hundred milligrams of LSD. She gave him the injection and whispered into his ear, "Let go, darling; forward and up. You are going forward and up; you are going toward the light. Willingly and consciously you are going." Coincidentally, Aldous Huxley was sent on his last journey of discovery the same day as John F. Kennedy's assassination.

- Born in Surrey, England, in 1894, and raised among a gifted upper-middle-class family of biologists, writers and naturalists; lost his mother at fourteen and at sixteen came down with an ocular disease that left him practically blind, putting an end to his plan to become a doctor.

- Using a powerful magnifying glass and special glasses, managed to graduate first in English literature at Eton; received a degree in the same subject from Oxford.

- Penned a collection of poems, then his first novel, *Crome Yellow*, at the age of twenty-seven; over the next decade, published more than a dozen novels, establishing him as one of the *enfants terribles* of the literary world.

- After marrying Maria Nys in 1919 and fathering a son, Matthew, a year later, began a nomadic existence for nearly two decades around Europe and to such places as India and the Dutch East and West Indies.

ALDOUS HUXLEY,
Author;
Los Angeles, 1956

I think about Columbus or Lewis and Clark discovering the final frontiers of their time. Our current frontier is Pluto, Jupiter, Saturn and beyond. To think that I have a part of that voyage of discovery is pretty exciting. And pretty satisfying!

Bob Mitchell has been described by a fellow Jet Propulsion Lab colleague as the world's foremost space navigator, a guy who can guide a NASA spacecraft to Mars, Jupiter and Saturn with minute precision.

As manager of the Cassini-Huygens mission, the first spacecraft to orbit the jewel of the solar system, the ringed planet of Saturn and its moons, Mitchell is perched at the cutting edge of space exploration.

He pilots this delicate, gold-foil-wrapped, twenty-two-foot-high craft through the heavens, using sophisticated mathematical calculations and onboard adjustment engines the size of a fist. Launched in 1997, Cassini has been guided by Mitchell nearly one billion miles over seven years to enter Saturn's orbit. Each piloting command takes three hours to reach the craft in this, his and NASA's most technically challenging mission yet.

"The whole concept of navigating a spacecraft through a journey ten to a hundred million kilometers away . . . and controlling it within a kilometer . . . we are the only place doing that kind of precision flying. Nobody but JPL is doing anything more than orbiting earth," he says.

Mitchell spends years piloting these rare crafts without ever touching them after they are packed up for transport to Cape Kennedy, where they are launched. For a more down-to-earth experience, he drives and tinkers with a different kind of craft: motorcycles. He started this passion in his youth, dirt-biking off-road, even getting into competitive desert racing, including the Baja 1000. The mental and physical pounding has proved a useful antidote to the quiet JPL labs. Lately he has switched to collecting and restoring vintage motorcycles, first buying a few Triumphs, then some Indians. Now he has twenty classic cycles in his garage.

For our photo session, Bob chose to be shot with one of his prized possessions, a 1932 Indian motorcycle, which he has lovingly rebuilt. It was a surreal sight to see Bob ride this antique onto the Mars simulation field at JPL, carefully maneuvering the bike across the red sand and through the volcanic boulders, where only state-of-the-art Mars rovers have driven.

Mitchell isn't prone to fanciful dreaming. All of his great accomplishments have been from months of painstaking calculations, planning, and thoughtful deliberation, involving teams of colleagues. Yet he revels in the unexpected and lights up with the joy of discovery every time his spacecrafts send pictures of unimagined vistas. "One of my remaining dreams as a scientist," he said, "would be to discover on one of our missions a life form—even as simple as a microorganism—so we could prove that life has developed outside of Earth."

- Born in Springville, Pennsylvania, in 1940 and raised on a family farm; showed an early aptitude for things mechanical by helping his father fix tractors, while excelling in math and science in school.

- Was fascinated as a seventeen-year-old by the physics of the first space orbiter, Sputnik. "I argued with my high school physics teacher about how its earth orbits would work. I was still pretty naïve . . . but I think I was right about that argument."

- Earned an electrical engineering degree from the University of Arkansas "because it was alleged that it was the most difficult one there," and then a master's degree in math and electrical engineering.

- Hired by the Jet Propulsion Laboratory at twenty-five, just as the first of the Mariner Venus probes were being deployed; worked on trajectory design on Mariner 5, which flew by Venus in 1967; applied his planetary navigation skills to three Mariner missions and a Viking mission to Mars.

- Promoted to head designer of the Jupiter-bound Galileo mission, which took nine years to perfect before it launched in 1989, and six more before it descended into the giant planet's atmosphere; took charge of the entire mission.

**BOB MITCHELL,
Space Engineer; at the Mars
test field in front of a full-scale
Cassini spacecraft model, the
Jet Propulsion Laboratory,
Pasadena, 2007**

The most difficult thing is the decision to act; the rest is merely tenacity. The fears are paper tigers. You can do anything you decide to do.

Amelia Earhart

flew across continents and into people's hearts. Few women have captured the imagination of the American public as this aviation pioneer did. Her courageous accomplishments and mysterious mid-Pacific disappearance continue to inspire and intrigue generations.

Amelia Mary Earhart was in motion her entire life. As she rode the train across the plains to join her parents in Southern California in 1920, this twenty-three-year-old knew it was time to get serious with her life. A ten-minute ride in her first airplane at an airfield on L.A.'s Wilshire Boulevard proved to be the liftoff to her destiny. She said, "I knew I had to fly."

She spent four years barnstorming in a yellow two-seater biplane that she named *Canary*. After running through her savings and inheritance, she was forced to sell the plane and accompany her recently divorced mother to the East Coast. Earhart tried to finish her studies at Columbia University, but she ran out of tuition money and instead started writing newspaper columns promoting flying.

In 1927, her columns attracted the attention of a New York publisher, George Putnam, who had come up with the publicity stunt of having a woman join a flight over the Atlantic, just months after Charles Lindbergh's historic solo crossing. He chose Earhart to join two male pilots who left Newfoundland, and after flying mostly in fog for twenty hours and forty minutes, landed in Wales, nearly out of fuel. Although Earhart was not allowed to take a turn as the pilot, the public didn't care. Their landmark flight made "Lady Lindy," as she was dubbed, an instant celebrity and honored her with a ticker-tape parade in New York and a reception at the White House.

Her new fame allowed her to return to flying—and to Southern California. She moved to North Hollywood, where she began a series of appearances and flights, including a Los Angeles-to-Cleveland all-women's race and a women's flying league derby flying from Santa Monica to San Bernardino. Having become close friends with her promoter George Putnam, she wed him in 1931.

Exactly five years after Lindbergh's Atlantic crossing, this partnership sent Earhart back to Newfoundland—this time as the pilot. Strong winds and mechanical difficulties pushed her off course, but after nearly fifteen hours, she touched down in Ireland and landed in the international headlines again. In years that followed, she continued to push herself to new levels of endurance, speed and piloting skills. In 1935, she did what ten men had already died trying, becoming the first to fly solo across the eastern Pacific. As she approached her fortieth birthday, she formulated plans for a final record, the first female-piloted around-the-world flight.

On May 21, 1937 Earhart and her navigator, Fred Noonan, with her husband and her mechanic riding along as far as Miami, took off heading east from the Burbank airport to attempt to circumnavigate the globe "by about the longest route we could contrive," she said. Met by adoring fans throughout, Earhart's twenty-nine-thousand-mile journey proved to be her swan song after she and Noonan left New Guinea on July 2, en route to the tiny mid-Pacific Howland Island.

As radio audiences around the world waited for news, at 8:45 A.M. the next day, a U.S. Coast Guard sailor picked up a final message, "We are running north and south." Despite the most extensive air and sea search in history, the plane was never seen again.

Although rumors of Earhart sightings persisted for years, nothing was ever confirmed. In an earlier letter to her husband she wrote: "Please know I am quite aware of the hazards. I want to do it because I want to do it. Women must try to do things as men have tried. When they fail, their failure must be but a challenge to others."

■ Born in Kansas in 1897; attended high school in Chicago as a lanky tomboy, who at night clipped newspaper stories about prominent women in male-dominated fields, dreaming about one day becoming one of them.

■ While working as a nurse's aide in a World War I military hospital in Canada, saw a stunt-flying exhibition by a war ace. "I did not understand it at the time," she wrote later, "but I believe that little red airplane said something to me as it swished by."

■ Enrolled in Columbia University to study medicine, but quit after a year to reunite with her parents, who had moved to Long Beach, California, in search of a new life.

AMELIA EARHART,
Aviator;
Los Angeles airfield, 1928

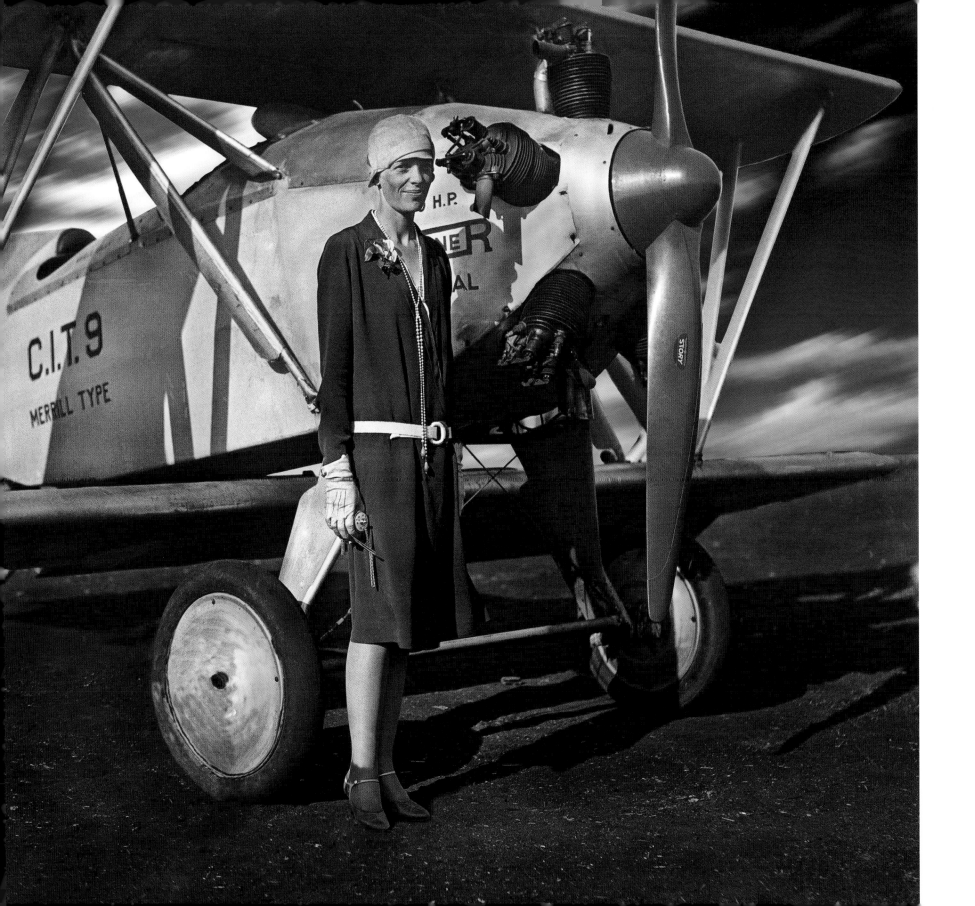

ACKNOWLEDGMENTS

I am one of those hyperactive, creative types with more hobbies than time (that's me, opposite, as a surfing teenager, in the orange trunks), more energy than skills, and more dreams than I can ever hope to realize. With my rediscovery of the joys of photography, which has circuitously led to this book, I have embarked on a third career. More than a few good souls have assisted me in making this journey possible, all of whom I would like to thank.

The genesis of my artistic inclinations is my mother, Marilyn (opposite, in the blue two-piece swimsuit), whose involvement in art as a docent at the Los Angeles County Museum of Art and as a sometime collector, thankfully put into my grade-school head an early appreciation for the visual arts. In high school, I was fortunate to attend Phillips Academy (Andover) in Massachusetts, with its outstanding photography and art studio facilities and instructors. Then at Stanford University, I minored in art, studying under such notables as Albert Elsen, the renowned art historian, author and the leading Rodin authority; Kirk Varnadoe, the Museum of Modern Art's chief curator of painting and sculpture for many years; and Leo Holub, a respected Bay Area landscape photographer. My recent re-immersion in photography was greatly aided by group shooting with Pat Faulstich, Nancy Baron, Mark Ross, and my son, Peter.

The layout and design of this book were masterfully done by the designer Amy Inouye of Future Studio.

Although my interest in Los Angeles history and the characters who inhabit it has been self-inspired, I have had to stand on several shoulders to accomplish the writing of these biographies and essays. It has been decades since I wrote anything more than business memos, script notes or short e-mails, so the task of cogently composing this text turned out to be much more challenging than I had anticipated. I could not have realized the final results without the invaluable editing help I received: initially from my wife, Denise, and daughter, Margot; then from Amy Dawes and Michael Parrish; and finally from my editor, Paddy Calistro. I am much in debt to each of them for improving my "raid on the inarticulate."

PHOTO CREDITS

All portraits of living individuals and all landscape photos have been photographed and digitally enhanced by the author.

All portraits of deceased persons were created by the author from a combination of elements including digitally added backgrounds and hand-colored and retouched photographs of the individuals licensed from the following individuals and institutions:
- Dorothy Chandler and Harry Chandler: personal collection of the author; original photographers and publishers unknown.
- Otis Chandler family: personal collection of the author; original photograph by Alex Spear.
- George Ellery Hale by E.B. Gray of Mount Wilson and Las Campanas observatories: AIP Emilio Segre Visual Archives.
- Hobie Alter carrying balsawood: courtesy Jeff Alter.
- Jim Morrison: Michael Ochs Archive, Getty Images.
- Gene Autry, Nat King Cole, Cecil B. DeMille, Walt Disney, Charles Hatfield, Aldous Huxley, Abbot Kinney, Charles Lummis, Upton Sinclair and Billy Wilder: *Herald Examiner* Collection, Los Angeles Public Library.
- William Mulholland: Security Pacific Collection, Los Angeles Public Library.
- Helen Hunt Jackson: California Historical Society—C.C. Pierce Photographer, Title Insurance and Trust Collection.
- Tom Bradley, Raymond Chandler, Donald Douglas, Amelia Earhart, Aimee Semple McPherson, Ronald Reagan and Simon Rodia: *Los Angeles Times* Collection, Charles E. Young Research Library Department of Special Collections, University of California Los Angeles.
- Rudi Gernreich: Charles E. Young Research Library Department of Special Collections, University of California Los Angeles.
- Howard Hughes: University of Nevada Las Vegas Special Collections.

All backgrounds to the portraits have been photographed by the author with the exceptions of:
- Dorothy Chandler inside the Dorothy Chandler Pavilion: *Los Angeles Times* Collection, Charles E. Young Research Library Department of Special Collections, University of California Los Angeles.
- Dorothy Chandler in her car: from a postcard of Palm Drive, 1914; photographer and publisher unknown.
- Harry Chandler in front of the *Los Angeles Times* building: *Los Angeles Times* Collection, Huntington Library.
- Harry Chandler in front of Santa Monica Bay: artwork from Los Angeles County publicity pamphlet, 1928; artist unknown.
- Gajin Fujita in front of his mural: from a photograph by Maria Ramirez.
- Helen Hunt Jackson: from a vintage photo of Rancho Camulos; date, photographer and publisher unknown.
- Abbot Kinney: from a souvenir postcard of Venice boathouse and lagoon; date, photographer and publisher unknown.

Frontispiece: Potential buyers at Beverlywood, late 1930s: *Los Angeles Times* Collection, Charles E. Young Research Library Department of Special Collections, University of California Los Angeles.

Page 33: Sport divers, ca. 1933: photographer unknown, Los Angeles Public Library.

BIBLIOGRAPHY

BOOKS

Barris, George and David Fetherston. *Barris TV & Movie Cars*. Osceola, Wisconsin: MBI Publishing Company, 1996.

Blumhofer, Edith Waldvogel. *Aimee Semple McPherson: Everybody's Sister*. Grand Rapids, Michigan: William B. Eerdmans Publishing, 1993.

Bradbury, Ray. *Fahrenheit 451: A Novel*. New York: Simon and Schuster, 1993.

—. *The Martian Chronicles*. New York: HarperCollins, 1997.

Chandler, Raymond. *The Big Sleep*. New York: Alfred A. Knopf, 1939.

—. *The Little Sister*. Boston: Houghton Mifflin, 1949.

—. *The Long Goodbye*. Boston: Houghton Mifflin, 1954.

—. *The Simple Art of Murder*. Boston: Houghton Mifflin, 1950.

Delyser, Dydia. *Ramona Memories*. Minneapolis: University of Minnesota Press, 2005.

Fenton, Frank. *A Place in the Sun*. New York: Random House, 1942.

Freeman, Judith. *The Real Long Goodbye: The Unconventional Marriage of Raymond and Cissy Chandler*. Los Angeles: UCLA Library, 2006.

Goldstone, Bud and Arloa Paquin Goldstone. *The Los Angeles Watts Towers*. Los Angeles: Getty Conservation Institute, J. Paul Getty Museum, 1997.

Gordon, Dudley. *Charles F. Lummis: Crusader In Corduroy*. Los Angeles: Cultural Assets Press, 1972.

Halberstam, David. *The Powers That Be*. New York: Alfred A. Knopf, 1979.

Hiney, Tom. *Raymond Chandler: A Biography*. New York: Grove Press, 1999.

Huxley, Aldous. *The Doors of Perception and Heaven and Hell*. New York: Harper & Brothers, 1954.

Ingersoll, Luther. *Ingersoll's Century History, Santa Monica Bay Cities*. Los Angeles: L.A. Ingersoll, 1908.

Jackson, Helen Hunt. *Ramona*. Boston: Little, Brown, and Company, 1908.

James, George Wharton. *Heroes of California*. Boston: Little, Brown, and Company, 1910.

—. *Through Ramona's Country*. Boston: Little, Brown and Company, 1913.

Lawrence, T.E. *Seven Pillars of Wisdom: A Triumph*. New York: Anchor Books, 1991.

Lummis, Charles F. *A Tramp Across the Continent*. New York: Charles Scribner's Sons, 1892.

Matsuhisa, Nobuyuki. *Nobu, the Cookbook*. New York: Kodansha International, 2001.

McDougal, Dennis. *Privileged Son: Otis Chandler and the Rise and Fall of the L.A. Times Dynasty*. Cambridge, Massachusetts: Perseus Publishing, 2001.

McWilliams, Carey. *Southern California: An Island on the Land*. Salt Lake City, Utah: Gibbs M. Smith, Inc. Peregrine Smith Books, 1946

Mulholland, Catherine. *The Owensmouth Baby: The Making of a San Fernando Valley Town*. Northridge, California: Santa Susana Press, 1987

—. *William Mulholland and the Rise of Los Angeles*. Berkeley: University of California Press, 2000.

Rasmussen, Cecelia. *L.A. Unconventional: The Men and Woman Who Did L.A. Their Way*. Los Angeles: Los Angeles Times Books, 1998.

Ruscha, Ed. *Leave Any Information at the Signal: Writings, Interviews, Bits, Pages*. Boston: MIT Press, 2004.

Schuller, Dr. Robert H. *My Journey: From an Iowa Farm to a Cathedral of Dreams*. New York: HarperCollins, 2002.

Sinclair, Upton. *I, Candidate For Governor: And How I Got Licked*. Berkeley: University of California Press, 1994.

Starr, Kevin. *Americans and the California Dream 1850–1915*. New York: Oxford University Press, 1973-2007. (First in a series of eight volumes by the author on California history.)

Wolfe, Tom. *The Kandy-Kolored Tangerine-Flake Streamline Baby*. New York: Farrar, Straus & Giroux, 1965.

Zimmerman, John. *Dan Gurney's Eagle Racing Cars*. Phoenix: David Bull Publishing, 2007.

ARTICLES

Bollen, Christopher. "Ed Ruscha, Painter." *Believer Magazine*, March 2006.

Colacello, Bob. "Eli Broad's Big Picture." *Vanity Fair*, December 2006.

Daraby, Jessica. "Eli Broad: Venture Philanthropist." *Art and Living Magazine*, June 10, 2007.

Harmetz, Aljean. "Billy Wilder, Master of Caustic Films, Dies at 95." *The New York Times*, March 29, 2002.

Motavalli, Jim. "To Be the Fastest Car on the Road (Callaway C12)." *The New York Times*, February 28, 2003.

Reynolds, Susan. "A Prophet Returns: Brave New World Movie Coming." *Los Angeles Times*, March 16, 2008.

Singh, Simon. "Big Bang Observatory Reaches 100." BBC News, December 20, 2004.

"Billy Wilder—obituary." *Variety*, April 1, 2002.

"Death of Chandler." *Time Magazine*, October 2, 1944.

"Finale For Fashion?" *Time Magazine*, January 26, 1970.

"2008-2009 Economic Forecast and Industry Outlook." Los Angeles County Economic Development Corporation, February 2008.

WEB SITES

The World Wide Web is a valuable research tool, but the dynamic nature of its content presents a challenge in a printed bibliography. References with an attributed author are listed first; unattributed pages follow and are ordered by subject. The Web addresses listed here were all "live" at the beginning of 2009. If any have since moved or disappeared, you may be able to access their content using the Wayback Machine feature of the Internet Archive (www.archive.org).

Barnes, Sandy. "Remembering the Lizard King—Classmates Talk About the Jim Morrison They Knew." *Alexandria* (Virginia) *Gazette Packet*, March 21, 1991. http://forum.johndensmore.com/index.php?showtopic=2398

Boyne, Walter. "The Rise and Fall of Donald Douglas." *Air Force Magazine*. http://www.airforce-magazine.com/MagazineArchive/Pages/2006/March%20 2006/0306douglas.aspx

Gehry, Frank. "Frank Gehry's Acceptance Speech." Pritzker Architecture Prize, 1989. http://www.pritzkerprize.com/laureates/1989/ceremony_speech1.html

Head, Steve. "An Interview with Jerry Bruckheimer." IGN.com, October 15, 2003. http://movies.ign.com/articles/455/455046p1.html

Patterson, Thomas. "Hatfield the Rainmaker." *The Journal of San Diego History*. Volume 16, Number 3, Summer 1970. http://sandiegohistory.org/journal/70winter/hatfield.htm

Rayl, A.J.S. "Planetary News: Cassini-Huygens (2004)—A Conversation with Bob Mitchell." The Planetary Society. http://wea.planetary.org/news/2004/0811_A_Conversation_With_Bob_Mitchell.html

St. Antoine, Arthur. "First Drive: 2008 Callaway C16 Speedster." *Motor Trend*. http://www.motortrend.com/roadtests/exotic/112_0708_2008_callaway_c16_speedster_first_drive/index.html

Thomas, Joe. "Gernreich, Rudi (1922–1985)." *GLBTQ: An Encyclopedia of Gay, Lesbian, Bisexual, Transgender & Queer Culture*. http://www.glbtq.com/arts/gernreich_r.html

Thomas, Steve. "Letting In the Light: Robert Schuller has Led his O.C. Congregation for Decades." *OC Metro Business*, December 9, 2004. http://www.ocmetro.com/t-CoverStory_Robert_Schuller_Crystal_Cathedral_religion120904.aspx

"Gene Autry." The Wild West: Cowboys & Legends. http://thewildwest.org/interface/index.php?action=383

"Gene's Biography." Gene Autry Entertainment. http://www.geneautry.com/geneautry/

"Tom Bradley: Mayor Who Reshaped L.A. 1917–1998." Los Angeles Unified School District. www.lausd.k12.ca.us/Tom_Bradley_EL/TBradBio.html

"Jerry Bruckheimer: Biography." *Variety*. http://www.variety.com/profiles/people/Biography/29063/Jerry+Bruckheimer.html?dataSet=1

"Jerry Bruckheimer: A Biography." Jerry Bruckheimer Films. http://www.jbfilms.com

"About Ray Bradbury." Raybradbury.com. http://www.raybradbury.com/bio.html

"Eli and Edythe Broad." The Broad Foundation. http://www.broadfoundation.org/about_broads.html

"List of LAIH Fellows: Gordon Davidson." University of Southern California. Los Angeles Institute for the Humanities. http://www.usc.edu/libraries/partners/laih/fellows/GordonDavidson_000.htm

"Walt Disney, Biography." JustDisney.com. http://www.justdisney.com/

"Biography: Amelia Earhart." CMG Worldwide.
http://www.ameliaearhart.com/about/biography.html

"Amelia Earhart (1897–1937)." Forney Museum of Transportation.
http://forneymuseum.org/ameliaearhart.htm

"Bill Gross." Idealab. http://www.idealab.com/about_idealab/management.html

"Biography: Dan Gurney." All American Racers.
http://www.allamericanracers.com/bio.html

"The Hobie Story (Since 1950)." Hobie Cat.
http://www.hobiecat.com/experience/story.html

"Since 1950: Hobie History." Hobie Brands International.
http://www.hobie.com/history/

"About Huell Howser." Huell Howser Productions. http://calgold.com/about.asp

"The Howard Hughes Story." The Howard Hughes Corporation.
http://www.howardhughes.com/pdfs_hh/allText4.pdf

"The Story of the Los Angeles Aqueduct." Los Angeles Department of Water & Power.
http://www.ladwp.com/ladwp/cms/ladwp001006.jsp

"Charles F. Lummis Home & Garden." Historical Society of Southern California.
http://www.socalhistory.org/Socalhistory.org%20_mainfolder/Lummishome%20
and%20garden/LummisHome.htm

"The Production Team." MacGillivray Freeman Films.
http://www.macfreefilms.com/company.htm#team

"Nobu Matsuhisa." Myriad Restaurant Group. http://myriadrestaurantgroup.com/
nobu/nobu.html

"Bob Rogers." BRC Imagination Arts. http://www.brcweb.com

"Biography: Dick Rutan." http://www.dickrutan.com/biography.html

"Life." Oak Productions. http://schwarzenegger.com/en/life/

"Upton Beall Sinclair (1878–1968)." Kuusankosken kaupunginkirjasto.
Authors' Calendar. 2003. http://www.kirjasto.sci.fi/sinclair.htm

"Biography: Antonio Villaraigosa." City of Los Angeles.
http://www.cityofla.org/mayor/mayorsoffice/Biography/

"History of the [Watts] Towers." KCET: *Life And Times*.
http://www.kcet.org/lifeandtimes/arts/watts_history.php

Additionally, the author used a number of general reference Web sites,
including IMDB.com, Wikipedia.com, Wikiquote.com, Brainyquotes.com,
memorable-quotes.com and Answers.com